# THE
# NEW GUIDE
# TO
# ILLUSTRATION

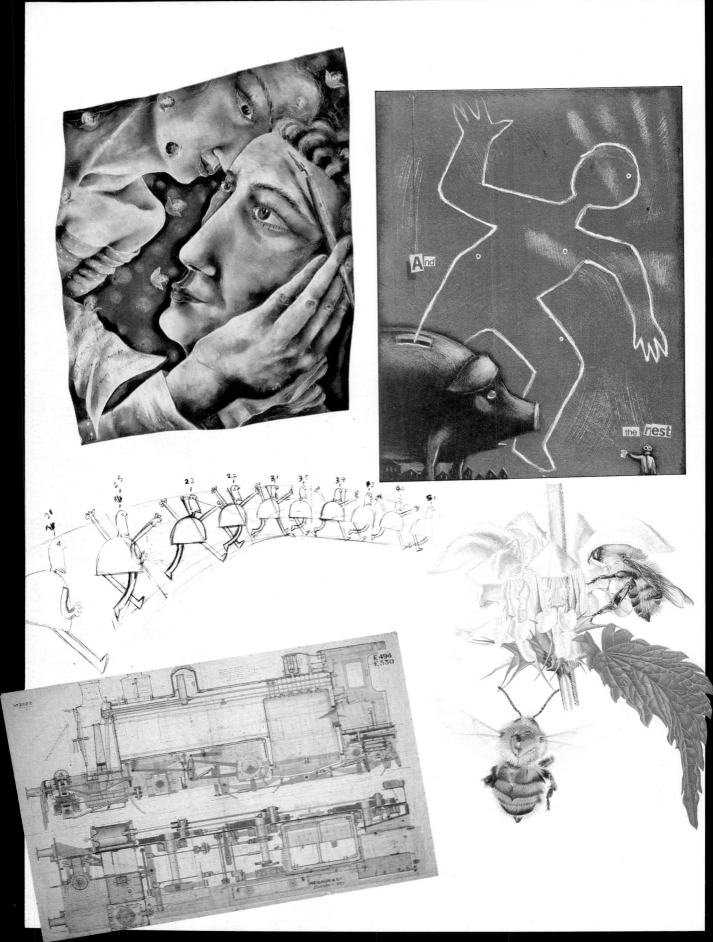

# THE
# NEW GUIDE
# TO
# ILLUSTRATION

**Editor**
Ian Simpson

PHAIDON · OXFORD

**A QUARTO BOOK**

Published by Phaidon Press Limited
Musterlin House
Jordan Hill Road
Oxford OX2 8DP

First published 1990

A CIP catalogue record for this book is available from the British Library

ISBN 0 7148 2628 6

This book was designed and produced by
Quarto Publishing plc
The Old Brewery
6 Blundell Street
London N7 9BH

**Senior Editor** Cathy Meeus
**Project Editor** Susan Berry

**Designers** Frances Austen, George Ajayi
**Picture Researchers** Valya Alexander, Prue Reilly

**Editorial Director** Carolyn King
**Art Director** Moira Clinch

Quarto would also like to thank the following for their help in the
preparation of this book: Susan George, Hazel Harrison, Jeremy Harwood,
Irene Kotlarz, Kaye McInerney, Judy Martin, Andrew Restall

Manufactured in Hong Kong by Regent Publishing Services Ltd
Printed in Hong Kong by Leefung Asco Printers Ltd

# CONTRIBUTORS

**IAN SIMPSON** (general editor and MEDIA AND TECHNIQUES) was until recently principal of St. Martin's School of Art and lecturer at Syracuse University, New York. The writer and presenter of three television series on drawing and painting, he has also been president of the National Society for Art Education, a council member of the Council for National Academic Awards and Chairman of the CNAA's Fine Art Board. He is currently consultant to the Open College of the Arts.

**Andrea Bassil** (SPECIALIST ILLUSTRATION) is Course Director in Natural History Illustration at Bournemouth and Poole College of Art and Design. She also teaches computer graphics.

**Martin Colyer** (MAGAZINES AND NEWPAPERS) is a magazine designer. From 1982 to 1985, he was Art Editor of the *Listener* and then, until 1988, Art Editor of the *Observer* magazine. He has served on the judging panels of various international illustration awards.

**Peter Cull** (SPECIALIST ILLUSTRATION) is Director of the Education and Medical Service of a major teaching hospital. He is former Chairman of the Medical Artists' Association and of the Institute of Medical and Biological Illustration.

**Sarah Culshaw** (PROFESSIONAL PRACTICE) is the founder of Sharp Practice, a leading illustrators' agency. She was Administrator of the Association of Illustrators between 1980 and 1985.

**Leo de Freitas** (INTRODUCTION) lectures and writes on the history of illustration and graphic design. He has written several books on individual artists, including John Tenniel, Arthur Rackham, W. Heath Robinson and Charles Robinson.

**Michael Leek** (SPECIALIST ILLUSTRATION) is Senior Lecturer in Technical Illustration at Bournemouth and Poole College of Art and Design. He is a member of the Chartered Society of Designers, a Fellow of the Institute of Scientific and Technical Communicators and a Life-Fellow of the Royal Society of Arts.

**Michael McGuinness** (MAGAZINES AND NEWSPAPERS) is Art Editor of *The Independent on Sunday*. A practising illustrator, he is also an Associate Member of the Royal Watercolour Society.

**Tony Potter** (BOOKS) is a writer and designer of information books for children. He currently runs his own book-packaging firm.

**Mark Reddy** (ADVERTISING AND GRAPHICS) is an Art Director of BMP DDB Needham Ltd. He is also an artist and illustrator in his own right.

**Howard Tangye** (SPECIALIST ILLUSTRATION) is a freelance fashion illustrator. He has worked as assistant designer and illustrator for Zandra Rhodes.

**Brian Webb** (ADVERTISING AND GRAPHICS) is a director of Trickett and Webb, one of Britain's leading design groups. He has also lectured at the Royal College of Art, Kingston Polytechnic and the Crafts Council. Among his many awards are a gold award for package design from the Package Design Council International, in the USA, and a bronze medal in the first Poster Triennial at the Museum of Modern Art, Toyama, Japan.

# CONTENTS

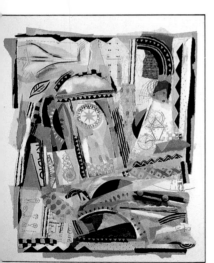
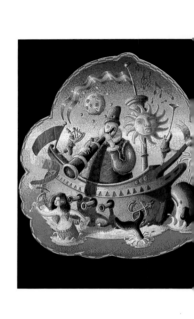

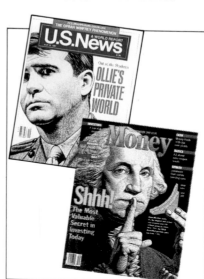

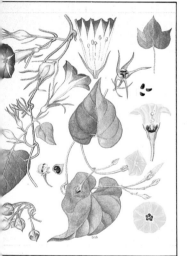

# FOREWORD

This book is a comprehensive source of information for anyone interested in the art of illustration but is intended particularly for students or others who are considering becoming illustrators.

A number of people eminent in the field of illustration were invited to write the various sections of the book. Some are distinguished professional illustrators, others are the equally important people who commission illustrations and who often act as crucial links between client and artist.

I have used the word "artist" here as one which can be interchanged with "illustrator" because today the distinction between the illustrator and the fine artist is, to say the least, blurred. Highly personal and imaginative work, usually considered to be the hallmark of the artist, is as evident (if not more so) in the work of the best illustrators as in the work of gallery artists and some illustration is actually exhibited, in precisely the same way that paintings are usually displayed. In art education many illustration students exist uneasily on the edge of graphic design departments as being closer in sympathy with their fine art colleagues than with the other students in their own department. We have therefore been careful in this book not to define illustration too precisely because to do so would be misleading.

There is nevertheless usually a significant difference between an illustrator and, for example, a painter. The illustrator generally has to produce work which satisfies a brief. At best though, illustrators don't merely provide clients with what they want, they achieve what I believe should be the true aim of all designers, to provide clients with what they never dreamed they could have.

By now linking the aims of illustrators with those of designers, I am perhaps suggesting a definition of the

illustrator's role as part artist and part designer. Though there can be exceptions, I do not think this definition is too wide of the mark. Certainly, as the illustrators contributing to this book testify, there is much more to illustration than being able to draw and paint in an "illustrative way".

Each contributor to this book has written from their own particular viewpoint and so the book reveals occasional contradictions and differences of emphasis. Most practitioners from any walk of life will, in describing their profession, present the problems and difficulties, the "down side" of the job, rather than its virtues, and those writing in this book are no exception. It is right to present prospective illustrators with the pitfalls of the job rather than showing it as a bed of roses. But most would agree that being an illustrator is a highly rewarding as well as a demanding profession.

The illustrator today has an exciting role which is constantly changing but which seems to have greater and greater possibilities. If you feel confident in your desire to become an illustrator, I hope you will see the professional difficulties presented in this book as a challenge rather than a deterrent.

IAN SIMPSON

9

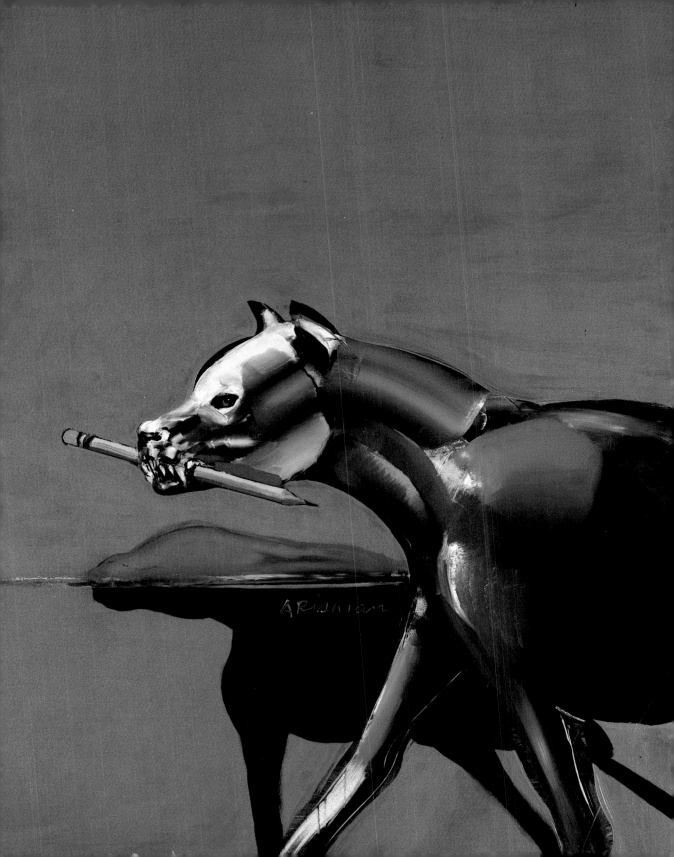

# INTRODUCTION

Illustration has been a vital art in the history of the modern world, and is an established part of our cultural experience today. Certainly there has been much pedestrian work brought before us during the past 200 years, but there has also been that which has been aesthetically stunning, conceptually exciting, spiritually encouraging – art that has been genuinely inspirational. Having picked up this book it is likely that at some time or another you have found yourself arrested by the beauty, poignancy or relevancy of just such a piece of work. Illustration is alive and kicking, with much to offer those with individual vision, technical accomplishment and an active appreciation of the world of commerce.

◀ MARSHALL ARISMAN
**The Dog and Pencil**
Arisman is one of the leading figures in contemporary illustration; in common with many of his peers, he has explored and extended his repertoire of drawing skills, taking a more "painterly" approach to his subjects. Among the influences on his work are Andre François, Velasquez, Goya, primitive art and the British painter Francis Bacon.

Before World War II, illustrators had generally worked within the realistic and comic tradition set by the great Victorian artists. Academically sound drawing was at its core, even when the illustration was at its most decorative or humorous. In the 1920s and '30s a certain graphic "stylishness" in illustration had found fashion with editors and advertising agencies, and new visual languages borrowed from painters and sculptors were explored by the avant-garde in illustration. But still the traditions of the Victorians largely dominated.

**The new challenge**
In the 1950s and '60s, however, in the commercial post-war expansion, opportunities to challenge this tradition

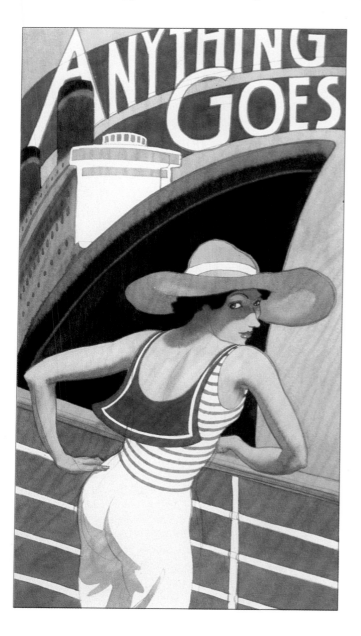

gave willing illustrators the chance to work in more modern and self-expressive ways. This type of illustration was calculated to catch and promote (and also criticize) the spirit of the new era – the era of mass communication and the consumer society. Illustration could be "self-directed", adventurous, reflective, thoughtful and mature.

Fundamentally, and significantly for the future, the dominance of the graphic line – pen and ink and pencil drawing and line sketches filled in with colour – wavered before the "painterly" approach of the innovators. Of course the old tradition did not simply die away – there was too much that was good about it for that to happen. But the illustrators who chose pen and ink, and followed on from men like Saul Steinberg and Ronald Searle, were altogether a different breed of artist from the greats of the 19th century and these men and women are still working within the tradition today.

In the pages of new or restyled magazines, the unique qualities of the paintbrush rather than the conventions of the pencil began to thrill and chill the eye. New benchmarks were being laid down for the generations to come.

Graphic decorum and ponytail cuteness surrendered to incisive, biting drawing and comment. From the springboard of technical knowledge a number of "black and white" illustrators explored and extended the repertoire of drawing skills conventionally associated with the genre. Composition became more exciting and rendering techniques more expressive; the older drawing disciplines were under siege.

**The influence of the modern art movement**
Behind this revitalized pen and ink drawing and the new use of painterly illustration lay both a sympathy and an antagonism with modern painting. The immediate art movement, conveniently grouped under the heading of "Abstract Art", was not as influential as the earlier Expressionist or Surrealist paintings, or naive painting, or even the later work of the "Pop" artists, but the intellectual spirit of experiment and adventure was not lost on the new illustration.

In the Pop Art of the 1950s and '60s, popular illustration (for instance, comic art) and popular graphics, as well as the techniques used to produce them, were

◄ JAMES McMULLAN
**"Anything Goes" poster**
McMullan's visual language here owes as much to popular culture as a whole as to the illustrative tradition of which he is a part. The composition shows a nicely understated sense of period, avoiding pastiche. McMullan has created a striking advertising symbol as well as a work of art in its own right.

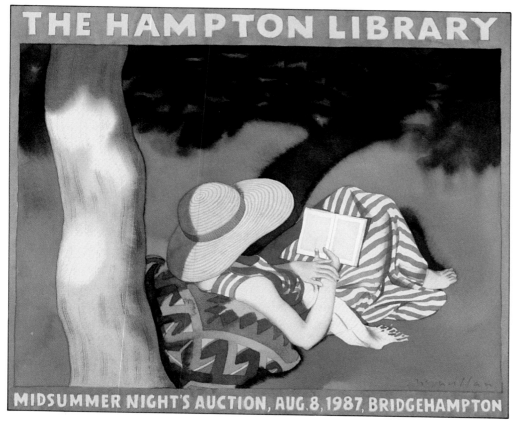

THE HAMPTON LIBRARY

MIDSUMMER NIGHT'S AUCTION, AUG.8,1987, BRIDGEHAMPTON

◀ JAMES McMULLAN
**Poster for the Hampton Library Midsummer Night's Auction**
Here, again, McMullan has gone back in time to a past era, in which reading was a pleasurable leisure activity, and the illustration that he has produced reflects the thought inspiring it. Many modern illustrators study historical examples carefully; some of them deliberately experiment with older reprographic techniques in order to convey a truly authentic atmosphere. Other sources of inspiration include picture postcards, old advertisements, fashion drawings and comic strips.

themselves subjects for painters and sculptors. Both Pop Art and the popular cultural artefacts it used were in different ways celebrations of the affluent, technological, consumer society and a particular kind of symbiosis existed between the two: both Peter Blake and Andy Warhol, for example, were graphic artists before turning to painting.

Perhaps nothing could have been further from tradition than the use of picture space by some illustrators. Full-blown montage and collage techniques were adopted from the Cubists and Surrealists, allowing complex messages to be made in one image space.

The decorative colour effects in Fauvist paintings and the disruptive, uneasy, exciting quality in Constructivist graphic design also offered alternative influences.

**The role of popular culture**
Twentieth-century fine arts have not been the only influences on modern illustrators. Popular culture at large has contributed to the range of emerging visual languages and all forms of popular print have been explored (not always knowledgeably or wisely) by artists in search of a personal style. Fairground and pantomime art, vernacular graphics and surface decoration on popular industrial products are just some of the areas

young illustrators have been mining.

It would be inconceivable for the popular illustration of the past not to be a part of this influence. Pastiches of earlier illustrative styles and experimentation with the particular qualities of older reproduction techniques, together with a conscious and careful study of historical examples (on the part of some illustrators), have all contributed to the growing range of illustrative styles. Picture-post-card illustration, drawings on old advertisements, comic books, fashion illustration, the imagery in the "pulps" and the gauche illustration from children's annuals and magazines are just some examples of historical illustration serving as visual sources and attracting attention today. Film (including animation) and photography, too, have provided references and ideas for composition and arrangement of the illustrated page.

Personal development and discovery through drawing, combined with this eclecticism, has been at the core of much recent illustration, but not to the exclusion of the older tradition. Excesses have been perpetrated in the name of "modern illustration" and have made those who buy illustration sometimes hostile to art that is without commercial responsibilities. Today, knowledgeable draughtsmanship and good composition, together with sound ideas, are much sought-after qualities by art

13

directors and designers, and the competent illustrators working in a less avant-garde mode will always find a niche in the market-place.

## The changing face of commerce

While this gradual expansion of styles was going on, there were voices prophesying the end of illustration. The ubiquitous photograph and good, cheap methods of colour reproduction together with the phenomenon of television for the masses seemed to point to the inevitable demise of popular illustration

What such observers had overlooked or underestimated was the continued and increasing need for illustration of all kinds by commerce, the limitations of the camera and the photographic image, and the costs of employing an illustrator and a photographer. Television, despite its obvious, powerful impact on modern life, has

not only not replaced print (in fact, today it helps generate printed material – in support of, and growing out of, its programmes), but has employed illustrators and illustration on everything from news broadcasts through educational programmes, features and titling sequences to that unique illustrative genre, animation. The scope for illustration today is wider than it has ever been. In addition to this new medium, books, magazines, comics, advertisements, posters, packaging, indeed the whole gamut of printed materials have created a healthy environment in which illustrators can work.

The exciting new technology of the later 20th century may – like the camera and the photograph before it – create the imagery that was once drawn or painted by hand. But if history has anything to show us, the illustrator working with pen or brush, canvas, cartridge paper or cel will continue not only to work alongside the new technology, but with it too.

## The opportunities for experimental work

Currently, of all the areas open to illustrators it is magazine or editorial illustration which provides the best opportunities for experimental or avant-garde work. The frenetic business of informing and entertaining us through the pages of the mass of periodical literature

▼ RALPH STEADMAN
**Book illustration for *Fear and Loathing in Las Vegas***
Hunter S. Thompson is a figure whom Steadman recognizes as a major influence on his work. Their collaboration resulted in Steadman being voted Illustrator of the Year by the American Institute of

Graphic Arts in 1979. As an illustrator, Steadman is not afraid to shock or stimulate. His political cartoons for the satirical magazine *Private Eye* are recognized as classics of their kind. Other powerful stimuli include the powerful and caustic drawings of George Grosz and John Heartfield.

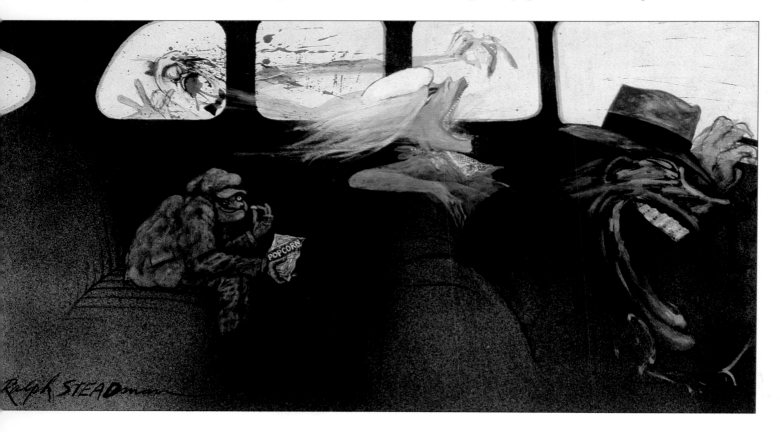

now available means art directors are constantly in need of appealing illustration and reliable illustrators.

Literally every subject under the sun is covered by magazines, and the scope for the illustrator's imagination needs be bounded only by his or her own vision and skill, and the publisher's nerve.

The very frequency of publication and the urgent need for dynamic "shelf-appeal" encourages editors to consider the new and the unconventional. It is arguably the case that more "modern" art has been presented to the general public through the illustrated pages and covers of magazines than through the open doors of museums and galleries.

Publishers of books are generally not so free to explore the range of innovative styles on offer. Adult fiction – an area where avant-garde illustration could perhaps be employed – is today largely left unillustrated and children's books, by far the biggest market for illustrated fiction, have the constraints of legibility (both literary and visual), cultural expectations, fashion and commerce that usually encourage a more conventional treatment of a text by both publisher and illustrator.

These boundaries have been successfully challenged by some publishers and illustrators, however, and by slow degrees the art of the children's book is being expanded. Certainly, when the historical record of 20th-century illustration comes to be written, selected illustrators of children's literature will occupy a significant place in it.

The covers of paperback books have in recent years given great scope to illustration and whilst the all-important marketing factor of "shelf - appeal" has ensured the continuance of certain (aesthetically tired) traditions, much that is new in illustration and design has been given a chance here.

The fact that at one time to illustrate a paperback cover was considered dropping to the bargain basement of the profession, and yet today there is keen competition from very serious illustrators to "have a cover to do", demonstrates something of how cultural and commercial shifts can influence the opportunities presented to the illustrator.

▼ PAUL DAVIS
**Artwork commissioned by Atkinson Brennan Design for C–Fax**
Today, the scope for illustration is wider than it ever has been and this is reflected in the daring techniques and styles adopted by some modern illustrators. The dramatic effect that Davis achieves here could never be captured by, say, the camera. What he has achieved is a powerful statement about the speed of modern communication. It is also a highly commercial piece of work, showing how a leading illustrator can balance an artistic statement with the demands of a client's brief.

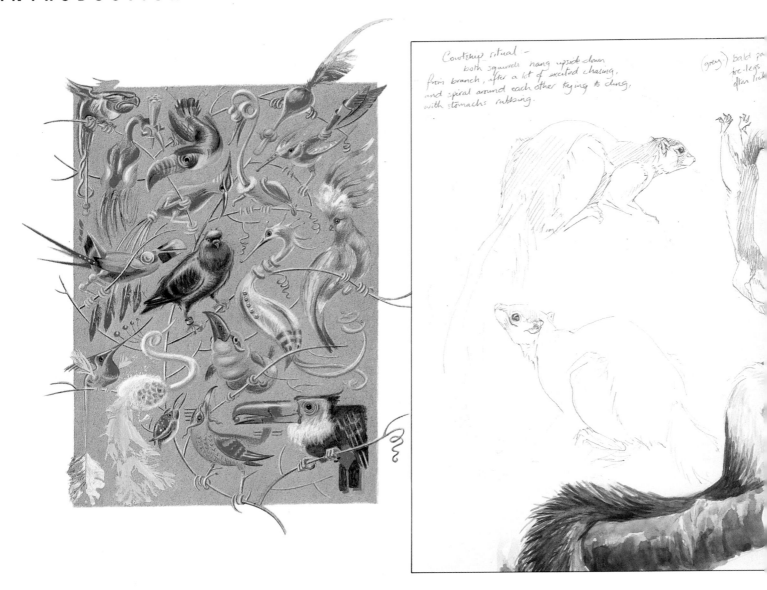

### The development of comic books

In the 1980s comic books and their art have attracted wide attention. Writers and artists working in the genre are studied and discussed in a much wider cultural context than before and in a more sympathetic manner too. The censorious and condescending nature of much of the earlier debate has given way to genuine interest in the possibilities of the medium.

Although traditions persist, new styles of drawing, layout, colouring and lettering have meant radical departures in how the comic book looks and the scope the comic book illustrator now has to work with. In Japan – a nation with a marvellous and respected history of graphic art – the comic book has already taken a central place in literary culture – something that many would like to see happen in the West.

A maturing of the comic book – where issues of some substance and less adolescent fantasy are tackled - could mean some really exciting prospects for illustrators in the near future.

In the image-hungry world of advertising, the visual language of comics has been but one of the illustrative approaches used to promote products and services. From computer-generated imagery, through photo-realist painting to animation, agencies have been using the almost endless, and unique, qualities of illustration for advertising in print and on film or television.

### The craft of illustration

There has always been both an art and a craft to illustration. Whether a decoration of a 12th-century manuscript or a rendering of a science fiction space vehicle, good illustration has always embodied both personal vision and accomplished technique.

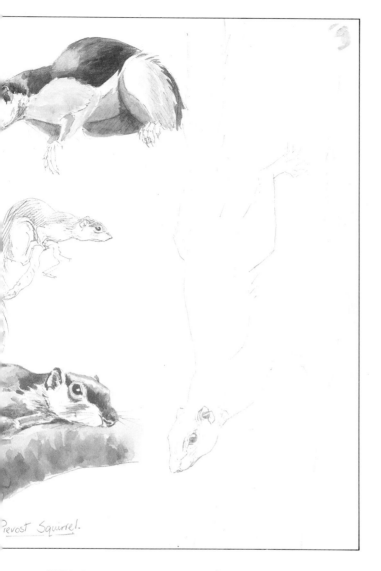

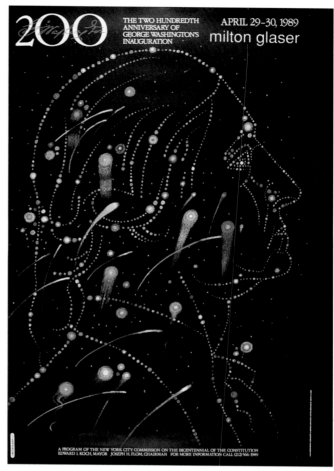

**◀ BUSH HOLLYHEAD**
**Calendar Design**
In his images, Hollyhead aims at preserving a sense of rhythm and movement, while, at the same time, ensuring that the various elements retain an overall cohesion. This calendar design is a typical example of his style; each bird featured in it has an individuality all of its own, while Hollyhead has also created a sense of life and movement within the framework of the composition as a whole. The overall theme is migration, which Hollyhead symbolizes by placing a grey pigeon at the heart of the illustration and surrounding it with exotic bird species.

**▲ DAVID BOYS**
**Prevost Squirrel**
Boys' pencil and watercolour sketches, made on location at London Zoo, are a skilled demonstration of the art of a natural history illustrator, working in traditional style. There are two main concerns here – effective rendering of the chosen subject and zoological accuracy in their depiction.

**▶ MILTON GLASER**
**Poster for the 200th anniversary of George Washington's inauguration as US president**
Glaser is a master of many styles and is probably one of the most catholic of present day illustrators .

The particular characteristic of a professional illustrator is the combination of these two abilities in the making of images. Whether drawing or painting for a children's book or some form of brand packaging, the professional illustrator has the job of generating and executing an appropriate image for a given commission.

It is the hallmark of the successful professional illustrator that a great deal of satisfaction is found in earning a living in this way, working with and for others.

In recent years, as a reflection no doubt of the scope and variety to be found in illustration and the differing approaches to it, there has been no simple consensus of what illustration is. Quite often this failure to arrive at any agreed definition of illustration is simply the unwillingness on the behalf of one group of practitioners working in a particular mode to accept the attitudes and work of another group working in a contrasting manner.

17

# INTRODUCTION

As an art form, it is argued by some, illustration is in a constant state of change and evolution and to attempt any form of narrow definition would be to describe it incorrectly and limit its potential.

Others complain that all sorts of nonsense is being produced in the name of illustration – that style without content has been allowed to flourish in the frantic desire to have something new and different. It is argued that unbridled encouragement to say what you want in whatever way you want (whether or not you have something worthwhile to say or the ability to say it well) does nothing to serve the prestige and identity of illustration.

That such near-polarized attitudes exist is a sign that a healthy restlessness characterizes illustration today. If, however, there appears to be little agreement on a definition of what illustration is, usually no such discord exists over what illustrators are employed to do.

The role of the professional illustrator is to accompany, explain, decorate, or to expand an idea in a visual way. It is to do with the effective communication of ideas using all the techniques and media available to the visual artist. To this can be added the parameter that the illustrator's work will generally be reproduced in some way and not seen in its original art form.

There is no single answer to effective communication in illustration today, so diverse are its applications. Instead one should perhaps speak about appropriate illustrative solutions: illustrative interpretations or dimensions that answer the particular requirements of a commission in an imaginative (yet precise) and satisfactory manner.

Those who commission illustration – designers, publishers, art editors and art directors – are in search of exactly this, and the successful illustrator is the one who is able to respond to the particular requirements of a brief with imagination and accomplishment.

## The importance of style

There have been noticeable (and notable) fashions in illustration throughout most of the 20th century and the associated question of "style", or of "possessing a style", has been of central importance to the profession since at least the late 1890s.

There appears once to have been a relatively leisurely period when young illustrators were encouraged to work hard at their drawing and not bother too heavily about a particular style – this would emerge gradually as the understanding of illustration techniques and expertise in their application combined and the individual's own voice began to assert itself.

▲ TOM CURRY
**Illustration**
*Video magazine*
Curry's original background in painting and drawing, which he studied at East Texas State University, clearly influences the

way he has tackled his subject here. He developed an interest in the fine arts while serving with the US Army in Germany.

For many illustrators today this exhortation to patience is incompatible with the pace of life. A recognizable style is a must for success; and the earlier one has it the better.

But style in illustration has ever been a double-edged weapon. On the one hand it identifies an individual illustrator, and possibly acts as self-promotion too, but on the other it can date and typecast an artist. An illustrator who is too heavily dependent upon, or too readily associated with a unique style of drawing can be dangerously vulnerable to the fads and fancies of fashion in publishing and design.

This contradiction is something the modern professional illustrator must confront or resolve. Casualties of the dilemma are scattered throughout history. But so are their opposites: those illustrators who have enjoyed a long life in illustration working with a dominant style that seems forever relevant. There are also illustrators who have successfully developed, and found an application for, a number of styles throughout their careers in response to their maturation as artists or to the changing aesthetics of the market place.

### The profession of illustration

Throughout the history of modern illustration there have been men and women who have successfully illustrated but who were never educated as professional illustrators. They have been trained perhaps as painters, sculptors or designers, and for one reason or another, have found themselves engaged with the illustration of texts. This gives rise to the question, "Is there a profession of illustration?"

It is surprising how many times one hears embarrassed, evasive replies from young students of illustration (or indeed even from some "professional" illustrators) to the question "What do you do?" "Oh, I'm not an illustrator. I'm a draughtsman"; or alternatively, "Oh, er, I draw for a living"; and, of course, "I'm not an illustrator. I'm an artist!"

Does this mean then that illustration as a profession has no independent existence? Is there no particular set of skills or attitudes to the work, no special knowledge needed, that deserves codifying into a professional stance towards what one does and how one does it?

▶ LANE SMITH
*Car Stereo Review*
Californian-born Lane Smith studied at the Art Center College of Design in Pasadena before moving to New York to begin his career as a freelance illustrator. His striking style is extremely individual, at the same time avoiding the risk of becoming dated or typecast.

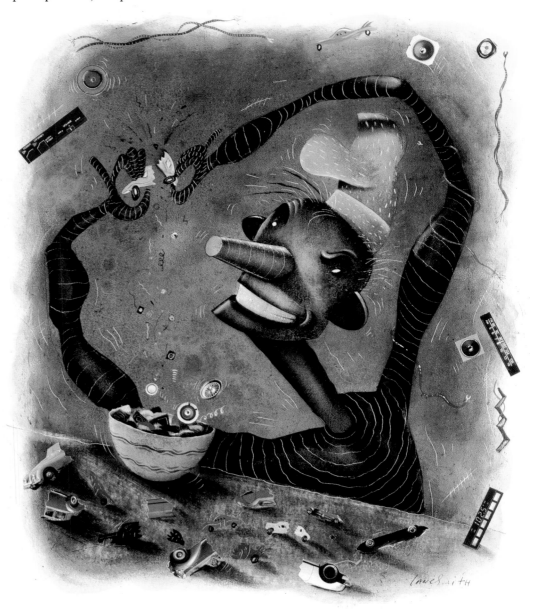

◀ LANE SMITH
**Quality Review**
Smith's work is regularly included in American Illustration; he has been awarded a silver medal by the Society of Illustrators. In 1987, his Hallowe'en ABC was picked as one of the ten best books of the year by the New York Times and the best book of the year by the School Library Journal.

Despite the ever-changing state of illustration, the professional illustrator is engaged with constants: drawing or painting for reproduction, generally working for and with others and earning a living from commerce. These are parameters within which the professional must work, and whether or not one was originally trained as a fine artist, as a designer, or as an illustrator, sustained success will come only to those who understand, respect and explore these boundaries.

An illustrator who cannot be relied upon to respect deadlines and the professional responsibilities of others he or she is working with will not enjoy a lucrative career for long. It is one of the particular disciplines of a professional illustrator, for example, that creative work has generally to be done by (and often against) the demands of the clock.

It has been argued that it is working for commerce that denies the professional illustrator the right to be called an artist. "Artists", after all, are not bound by the narrowed horizons of money-making.

However, making a livelihood out of an ability to perceive an idea visually together with the skill to realize 21

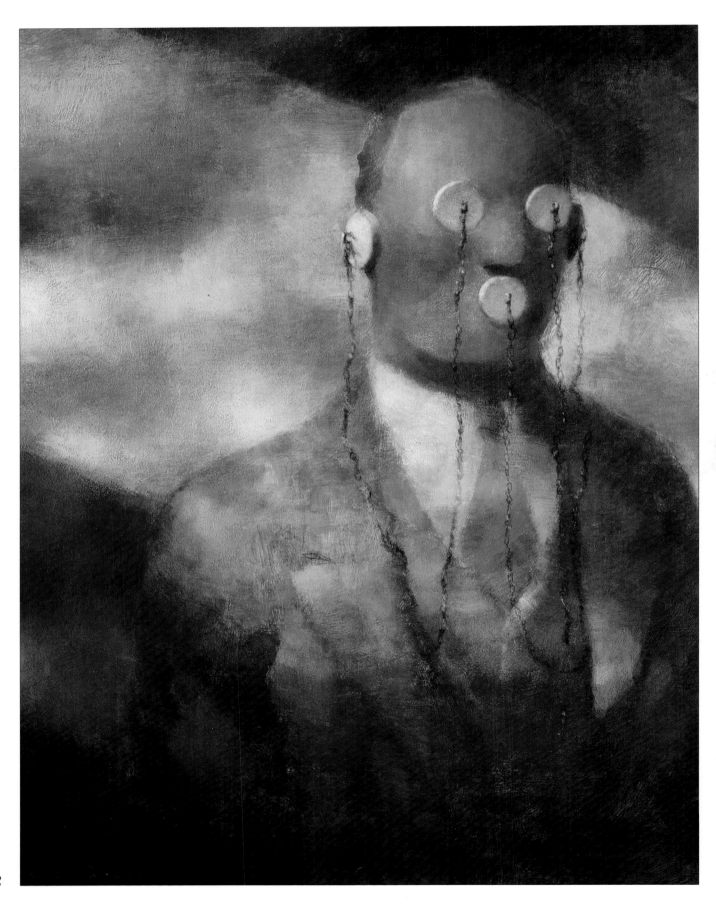

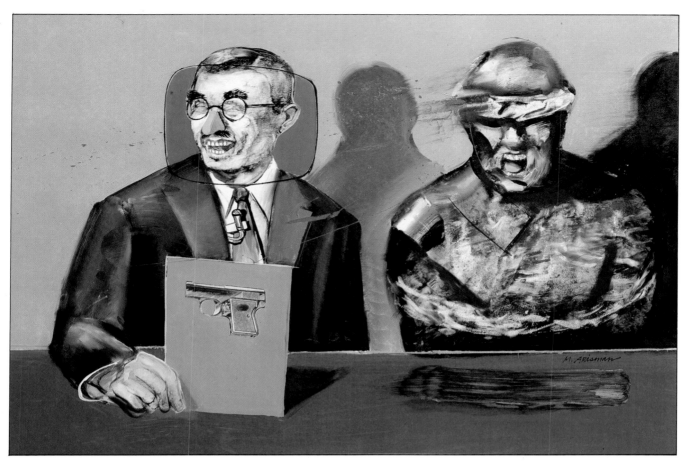

**Untitled illustration**
Holland prefers minimal briefing and supervision in his work; art directors see nothing until he has finished. This approach is as unconventional as Holland's work itself; it only works with a proven illustrator whose work an art director knows and admires. Holland believes the idea is all-important; frequently, he works on four or five illustrations at a time, experimenting with different ideas which, as he progresses, start to interrelate one with another.

that idea has ever engaged "the artist", whether a fine artist or a commercial artist. What counts is whether or not the art is good.

Although there certainly cannot be any one narrow definition of what is "good" illustration, the exceptional illustration is demonstrably the work of an original, creative mind allied with the skills of an accomplished draughtsman.

Virtuosity alone may make an illustrator competent, but it will not make exceptional illustration. Tired ideas expressed with formidable technical expertise are as easily ignored by the critical eye as the "stylish", self-expressive image that has nothing to say. There will always be room for such work, of course (not everything the illustrator is asked to contribute to admits in-depth analysis), but there is little likelihood of its enjoying anything other than an ephemeral life.

This is not to argue that everything the professional illustrator does can always be of the highest order (original ideas are surprisingly rare), but it is the ideal that will always be in the creative illustrator's mind.

▲ MARSHALL ARISMAN
*Frozen Images*
This image is from a book of illustrations on the theme of violence. Here, Arisman shows that it is the alliance between a virtuoso technique and an original idea that produces the out-of-the-ordinary result. Arisman is particularly concerned with contemporary issues; currently, he is working on a series of paintings, sculptures and videos on the theme of the atomic bomb and the future of mankind.

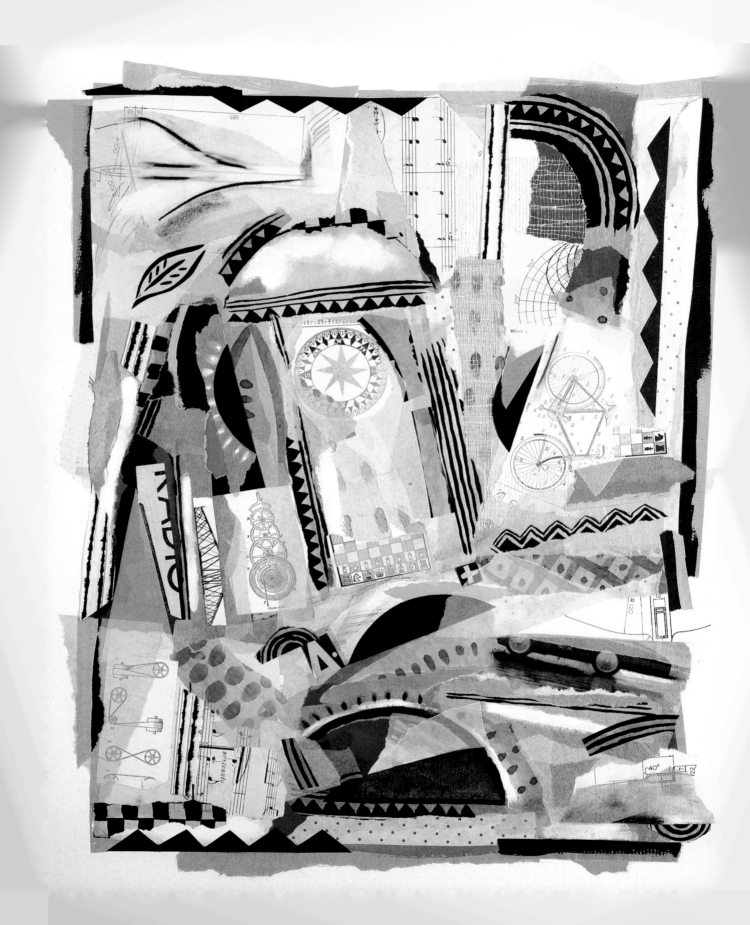

# MEDIA AND TECHNIQUES

In the past, reproduction methods limited the techniques and media that illustrators could employ, but nowadays reproduction techniques are sophisticated enough to cope with whatever medium the artist chooses. Reproduction, particularly in full colour, is expensive and reproduction costs can therefore still be a limiting factor on the techniques the illustrator uses, but basically illustrators have at their disposal any techniques and media that create images.

This section of the book describes some of the main techniques and shows how they have been used by contemporary illustrators.

◀ CATHY FELSTEAD
Skilful use of the torn paper collage technique, combined with a muted, carefully controlled colour scheme, has produced an illustration reminiscent of the Cubist still lifes.

# Pencil and charcoal

These are the principal dry media for drawn illustration, where line is a predominant factor in the work.

### Pencil

There are a number of different kinds of pencil for black and white and colour work. Graphite (usually known as lead) pencils are available in several grades from 8H (hardest) to 8B (softest). Some manufacturers use a simple numerical system, no.1 being the softest in the range. There are also carbon pencils, which produce strong black lines, and are graded soft to hard.

### Coloured pencils or crayons

These are available in extensive ranges – anything up to 72 colours. Although most coloured pencils are fairly soft and not easily erased, there is a small range of coloured pencils that can be erased in the normal way with an eraser. A pencil sharpener, a craft knife or a scalpel blade will produce a sharp point for drawing. An electric pencil sharpener is invaluable.

**Papers** Pencil can be used effectively on both white and coloured paper, either bought coloured or given a wash of watercolour paint. Smooth papers and card (eg Bristol board) tend to suit soft pencils; textured paper (rough cartridge or watercolour) is best for harder grades.

**Erasers** Plastic erasers and art gum erasers are the most effective; putty erasers, which can be moulded to any shape, are good for creating highlights or where great precision is needed. Strong pencil marks and most coloured pencil marks can usually only be effectively erased with a sharp blade – a single-edged razor blade or a scalpel blade.

**Fixatives** Drawings made with soft pencils smudge easily unless they are fixed. Although fixatives are often supplied in aerosol cans, they are not recommended as some are environmentally harmful. Fixative is best bought in a bottle and sprayed on the drawing using a spray diffuser.

**Techniques** Pencil is basically a linear medium and the lines can be very expressive, depending on the pressure and speed of the drawing hand and the grade of the pencil. Tone can be produced by rubbing, shading or hatching, or by dots and short strokes. Textures can be produced by laying the paper on a rough surface and rubbing a pencil over it. Using pencils of different grades in a drawing is one way of exploiting the medium.

### Charcoal

Standard stick charcoal is made in different thicknesses and degrees of hardness. The sticks can be sharpened with a knife or fine sandpaper, but it is far better to learn to create sharp lines by drawing with the "edge" of the stick, turning it as the edge becomes rounded. Sticks of compressed charcoal are also available. They do not break as easily as the "standard" sticks, but they are less easily dusted off the paper. Charcoal pencils are like ordinary pencils in which compressed charcoal replaces

the graphite. They are also available with a rolled paper coating. They can be sharpened and used more easily than sticks and are made in a range from HB to 6B.

**Papers** The best paper for charcoal is one with a texture which will exploit its intensity. It can look very effective on coloured paper.

**Erasing and fixing** Stick charcoal can often be removed by dusting with a soft cloth (a handkerchief is ideal!) but with very dark images or with compressed charcoal, the same methods as for erasing pencil are used. Fixing is essential and is the same as for pencil drawings.

**Techniques** Charcoal is messy to use and usually produces a powerful (but fragile) black image. It produces both line and tone easily. Tone can be made by rubbing a large quantity of charcoal on the paper and spreading it with a stump of rolled paper or with the fingers. Areas can be partially dusted off to make them lighter and highlights can be produced using an eraser. Because the images produced are so easily smudged, fixing is almost always necessary at intermediate stages of the work.

▲ BILL VUKSANOVITCH
An almost photographic image is created by skilful pencil shading, enhanced by the paper's fine-textured grain. The range of contrasting textures is achieved through subtle variation of tonal values. A cleverly selective use of line adds crispness.

▶ DAVID BOYS
The illustrator adapts the coloured pencil drawing techniques to different aspects of the subject. Soft, sensitive touches describe the insect's fragile wings; bold strokes colourfully model the surface of the leaf.

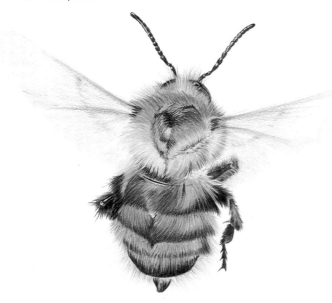

# Pen and ink

A variety of pens can be used including reed pens, dip pens, fountain or reservoir pens, ballpoints, felt-tips and rotrings. Drawing ink, sometimes called Indian ink, comes in a range of colours, but black or brown are the most commonly used.

**Papers** Best quality cartridge paper is used by most artists, ideally with a hard surface. If using a wash with ink, remember to stretch the paper first.

**Techniques** There are two basic styles: line or dot, from which myriad strokes can be built up. Artists tend to develop their own methods, which then become a distinctive attribute of their style. When making corrections to pen drawings, a razor blade or glass fibre eraser will deal with small blots and inked areas once

▼ MERVYN PEAKE
In this illustration to *Alice's Adventures in Wonderland*, the pen has been used to create textured tone, rather than to describe shapes. The trousers and the straggly hair, for example, are described vividly with little use of line for drawing contours.

▶ MARK REDDY
This illustration uses the medium imaginatively, creating a dramatic sense of space as compared to the more uniformly decorative effect often typical of scraperboard images. The strong contrast of black and white lines travelling diagonally across the picture is complemented by detailed treatment of form and texture in the clasped hands and surrounding structures.

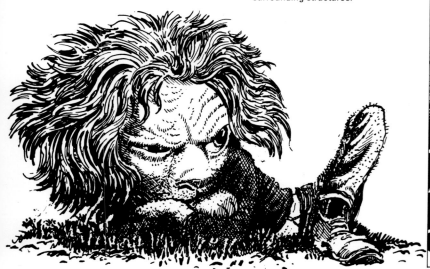

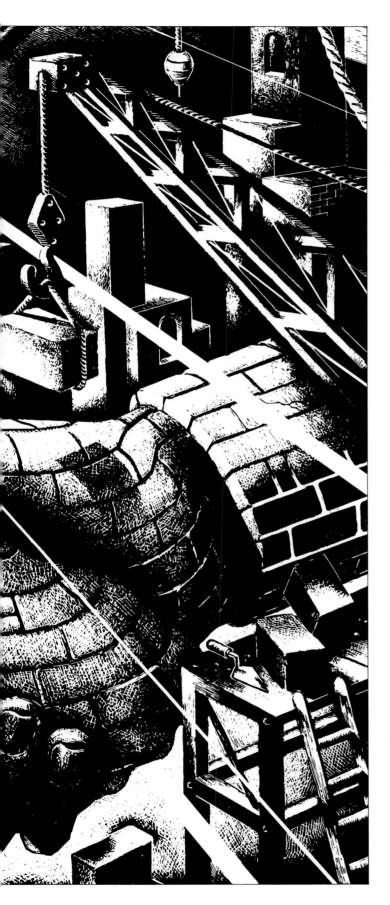

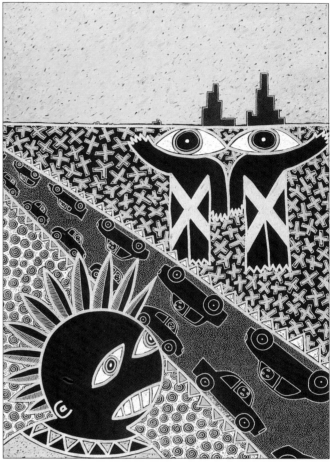

▲ STEPHAN DAIGLE
To create this striking image evoking "primitive" American Indian art, the illustrator worked on acetate film, making separate films for the gold, copper and black areas. A felt-tip pen was used for infilling the white detail, adding emphasis to the rich combination of metallic colours and black.

they are completely dry, providing the black paper particles are gently blown off the paper.

## Scraperboard

This produces an image which looks somewhere between a pen and ink drawing and a wood engraving. A prepared board is used, which may be white, in which case black areas are painted on with Indian ink. More usually, it has a black surface and once the drawing has been traced on very carefully, so as not to damage the board's surface, white areas are created by cutting away the black surface with a sharp knife or scalpel. A sharp point is used to incise or produce notched or stippled effects. With scraperboard the black and white images are not reversed as with a woodcut. The scraperboard drawing is reproduced facsimile.

29

# Pastels

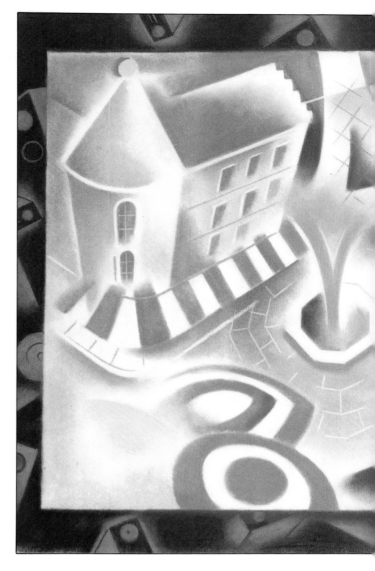

Pastel crayons (sometimes called soft pastels) are powdered pigments bound with just enough gum or resin to hold them together. They are softer than chalks (where the pigment is bound with oil or wax) and very effective, particularly for creating soft delicate transitions of tone and colour. However, they are difficult to erase and any second thoughts are not easily accommodated. There are almost 600 different tints of pastel available.

**Papers**  The surface for pastels, which can be canvas or paper, must have a good texture to hold the fine particles of pigment. Special papers are produced which are mostly coloured. Ingres-type papers are available in a wide range of colours and textures. Often the texture of the paper is lightly drawn over so that it shows through. Even suitably coloured ordinary glasspaper (from a DIY shop) can be used for pastels as it holds the pigment well. Canvas, mounted on a stretcher as for oil painting, is also an ideal surface, but the canvas needs to be protected at the back so that knocks do not dislodge the particles of pigment.

**Fixing**  As for pencil (p.26).

**Techniques**  Pastels cannot be mixed to produce new colours, as paints can, and illustrators have to select from the enormous range available (one well-known manufacturer makes boxes of 72 colours) the colours and tones to suit them. Most pastel artists start by making an outline drawing in charcoal. The range of marks that can be made depends on the softness of the pastel, the surface of the paper and hand pressure. Generally too much rubbing in should be resisted as it produces a surface which is unpleasantly smooth. To exploit the medium, the texture of the paper and the stroke of the pastel should be revealed. Over the centuries, artists have developed techniques for working in pastel. Delacroix, for example, drew on canvas primed with size, which was later softened with hot steam to bind the pastel drawing to it. Degas sprayed boiling water on to selected areas of his pastels so that the pigment formed a paste which could then be worked with a brush. Pastels have often been used over other media and there are complete books devoted to artists' recipes for the use of pastels.

**Oil pastels**
Oil pastels are very different from "pure" soft pastels. Using them is similar to oil painting: the colours can be mixed and softened with turpentine and then used with a brush or simply worked in over each other in layers. They can be used on paper or canvas and they require no fixing. Their most effective use often combines washes of colour with more precise drawing made with the solid pastel colour.

**Fixing**  There are different schools of thought on fixing. The illustrator's choice may be limited because if the drawing is to be handled by several people before reproduction it must be fixed. Fixing does, however,

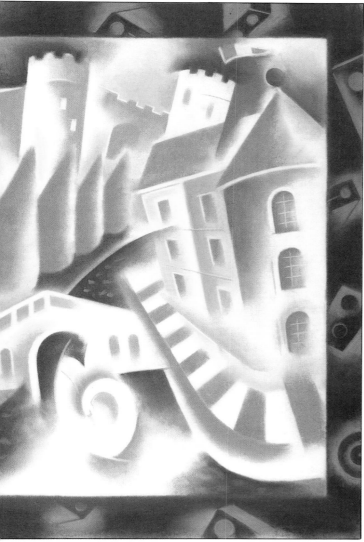

► LIZ PYLE
The illustrator uses smoothly laid oil pastel to evoke the misty landscape of the Scottish highlands, eliminating the evidence of individual pastel strokes. The paper texture softens the shapes, giving form and atmosphere. The pastel has barely touched the surface in the background and sky. Toward the foreground, the colour becomes heavier and more opaque.

◄ JEANNE FISHER
Pastels are often used to produce soft gradations of colour and tone, but this illustration makes a feature of the different kinds of "edges" that can be given to isolated colour areas. Some of the edges are hard but, because of the powdery pastel texture and the softening touch of the vellum and tracing paper used as the support, they are not sharply defined. A gentler effect occurs where the edges of the pastel colour have been finger-rubbed to merge subtly into the white ground.

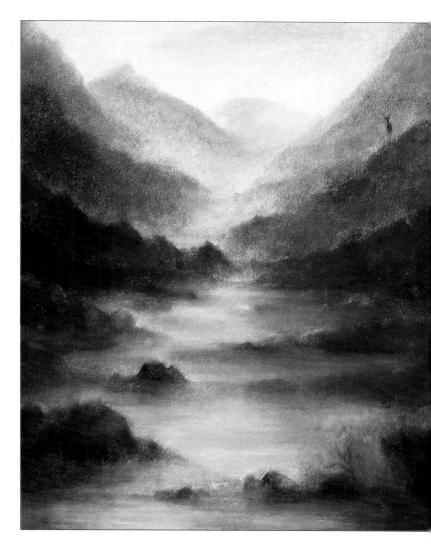

change the character of the work. The colour loses its brilliance and tends to darken in tone. Some work is carefully handled but not fixed. Some artists fix intermediate stages in the drawing and (as Degas did) leave the top layer of pastel untouched. Pastel can be built up to create impasto effects by repeatedly adding layers of pastel and fixing them. A degree of fixing can also be achieved by covering the drawing with a sheet of smooth paper, placing a board on top and applying firm pressure.

# Watercolour

Watercolours are pigments that have been finely ground and then bound with gum arabic, which dissolves easily in water. Watercolours adhere strongly to paper and the gum gives the colour brilliance, acting as a thin, light varnish. The main virtue of watercolours is their transparent quality. They are available in many grades but the cheaper paints tend to fade quickly. Colours are produced in dry cakes, semi-moist pans or in liquid form, in tubes or bottles.

**Papers** There are many different kinds of paper used by watercolour artists but generally semi-rough "cold-pressed" paper is used because it is equally good for washes and more detailed work. Rough paper also has its devotees who like the speckled effect which can be obtained by laying a wash over it. The paper weight is important. Thin papers "cockle" and need to be stretched before painting but heavy paper can be used without stretching, although even these may need stretching if a particularly wet painting technique is employed.

The very best papers are hand-made ones containing a high proportion of linen. They have a manufacturer's watermark which reads the right way round when the prepared surface of the paper is uppermost. Rice papers, although delicate and fragile, are also used because they are highly absorbent. Papers for watercolours are sometimes tinted but white paper is most commonly used, not least because highlights can be retained by leaving areas of the paper untouched.

**Techniques** Pure watercolour painting relies for its effect on the transparency of the colour. The whiteness of the paper is used to lighten tones and provide highlights. Colour washes are overlaid to build up the correct tones, but the more accurately the required tones can be assessed and laid down without repeated overpainting, the fresher the look of the painting. If a highlight becomes overpainted, it can be scratched in, using a sharp knife. Some artists use white paint for rendering highlights but as white is opaque, if even a trace of it mixes with other colours, they lose their luminosity. Turner, by putting a few drops of white paint in with his painting water, gave a special bloom to some of the colours in his watercolour paintings.

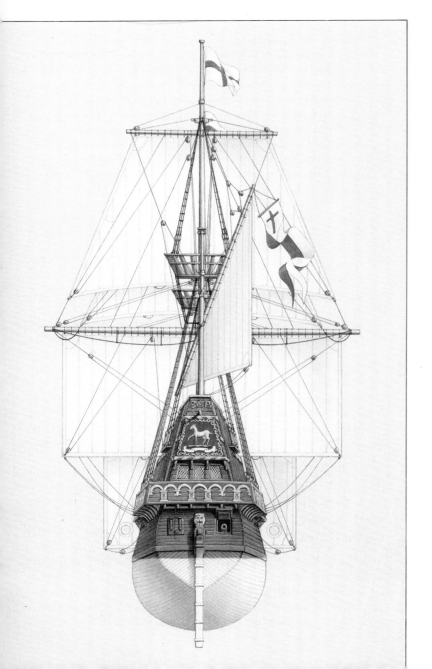

◀ LYNN GREGORY
In technical illustration, the medium is rarely allowed to compete with the content of the image. This illustration makes its impact by contrasting the coolly geometric shapes of the sails with the decorated hull of the ship. The watercolour work is supported by a firm linear drawing. Thin, transparent washes trace the details of the rigging against a pale background wash that makes the sails stand out clearly. The hull shows the more elaborate overpainting needed to develop details of its structure and decoration, as well as the brilliance of its colouring.

Because watercolour is transparent it lends itself to being used with a linear medium (pencil or pen) which will show through the washes of colour and, because the water-based paint is resisted by oil, this property can be used to great effect. Candle wax or wax crayons can both be used so that areas drawn in with wax resist the watercolour laid over them, resulting in these areas remaining untouched except for attractive accidental textures. Other methods for leaving areas of the paper untouched include the use of masking tape, where hard edges are required, torn paper where soft edges are required, and masking fluid, a latex substance that can be applied with a brush or pen before painting.

Innumerable techniques have been developed by artists to exploit the transparency of watercolours. The "chance" methods that may be adopted include blowing blobs of wet paint around, which can produce exciting accidents, and putting turpentine on the paper providing an unpredictable surface to which paint adheres in some places but not in others.

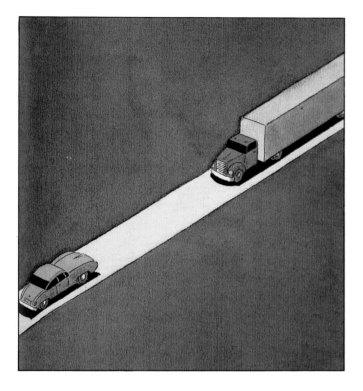

▲ STEVEN GUARNACCIA
The deceptive simplicity of this image is well served by clever handling of line and wash technique. The illustrator exploits the texture of the watercolour paper to add subtle interest to the areas of flat colour, and the grain of the paper contributes a pleasantly irregular quality to the lines tracing the road, the truck and the car. The colours have a clarity characteristic of the transparent medium of watercolour.

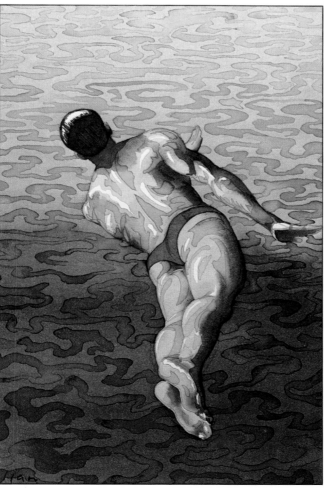

▶ JAMES McMULLAN
This stylized treatment of form and colour provides a surprisingly real sense of dramatic movement. The formalized patterns on the water surface and the figure's body have been developed by painting several layers of watercolour one over another. Patches of colour are allowed to dry out separately at each stage, thus allowing the hard-edged, linear effect to be achieved.

# Gouache

Gouache is opaque water-based paint made from less finely ground pigment than watercolours, bound with gum arabic and with white pigment added to give it opacity. Gouache (sometimes called "body colour") has much less luminosity than watercolours and can be altered and elaborated upon without becoming laboured. Gouache is often sold as "designer's colours" and is used extensively for magazine illustration, where its clean, flat colours reproduce well. Designer's colours are available in both tubes and bottles.

**Papers** All papers suitable for watercolours can be used for gouache. Gouache works well on dark-toned papers, rough unsized cardboard and brown wrapping paper.

**Techniques** The main feature of gouache is its opacity and it should not be used thinly like watercolours or made to impersonate oil paint. Flat, thickly painted areas of colour characterize the best gouache painting and, to achieve this, the paint must be applied with equal consistency. As gouache dries, the colours tend to lighten and if the consistency varies, so the dry colour will lighten to different degrees. Paste is sometimes added to gouache to thicken it and in this form it can be combed or drawn into with a pointed stick to create textures. Many techniques used with watercolours can also be used with gouache.

◄ BARBARA NESSIM
The technique used in this gouache illustration is spontaneous and direct. The paint has been freely laid on the slightly textured paper, with no subsequent alteration. The calligraphic bands and swirls have been made with fluid paint that mostly remains opaque but sometimes, where the brush has swept in a curve, the colour has a slight transparency. Thin swirls overlapping the bold, heavier marks, with the white of the paper weaving in between, provide an animated background for the figure. This has been painted in the final stage, again using bold, gestural brush strokes.

► BRIAN GRIMWOOD
With simple colour areas exploiting the flat tone and matt surface quality of gouache, the impact of this illustration comes from silhouetting the shapes against the white paper, which has been left untouched in many places. The clean white helps to make the carefully chosen pale colours stand out against the black shape, providing both sharp contrast and a unifying feature. A few details drawn in black on the creature's body also help to unify the image. Unbroken areas of flat colour point up the subtlety and variety of the brush-drawn edge qualities, from the clear-cut outlines of the animal to the softer edges of the surrounding shapes.





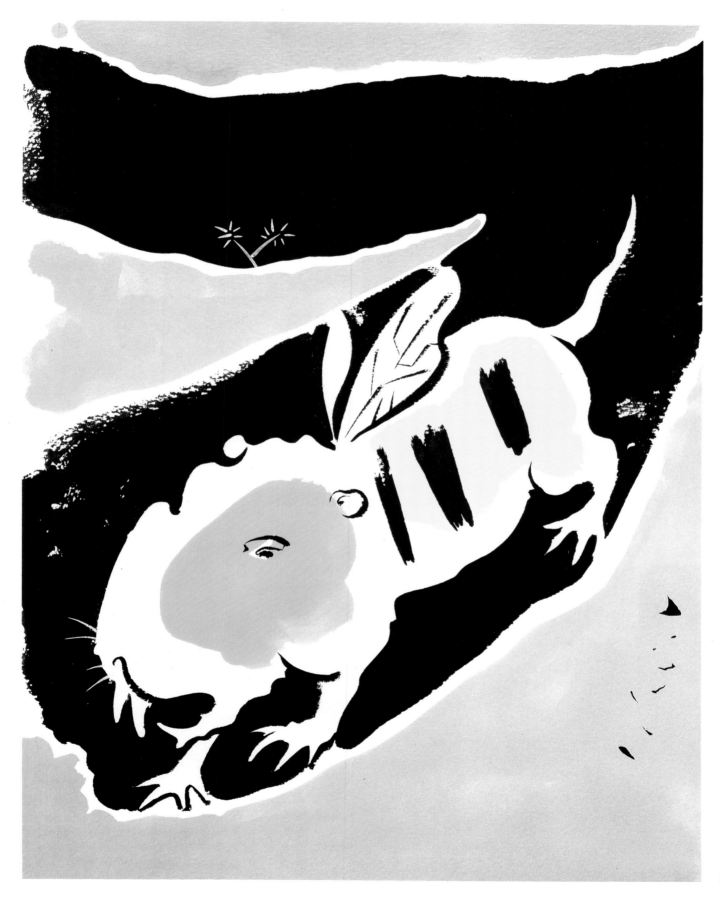

# Acrylics

Acrylic is the name commonly given to any pigment bound in a synthetic resin. Acrylics are thinned with water. They dry as quickly as the water evaporates and once dry they are waterproof. This enables overpainting to be done without disturbing the underlying colour. Acrylics are extremely versatile and, though basically opaque, the paint can be diluted to any degree of transparency that may be required. If the normal quick drying needs to be slowed at all, a retarder is available for use.

**Papers and other surfaces** Acrylics can be used on a wide range of different surfaces: canvas, wood, hardboard, card or paper, and no priming is necessary. Metals, such as copper or zinc, can also be used although it may be necessary to dull the surface by sanding it with rough abrasive paper. Acrylics will adhere firmly to all but shiny, oily surfaces. If a surface is to be primed, either because a white surface is required or the porosity needs to be reduced, it is essential to use acrylic primer. Ordinary oil-based primer, used as a primer for oil painting, is unsuitable as it tends to resist acrylics.

**Techniques** Acrylics are the most versatile paints available to artists and illustrators, and they can be used effectively in both transparent and opaque form. When used on canvas or board they can be almost impossible to distinguish from oil paints. Diluted with water and used transparently on paper, they can look like watercolours, to which they are more closely related in their technical composition than oils.

Acrylics are particularly useful for producing large areas of flat unbroken colour and for laying layers of thin washes of colour, one over another. Their single limitation – quick drying – can be a virtue when results are needed quickly. When using acrylics, care must be taken to see that brushes are rinsed in water before the paint dries on them. When the paint dries, it becomes waterproof and can usually be removed only by soaking the brush in methylated spirits for several hours and then carefully removing the paint with your fingers. Sometimes, if the paint has not dried too hard, hot water and detergent will remove it but neither this treatment nor methylated spirits is good for the brushes.

◀ MARK EDWARDS
This illustration has something of the quality of an etching, but the lines were created by scratching through layers of light-coloured paint, with knitting needles or pins, to reveal a darker underpainting. Acrylic thickened with texture paste was used for the underpainting, oil paint thinned with turpentine and linseed oil for the light overpainting. The "etched" effect was drawn into the paint when it had dried, and final details of the image were refined by painting with oils.

▶ TOM CURRY
The opacity of acrylic paint has been exploited in this illustration. The colours were applied over a dark underpainting, leaving dark traces showing through in most areas to link together the different elements of the image. This effect was achieved by consistent use of drybrush technique, with the lighter colours stippled and dragged over the underpainting to produce a broken texture that also softens the outlines of the isolated objects.

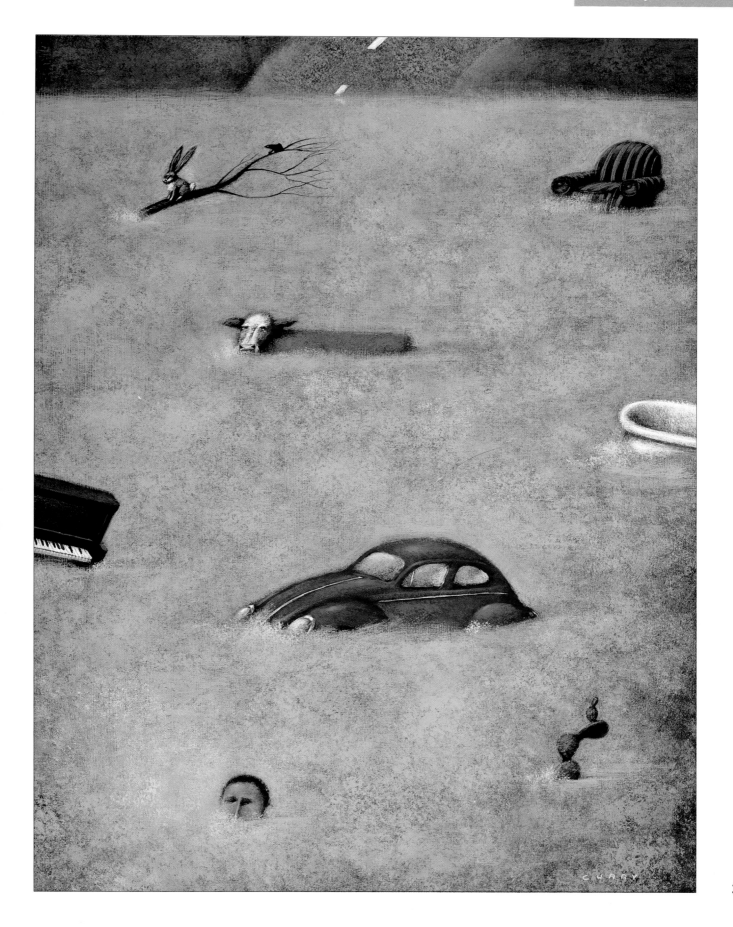

# Oils

For over 400 years, until the last two decades, oil paint was the most widely used painting medium. More closely associated with painters than with illustrators, it still remains popular but acrylics are now preferred by some artists. Oil paint is made from pigment mixed with linseed or poppy oil. These oils dry slowly by oxidizing and this process gives oil paint its characteristic richness of colour. A wide range of thinners is available for oil painting, but the most popular is turpentine, which, used in different amounts, will produce paint that is either opaque or transparent, and with a matt or gloss finish.

Some would claim that oil paint is the most flexible painting medium, in part because its slow drying permits "wet in wet" painting and the possibility of paint being removed back to the ground if required. Although oil paint changes its colour little as it dries, dark areas tend to "sink" and become dull and lifeless. Most manufacturers produce two grades of oil paints. Those labelled "Artists" are better quality and more permanent.

**Papers and other surfaces** Absorbent surfaces draw the oil from oil paints which causes sinking and reduces the adherence of the pigment to the surface. Basically most surfaces need to be primed before oil paints can be used on them, so that the degree of absorption can be controlled. Specially made oil sketching paper, which needs no priming, can be used. Other papers and boards usually need to be primed, either with glue size or with a white primer. Cardboard, strawboard, wood, plywood, chipboard and hardboard are all widely used surfaces for oil painting but the most popular support is canvas, stretched tightly on a wooden frame (known as a stretcher). All these surfaces need to be appropriately primed. This is most easily done by using prepared white primers. Canvas (the best is made from linen but cotton is extensively used) can be bought ready primed, as can boards, some of which have a simulated canvas textured surface. Synthetic canvases are also available.

Metal has been used in some instances for small paintings. This has usually been copper, which needs no priming, but must have its surface roughened with abrasive paper so as not to repel the paint.

▶ MARSHALL ARISMAN
This monochrome approach works well through a combination of varied oil painting techniques. The slightly warm-toned ground has also been cleverly used throughout the image. In the area around the head, the paint has been rubbed to create a soft background. Textures on the shadowed side of the face and in the crinkled hair have been developed by frottage technique. Highlights on the forehead, cheek and chin that round out the forms were made by rubbing away the dark colour. The same technique has been used on the apple. This contrasts with the heavy, opaque white highlights, applied in the final stages, that startlingly increase the sense of drama.

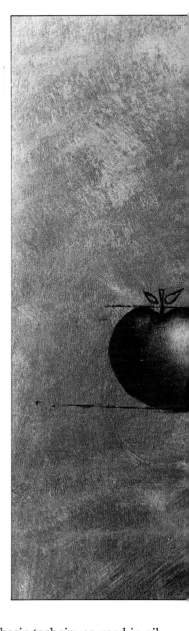

**Techniques** There are two basic techniques used in oil painting: carefully developed paintings where layers of paint are laid one over another, with each one allowed to dry before the next is applied, and direct painting (often called "alla prima") where opaque colour is used to complete a painting – usually in one session.

Where layers of paint are used, the underpainting is often made using a limited range of colours. Over this, opaque colour may be added, or thin glazes of colour used. Glazing produces a particularly distinctive luminosity. Opaque paint can also be applied over another layer so that patches of the original colour show through. This technique, called "scumbling", is much used, while thick paint laid on with either brush or painting knife, called

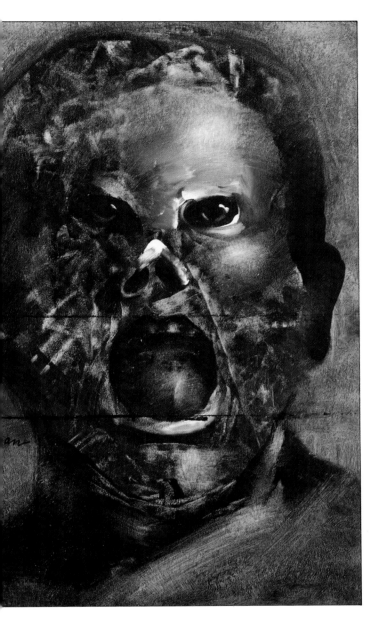

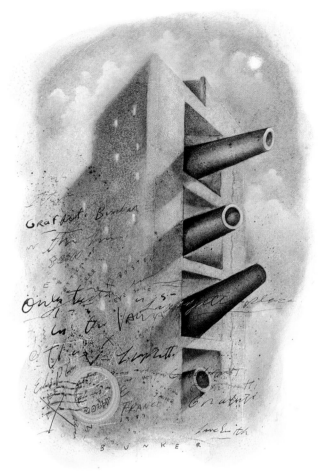

▲LANE SMITH
The unusually complex vignette was produced by alternating thin layers of oil paint and acrylic paint, each layer allowed to dry between sprayings. Varied densities of colour and tone allow the bunker to emerge menacingly from the cloud-like background.

The projecting weapons have been reinforced with ink drawing. The graffiti effects were "written over" the painting in the final stage.

"impasto", can be used in underpainting or in successive layers to create texture.

Sometimes a painting knife or a sharp tool is used to scrape back the paint surface to reveal layers of underpainting. Partially removing the paint surface while it is still wet is often done by using absorbent paper (newspaper or kitchen paper) or by pressing highly absorbent paper on to the painting and then removing it. The paper may be screwed up, so that when it is pressed against the paint surface, it produces a varied texture. This technique is known as "tonking", when absorbent paper is used, or "frottage", with non-absorbent paper.

Another commonly used technique is "wet in wet" painting. Unlike water-based colours, oil paints do not run into each other when applied wet, and one wet colour can be mixed (or partially mixed) with another wet colour on the painting, or areas of wet colour can be laid next to each other and blended together.

Because dark colours tend to sink, it is sometimes necessary to varnish oil paintings at intermediate stages so that the true depth of colour can be preserved. Retouching varnish, which can be applied once the paint is touch dry, is best for this purpose.

# Airbrushing

This is usually associated with modern technical illustration but the technique of blowing air and pigment to create images was probably used by cave artists over 35,000 years ago. The cave painters used hollow bones, but today's airbrush artists usually have an air supply provided by an electrically powered compressor and airbrushes which are precision instruments, able to produce fine lines, softly gradated tones and areas of flat, even colour.

**Equipment** A spray diffuser will, with practice and care, provide simple airbrushing but sophisticated and expensive mechanical airbrushes or air guns are now widely used to reproduce tonal gradations with photographic precision. They were, in fact, originally developed for photographic retouching by illustrators as a means of producing highly finished images suitable for re-production and printing.

There are a number of different types of airbrush and air gun, but they all work on the same principle: a nozzle directs the flow of air and paint or ink, a needle and valve controls this flow and a reservoir holds the medium. The airbrush is connected to the compressor by a flexible tube. The different types of airbrush vary only in size, with small nozzles and open reservoirs for fine work, and larger nozzles and reservoirs for filling in bigger areas.

**Paint** All kinds of liquid drawing or painting media can be used in airbrushes with concentrated designer's colour (gouache), concentrated watercolour and photographic dyes most commonly used. The medium used must be suitably thinned and care should be taken, particularly with acrylics and inks, to clean the airbrush frequently to prevent the pigment from drying inside it. For good results, finely ground good-quality paints must be used and the equipment should be kept perfectly clean and be well maintained.

**Paper and other surfaces** All the papers and other surfaces that are suitable for a particular medium when used conventionally with brush or pen, for example, can be used if the medium is applied using an airbrush.

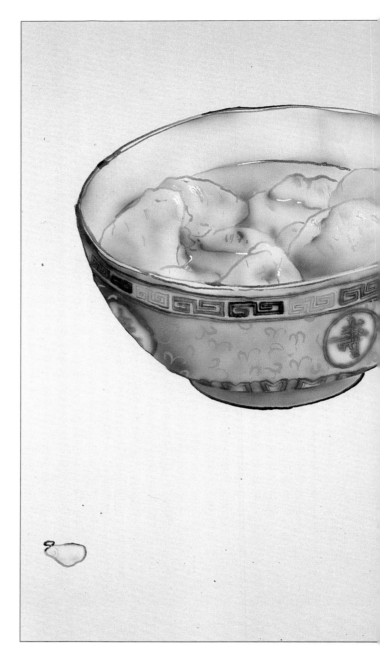

**Techniques** The main technique used with airbrushing is masking. Unless the airbrush is being used simply to brush in a large area, it is necessary to confine the area which is being sprayed by covering over other areas you wish to protect.

Skill and practice are needed with the airbrush. The angle at which it is held in relation to the paper determines the effect it creates. Using an airbrush also requires a good memory for tones and colours, as usually only the small area to be sprayed is visible and the rest of the illustration masked off. The illustrator must be able to visualize clearly the hidden part of the illustration.

40

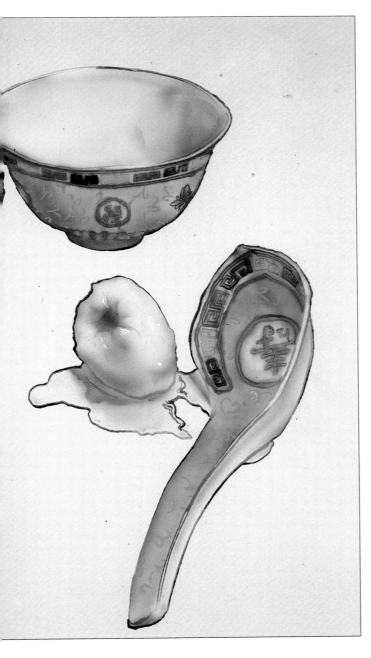

◄ASHLEY POTTER
It is unusual for an airbrushed illustration to be made as a direct interpretation from the subject, but this one was drawn "from life" in the traditional manner of still-life painting. The initial line drawing was made in coloured waterproof ink, mixed specially for this study. The "washed" colours were applied by freehand airbrushing, using loose paper masks. Shadows were eliminated, to achieve something of the graphic immediacy of Japanese prints. The result is an excellent representation of the objects, with a distinctly Oriental style.

▼BOB MURDOCH
Airbrush technique is conventionally used to produce the subtle gradations from light to dark that are needed to create, for example, an effective representation of curved, smooth metal surfaces. Here, the illustrator uses tonal gradations to develop a complex abstract effect of three-dimensional space and form, although the more typical technique of modelling surface contour is also demonstrated. Masking has been applied to make clear, hard edges from which the colours fade off into the white ground. The soft, semi-transparent colour areas have the interesting effect of partially concealing the objects.

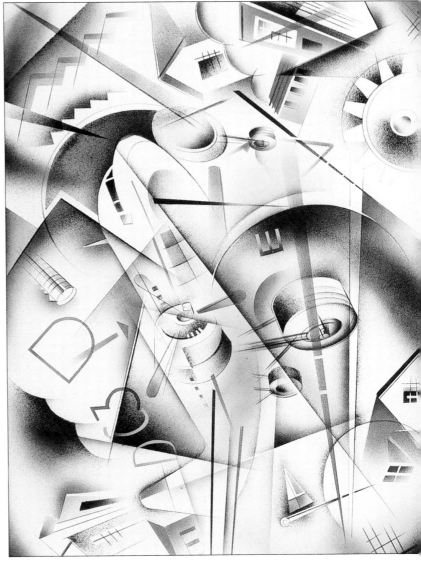

**Masking** Apart from protecting areas of the illustration, masks have to be used for every shape, whether its edge is to be hard or soft. Sharp edges are usually made using masking film, a transparent adhesive plastic. Fuzzy edges usually have masks cut from card or fabric.

Masking fluid is also used, particularly for intricate shapes and where lines or dots are required. These can be produced by painting an area of masking fluid and when dry, scoring fine lines or dots through the area before spraying over it. Many ready-made curves and stencils can be bought and all kinds of materials can be used when soft, irregular shapes are needed.

# Printmaking

There are a wide variety of ways in which prints can be made but basically each process is the same. Ink is applied to a surface, for example a metal plate, block or screen, and this surface is used to print an image. Most of the printmaking techniques were originally developed as a means of reproducing paintings but artists soon found that their particular qualities could be used to create original artwork that had its own aesthetic quality. The different techniques can produce images which are both powerful and complex.

**Relief printing** This is the simplest and most direct method of printing. Lines and areas are cut into a smooth surface block, usually wood or lino. When ink has been rolled on and the block printed, the areas which have been cut away do not print and the images are produced by the raised parts of the surface.

**Intaglio printing** In this form of printing the image is cut into a metal plate either by incising the plate by hand (*engraving*) or by using acids to "bite" the surface (*etching*). For printing, the plate is inked, so that ink is pressed into the lines which have been cut into it. The surface of the plate is wiped clean with only the crevices holding ink and providing the image.

Drypoint is similar to engraving, except that with engraving the tool used removes a line of metal from the plate, while with drypoint a ridge (or "burr") is raised on either side of the line. This holds the ink and when printed gives a soft velvety line in contrast to the hard, fine line of engraving.

The above intaglio methods are fundamentally for producing lines. Tones can be printed mainly by *mezzotint* and *aquatint*. Mezzotint uses a "rocker", a curved blade with a serrated edge, to make indentations in the plate. Aquatint uses powdered resin to provide a protective texture on the plate and when the plate is put in acid, the unprotected spaces are bitten to produce areas which will print as tone.

**Lithography** – literally printing off stone – nowadays almost always uses thin zinc or aluminium plates that

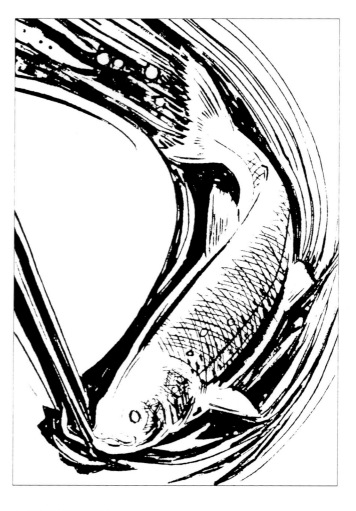

▲ JULIEN LIGHTFOOT
This is one of a series of wood engravings designed to illustrate an intensive study of the life of a river, written by the artist. This example illustrates fly fishing and was constructed from memory, demonstrating the artist's thorough knowledge of the subject. The image was traced in reverse on a boxwood block and cut with a spitsticker. The visual qualities of the medium have been used with great energy and freedom to convey the trout's movement through the water.

have been given a granular surface. The principle on which lithography works is that oil resists water, so when the stone or plate is washed over with water the surface absorbs water while the greasy drawing resists it. Greasy printing ink is then rolled over the stone and this is repelled from the wet areas of the stone but sticks to the drawn images. These images can then be printed on paper using a press.

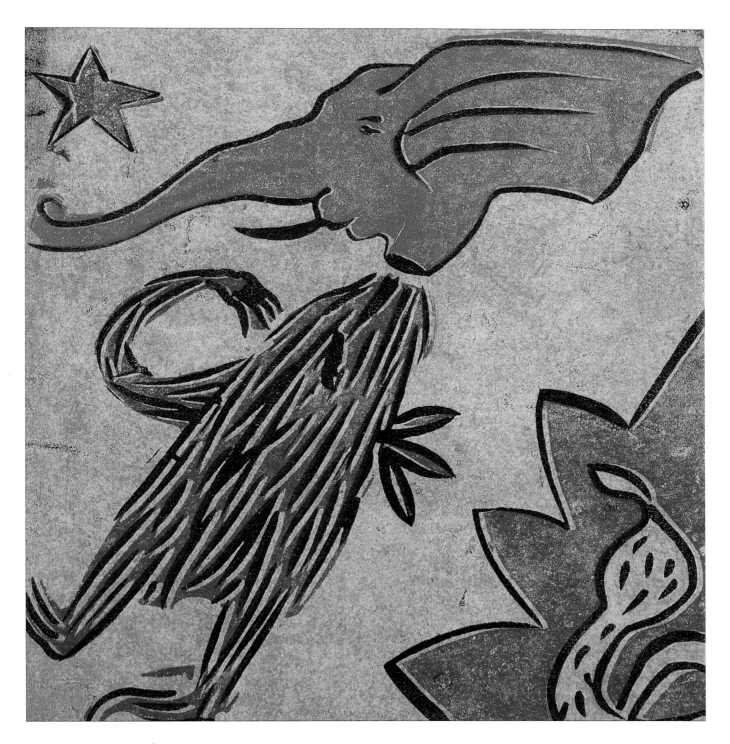

**Screenprinting** uses a fabric screen, stretched on a wooden frame. This type of printing is based on the principle that areas of the screen can be "blocked off" to make a stencil and ink forced through the open area of the screen. The screen can be blocked by gum arabic or special screen fillers, or simply by paper stencils. More sophisticated screenprints can be made from photographic images using special materials and equipment.

▲ANDREW KULMAN
This coloured lino cut , a stylized treatment of the elephant headed Indian god Ganesh, is the rough artwork for the 1990 Trickett & Webb calendar. The brief specified three to four colours to be presented as separated artwork. For all printing techniques, the paper used is an important factor. The choice of tissue paper here was a particularly happy one, as it has broken up the inks slightly to give a soft granular effect.

43

# Collage and assemblage

Illustrations can be made using the collage technique. Collage, derived from the French *coller*, to stick, is the word given to a picture built up entirely or in part from pieces of paper, fabrics, or other materials, stuck down on a surface which is usually paper or canvas. The technique can be used to create original images by cutting or tearing the materials. It may, however, incorporate found images such as photographs or type.

Collage was much used by the cubists, who attached fragments of newspaper and similar found images to their paintings.

**Assemblage**
This is a three-dimensional development of a collage which was first developed in Russia by artists such as Tatlin, who made abstract sculptures from sheet metal, glass, wire and other materials. The term "construction" has also been given to three-dimensional works of this kind which are built up from all kinds of objects, often "real" objects. Illustrations can be made in this way, where objects are assembled, usually to make a "low relief" construction which is then photographed.

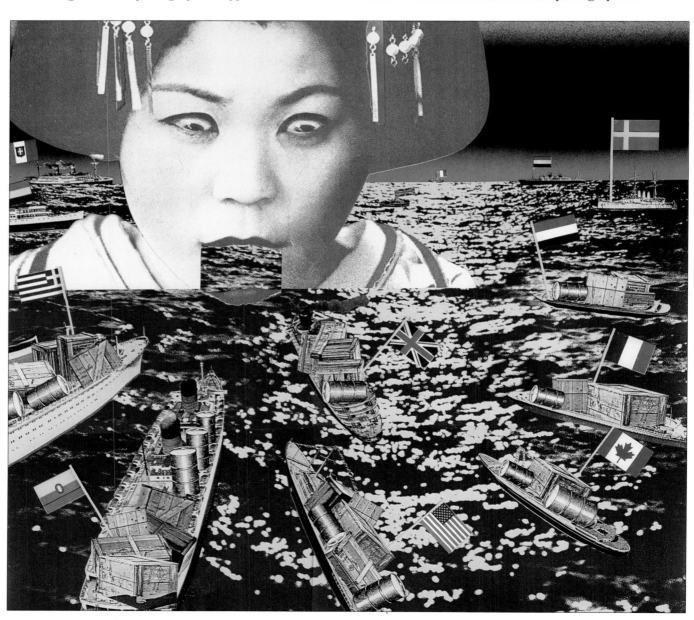

### ANDREW EKINS
Assemblage can be a very effective means of juxtaposing a number of objects to create powerful images. Although three-dimensional illustrations like this one are "pictures", inspired more by the "painterly" constructions of artists such as Robert Rauschenberg than by sculptures, they have to be designed both two- and three-dimensionally. The illustrator has built this construction on an almost symmetrical grid and the strongest single element, the gas mask, is carefully framed within the grid to create a threatening focal point.

### MELISSA GRIMES
Photocopiers have become increasingly useful for producing a new kind of collage. They can reproduce colour, supply colour to images, and enlarge or reduce them. In this composite image, the woman's head was a black and white half-tone enlargement of the original photograph, which was then coloured by the copier. The ships were all colour-copied on yellow paper to give them a toy-like appearance. By carefully placing and adjusting the different elements in the copier, the illustrator achieves dramatic changes of scale, but the copying process gives the image an overall unity.

### FELICITY BOWERS
In this collage, only the fragments of music are found images. The illustrator has cut and torn the shapes from coloured tissue paper, working from a basic outline drawing. Tissue tears into sensitively edged shapes, and its translucency allows a rich layering of colour. In this example, some additional textural effects have been made with PVA adhesive applied between the paper layers.

# Computer illustration

The increasing availability of ever more sophisti-cated computers for producing images has open-ed new and exciting possibilities for illustrators. As well as providing a high degree of accuracy for tech-nical illustrators, these computers have the facility to store work at different stages and to allow the artist to explore a number of variations of a given image before making a decision on the most successful treatment. Much depends on the type of program used. With scan-ning facilities, images from different sources (such as photographs and type) can be combined and manipulated in colour and size for collage-like effects. Text and image can be viewed together at an early stage creating the op-portunity – not allowed by other media – for the illustra-tor to see the image in context. Yet as with any medium, computer-generated illustration is only as good as the skill and imagination of the operator allows. Although at present not many young illustrators can afford their own computer, the rapid development of the computer indus-try will soon make them much more widely available.

▼▶ JONATHAN INGLIS
**Magazine illustration**
*The Spectator*
Jonathan Inglis has become known for his imaginative use of a fairly basic computer illustration package (D Paint 2 on an IBM PC) to produce simple but striking images. In this example the outlines were drawn on screen using a "mouse". He used the copying facility allowed by the system to duplicate the figures walking across the bridge in the foreground for use in the background.

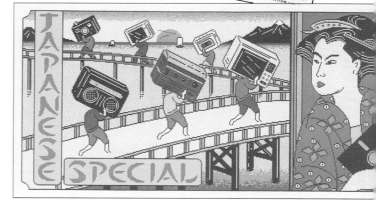

◀ HAZEL MORGAN
**Student work**
This impressionistic landscape was produced using the Imigit system on an IBM computer. The resolution on this relatively basic package is fairly crude – the pixels are visible on the image. A range of 265 colours are available and further variations can be introduced by superimposing one colour on top of another.

# Mixed media

▶ JANE STROTHER
A strong feature of this illustration is the almost symmetrical composition, with the landscape framed between two dark verticals and two plant pots beyond them on either side of the foreground. The illustrator has combined crayon and watercolour beautifully so that at first sight it looks as though a single medium has been used. The layers of crayon and paint have been cleverly placed one over the other to create this unified effect with the transparent quality of watercolour exploited to create a sense of distance.

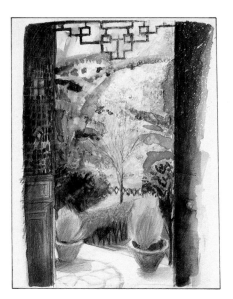

Many illustrators combine several media in the same work. This may be to create different effects in different areas of the illustration but often the different media are used speculatively. The illustrator, in this case, does not begin with a pre-conceived idea of the different stages of the work but, operating more like a painter, works experimentally with the various media, selecting and developing appropriate images as they occur from the results.

▶ PAUL DAVIS
Photographic collage is used here to construct a complex image, and it also reflects the topicality of the theme of "food terrorism". The layers of collaged colour and black-and-white images were sealed with varnish. The arms and syringe are photocopies, which darken under the varnish, giving a strong image for reproduction. Acrylic paint, applied after certain parts of the image were masked with tape, was roughened and scratched to provide varied textures.

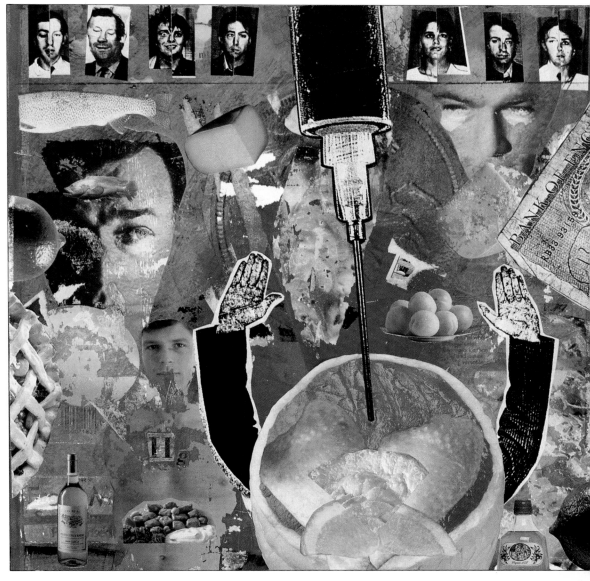

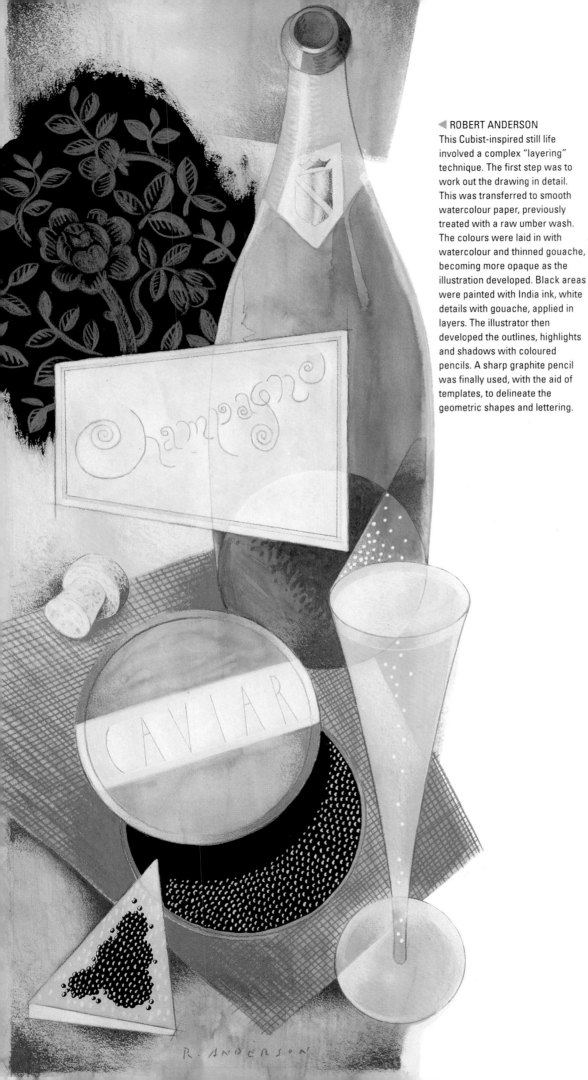

◄ ROBERT ANDERSON
This Cubist-inspired still life involved a complex "layering" technique. The first step was to work out the drawing in detail. This was transferred to smooth watercolour paper, previously treated with a raw umber wash. The colours were laid in with watercolour and thinned gouache, becoming more opaque as the illustration developed. Black areas were painted with India ink, white details with gouache, applied in layers. The illustrator then developed the outlines, highlights and shadows with coloured pencils. A sharp graphite pencil was finally used, with the aid of templates, to delineate the geometric shapes and lettering.

▲ KINUKO CRAFT
In style and technique, the illustrator has drawn on Renaissance values to construct this epic image. Pictorial quotations are taken directly from works of the Renaissance. Though the cars and the clothing are modern, the hunting animals on the right could have come straight from a fifteenth-century painting. The paint media are those with the oldest traditions – watercolour, tempera and oil, used successively. The "old master" quality is enhanced by gold leaf detail applied to the architectural feature at the top of the painting.

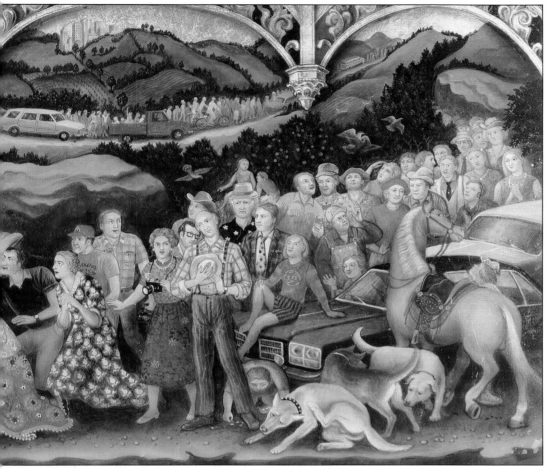

A quick line drawing was the basis of this idea, from which the illustrator worked experimentally towards the final version. The colour was first laid in by painting with inks, then black drawing ink and wax pastels were used to develop form and texture. As the image evolved, the illustrator used oil pastels, coloured pencils, acrylic paint and collage, in no particular order, but wherever appropriate. Precise definition of the heads and hand was introduced at a late stage. The varied elements add up to an unusual and haunting image.

▼MARK BAKER
Much of the actual drawing for this animated film was animated directly on to cel, for which a special type of hard wax pencil was used. The backgrounds started off being coloured only by pencil, but, after a while, Baker used a variety of techniques, painting, scratching and recolouring to produce a "worn" look.

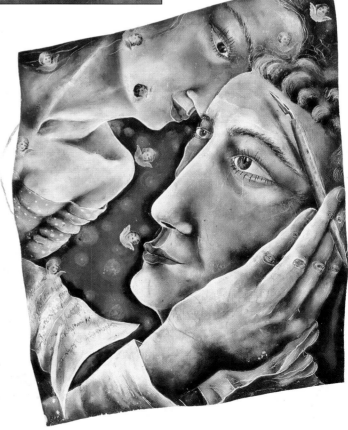

# Reproduction and printing

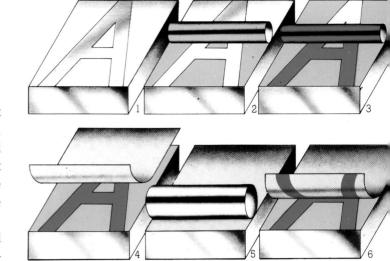

There are several different printing processes, but that used for publications is offset lithography. Lithographic printing is done from a thin metal plate, usually made from aluminium, which is bent to fit round a printing cylinder. Because the surface is flat, the ink has to be confined to the printing areas of the plate and kept away from the background (non-printing) areas.

The system depends on the action of two natural enemies – grease and water. The plate is treated chemically so that the image to be printed accepts grease (ink) and repels water. When water is applied to the plate, the non-printing area (which has a very finely grained surface) retains a thin film of water. When ink is applied it adheres to the greasy image but is rejected by the water on the dampened part of the plate, which therefore remains clean and does not print.

For publication work, offset lithography (sometimes just called offset) is used. The inked image on the metal

▼ **Black line artwork**
Reproduction of black and white images with no gradated tones, such as this illustration by Jon Blake for a newspaper advertisement for the Scandinavian Bank, requires a simple one-stage photographic process that produces a negative image from which the positive is printed.

▲ **Lithography**
The printing plate is treated so that the image to be printed repels water (1). Water is applied to the plate (2), followed by ink (3), which is repelled by the water on the non-printing areas, but accepted by the image area. Paper is placed on the plate (4), run through the press (5) and the inked image is printed (6).

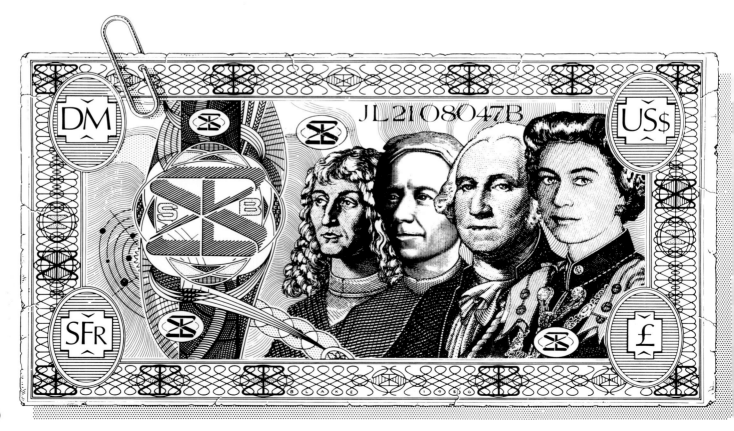

**▼ ▶ Hand drawn overlays**
For some types of colour artwork - particularly simple non-tonal images - the illustrator will be asked to supply separate overlays for each colour area. In this example the black outline of the piano is drawn on the base board, with two separate hand painted overlays. Registration marks on each overlay are essential.

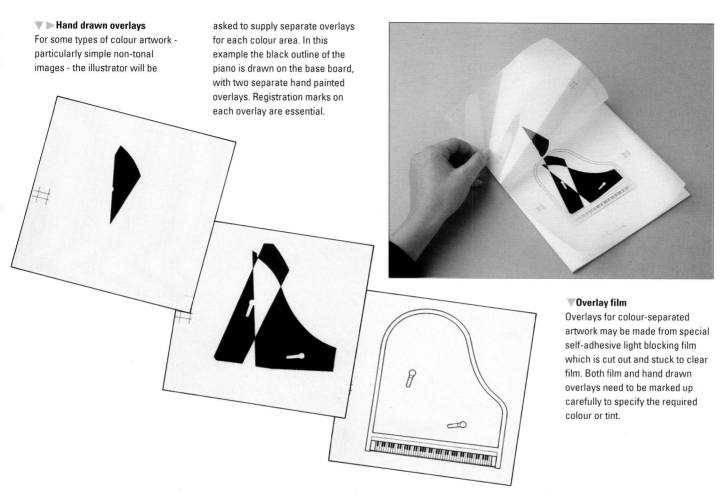

**▼ Overlay film**
Overlays for colour-separated artwork may be made from special self-adhesive light blocking film which is cut out and stuck to clear film. Both film and hand drawn overlays need to be marked up carefully to specify the required colour or tint.

plate is "offset" (printed) on to a rubber blanket wrapped round a rotating metal cylinder; the image is transferred from the blanket on to the paper.

To make the printing plates, the original illustration or photograph has to first be converted into film by using cameras or scanners.

In printing, there are just two kinds of illustrations, line and half-tone. With line pictures, the printing surface produces a solid colour on the paper without showing different tones – it is simply one colour or white, without any shades in between. A line illustration is prepared for printing by placing the original on a process camera which makes a negative film, where the part required to be printed is clear and the non-printing area is black.

Half-tone pictures are made in a similar way, but to get the tone effect the subject is photographed through a screen which has black lines crossing each other at right angles and forming a fine grid. The negative therefore consists of dots which vary in size, depending on the darkness of the area they represent. So, the original photograph has an almost infinite number of shades of

grey, but in printing these shades are shown by larger or smaller black dots. The dots are largest in the dark areas and very small in the pale areas. Although printed photographs look grey to the naked eye, they are in fact printed using black ink.

### Colour printing

Colour pictures are printed by the four-colour process. All the colours of the subject have to be produced by four coloured inks: yellow, red, blue and black.

Each of these colours is printed from half-tone film made in the same way as a black and white half-tone, except that a light filter is used to isolate the elements of the picture to print in each of the four colours. A violet filter is used to isolate yellow, a green filter for the red and a red filter for the blue. A combination filter is used for the black, which gives depth and contrast to the picture.

Nowadays, instead of using a camera, reproduction by the four-colour process is done using a scanner. Scanners use a high-intensity light or laser beam to scan the original; the colour filters and a computer are built into the scanner to convert the signals picked up by the beam into screened half-tone film for each of the four colours.

### Scanning

The original transparency of flat artwork is taped to the drum of the scanner and the scanner operator gives instructions to the computer to give the required size,

▲ **Black and white half-tone**
Black and white images that require gradated tones are photographed through a screen that divides the image into dots of varying sizes according to the darkness of the area. Nowadays the use of computerized scanners for reproducing black and white images is becoming more common.

◀ ▲ **Colour half-tone**
A separate half-tone screen is produced for each printing colour. The final colour image is created from a combination of the different sized dots for each colour. The fineness of the dot, and therefore the quality of the printed image, depends on the type of paper: Newsprint uses a relatively coarse dot, whereas high quality art paper uses a fine dot that allows greater refinement.

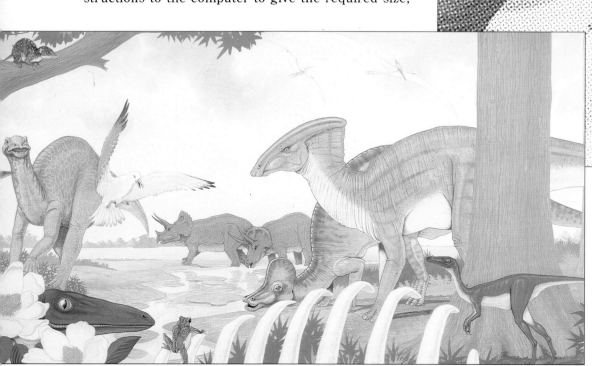

Yellow proof

Magenta proof

Cyan proof

Black proof

Yellow proof

Yellow plus magenta

Yellow, magenta plus cyan

Yellow, magenta, cyan plus black

**Four-colour process printing**
The image is photographed through four separate filters to produce a separate film for each process colour plus black (top row). The final image is then built up by printing each colour ink separately (bottom row). Although this process can reproduce most colours reasonably accurately, some types of luminous inks can never be reproduced in this way.

▼HANNAH FIRMIN
**A Taste for Tranquillity**
Modern four-colour process printing allows subtle colours, like those used in this delicate lino cut illustration for *Good Housekeeping* magazine, to be reproduced accurately. Often delicate original artwork will be photographed onto a transparency to avoid damage during the reproduction process.

which can be bigger or smaller than the original. Before scanning, the operator measures the strength of colours in different parts of the original picture and adjusts the scanner controls accordingly. (His skill at doing so helps to determine the accuracy with which the colours are reproduced.) The drum then rotates at high speed and the scanning head scans the image as it moves along the surface of the drum. These signals are sent, via the colour filters, to the computer, which converts this information into light signals which make the four colour films.

The scanner will reproduce flat artwork like paintings, as well as transparencies, but these must be on a flexible material so that they can be wrapped around the drum of the scanner. The high speed of the scanner has made four-colour reproduction cheaper and this has helped to increase the use of colour in books, newspapers and magazines. Scanners are now also starting to be used for producing black and white half-tones. Scanners have now been developed to

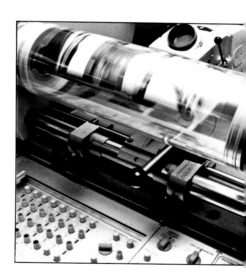

▲ **Electronic scanner**
Most large colour reproduction houses now use computerized electronic scanners such as this for originating colour artwork.

**▶ Paste-up**
The illustrations were placed in their final position by the designer and appropriate instructions given to the reproduction house on sizing the artwork, tint panels, backgrounds, type etc. Handwritten type elements were added at this stage. The final board as presented to the reproduction house had three layers: baseboard, carrying all the elements to be printed in black; first overlay, carrying the artwork position guide; and second overlay, carrying colour (tint) instructions.

carry out automatically other operations that were previously done by hand. These electronic page make-up machines scan the originals and store the information on a disk and this information is then fed into a computer and can be used to create the four-colour films for a complete page containing several pictures. These machines can also produce shapes like circles and cut out the background of a picture. They can change colours automatically; for example, a red car in an advertisement can be made into a blue car.

**Proofing**

When the four films have been made, a colour proof is produced to show the customer the result. Colour proofs can be cromalins (or matchprints) which are made photographically, or wet proofs where a proofing plate is made and printed on paper. Colour correction may then have to be done by hand to achieve the exact colours of the original artwork.

The film from the camera or scanner is then placed in contact with the plate, which has previously been coated with a light-sensitive chemical. This hardens in the printing areas and produces the image; the plate is then ready to print.

**▲ Original artwork**
The original artwork produced by the illustrator has to undergo several stages of production before it appears in print. In the example shown here, the artist executed a number of images for a book jacket on a single sheet of good quality watercolour paper. The images were drawn "half-up" – that is, 50 per cent larger than they will eventually appear. The illustrator was asked to give the images a hard edge because they were to be used as "cut outs" on the final jacket.

### ◀ Colour proof

A proof of the jacket was submitted to allow the designer to make any necessary correction to the quality of the colour reproduction. This is also the stage where the position of the artwork and the registration of the films is checked. All colour proofs should carry a colour bar that shows the quality of the four printing colours: cyan, magenta, yellow and black.

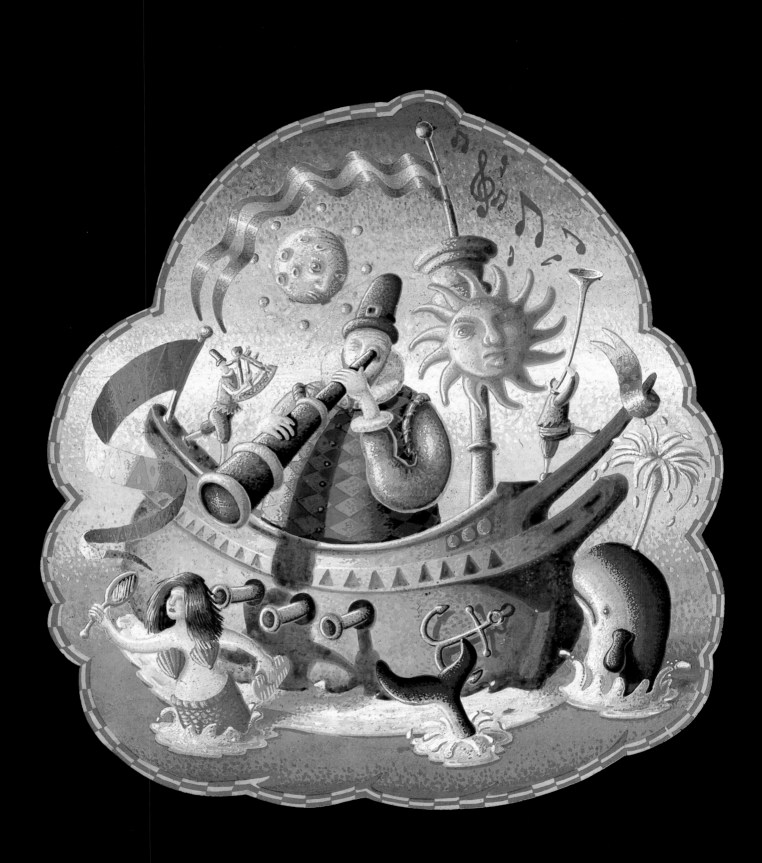

# ② PROFESSIONAL PRACTICE

This section focuses on the common-sense aspects to a newcomer's approach to illustration that will distinguish him or her from the many other young hopefuls emerging from art school every year. The following comments tend to dwell on the "down" side of the illustration business to warn newcomers just how tough it can be. But, as the images throughout the book demonstrate, the standard of contemporary illustration continues to be excellent and, if you manage to avoid the hazards described, a career in illustration can be a source of fascination and joy.

◀ IAN MURRAY
*Circumnavigation of the world*
This illustration, executed in ink, gouache and varnish, was highly commended in the Benson & Hedges Gold Awards on the theme of "Adventure".

# Starting out

he first thing a beginner to professional illustration should bear in mind is that there are no rigid rules because of the nature of the work and the people involved in it. Each commission is different, each designer is different and you will come up against a different set of circumstances almost daily. The only basic rule is to be flexible, alert and professional. For example, if you haven't made a note that your artwork should be portrait and have done it in landscape format, then you have only yourself to blame. Never forget that you are one of hundreds knocking on the door of the busy art editor: you need to work hard to make not only your work but also yourself memorable to him and her.

### Preparing the portfolio
The first essential is that your portfolio must sum up what you and your work are about. Most clients would far prefer to see 12 successful and well-presented pieces of work than acres of indifferent life drawings from your first year at college. Think hard about the sort of work each client commissions and adapt your portfolio accordingly.

Take the time to do some research: there is nothing more maddening (and rude) than a new illustrator who turns up at the door of a publishing house specializing in mass-market science fiction with a portfolio of sensitive interpretations of a novel by an obscure Central American writer. Study the latest works to be reproduced by the client in question and enumerate the jackets you found particularly effective – flattery may well get you somewhere. Another approach, if you're feeling particularly bold, is to be critical about something commissioned by that client and produce your own version with a flourish, "I would have tackled it like this...", although the inherent dangers of this method are self-evident.

Clients always like to see work reproduced and a familiar "Catch 22" situation is that art editors and designers will tell you that they "love" your work but don't want to commission you until you get something in print, and no-one is prepared to take the plunge. For this reason alone, it is vital that you chase proofs of your work. (This is a mind-numbingly boring job as you will need to phone the art director at least six times before you're sent them.)

**▲ Presenting your portfolio**
What you choose to include in your portfolio is all-important, as it will probably be the key factor in persuading an art director to commission you. For this reason, it is important that the work you select is a fair representation of your style and the subject areas you are happy covering. If possible, aim to include proofs of work as well as originals.

For obvious reasons students rarely have any printed work, so it's a good idea to reduce your work and surround it with type to give the potential client the chance to see what it could look like. However, for every client who thinks this a good idea, there is another who will find it too slick and would prefer a newcomer who's still "finding him/herself" (and more likely to do the job for less than the going rate because of it).

If your technique is one which is likely to confuse your prospective client – an esoteric method of drypoint etching combined with collage, for example – it is always a good plan to let them see the original alongside the printed version.

Another tip for the student or newcomer with nothing printed in the portfolio: if you do possess a series of abstract collages that weren't commissioned for anything in particular, try to describe the sources of inspiration, however tenuous. They may have been created in con-

junction with a friend of yours who is an up-and-coming jazz musician planning his first album, or perhaps you created them shortly after watching an incisive documentary on television about police brutality.

Clients do prefer to look through a conventional portfolio containing proofs and artwork neatly mounted on black or white backgrounds (and prefer not to have to look at slides or transparencies) rather than an artistic sheaf of massive charcoal drawings tied up with string. Think about the design of the book and plan the mixture of work appearing on each spread. It's sensible to start with the strongest pieces and never include anything that you feel apologetic about.

It's a good idea to set yourself a variety of briefs and put the results in your portfolio, even better if you have the self-discipline to work to a "deadline" as this may succeed in making your prospective client feel more secure. If you're hoping to work in the field of publishing (both books and magazines) this is comparatively simple. Read an article or novel and come up with your own visual interpretation: if it's imaginative and lively, if you have remembered where the type is likely to be placed and what the format is, and that book jackets have to impress the sales team in addition to the art editor, you will probably be quite successful.

It is much harder to set yourself advertising or design-group-style briefs as these are usually much tighter. The designer or art director is at the mercy of his or her client, who may not be at all visually aware and he or she therefore has to be more cautious: the client may never have commissioned an illustration before and the designer has only just succeeded in persuading him or her that the usual boring mug-shots of the board could possibly be replaced by something a little more exciting in the annual report. These clients are more likely to warm to colourful up-beat illustrations of happy nuclear families eating cornflakes or legions of businessmen cheerfully hammering data into their computers against a background of globes, graphs and aeroplanes than gloomy drawings around the themes of urban alienation or the transience of sexual passion. The latter will probably be more interesting to execute but the former much better paid. Most illustra-

tion commissions fall somewhere between these two extremes and the successful and happy illustrator probably does some of each, subsidizing the less commercial, more intellectually demanding work for books and magazines or indeed for exhibition, by commissions for advertising which are done to a much tighter deadline and brief, but for a financial reward which can be five times as much. Because of the competitiveness of the industry, most illustrators unfortunately are unlikely to be able to pick and choose until well into their careers.

## Developing a style

Students often leave college with no clear idea of the direction their work is taking. You might be moderately good at both scraperboard and watercolour and you will discover that this throws clients into a panic as they want to pigeonhole you or your work and may well have a vast array of files in which to store your work labelled, "Hedgehogs in skirts: watercolour", "Hedgehogs in skirts: scraperboard" and "Furry animals", "Cut-aways of petrol tankers", and so on. It is positive to be flexible in your approach to illustration but I fear that the old story of the art director who asked, on being presented with a

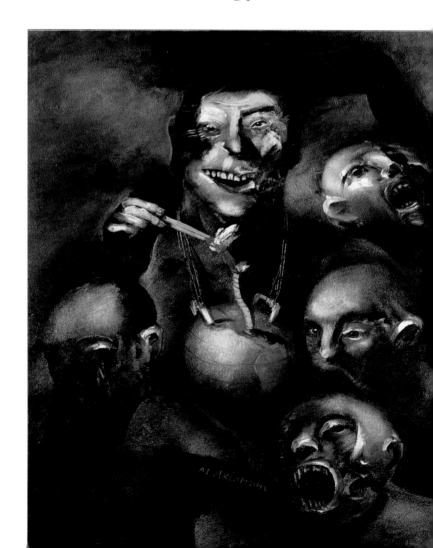

▶ MARSHALL ARISMAN
**Magazine illustration**
*Omni*
Top illustrators, such as Marshall Arisman, have painstakingly developed their own style over the years, which makes their work immediately identifiable. While it can be an advantage to vary in your approach, art directors value that touch of individuality that makes the illustration stand out.

gleaming air-brushed illustration of a slab of cheese in a hapless illustrator's portfolio, "Yes, but can he do butter?" is probably true. If you honestly feel that you don't know which direction your art is taking, either give it up or try to relax: most illustrators have found their niche after a year or two of pounding the pavements.

Having found your direction – perhaps you're the person for scraperboard rural scenes involving carthorses and sheaves of corn – beware of complacency. Don't get stale. The shrewd illustrator will be conscious of developing and changing in style and approach, as well as fulfilling commercial commissions in the currently popular style, otherwise when those fickle art directors decide that Leger pastiches are in, you'll be left stranded if you haven't been thinking ahead.

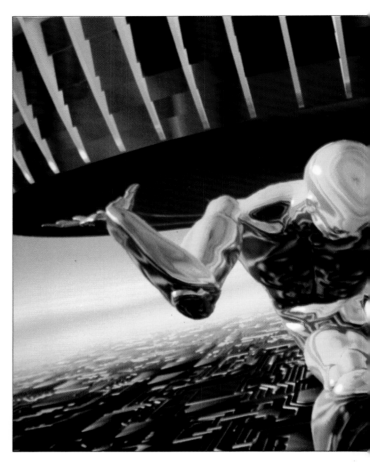

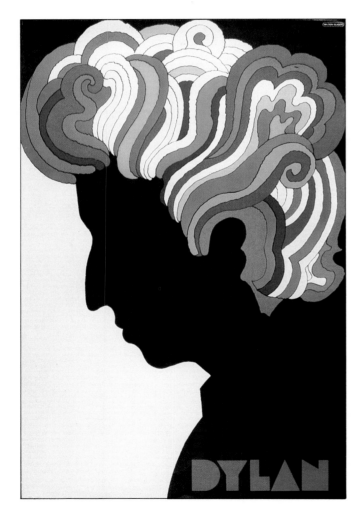

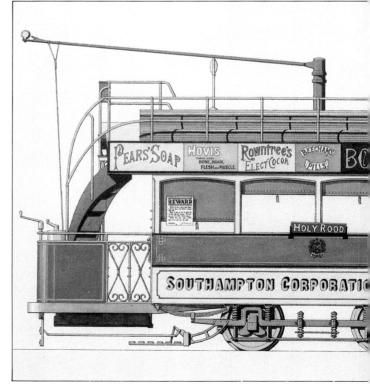

▲MILTON GLASER
**Dylan poster (1966)**
Shrewd illustrators, like Glaser, are aware of changing styles and approaches, while, at the same time, preserving the personal approach that makes their work identifiable.

◀ RHYTHM & HUES
**Human Tech II**
This California-based illustration group created this striking image of a golden man lifting the Olympic Stadium in Seoul, Korea, as a still for a Samsung commercial. Such groups are a prominent trend in the contemporary illustration scene.

▶ BRAD HOLLAND
**Mickey Mouse on Sixth Avenue**
*Frankfurter Allgemeine*
Holland is a prime example of an illustrator who has found his particular niche in the marketplace. His work is characterized by an exquisite pen and brush technique; it invariably revolves around powerful images, juxtaposed with apparently incongruous, yet revealing symbols.

◀ JERRY CAVE
**Southampton tram**
Technical illustration, a very important field, demands a totally different approach from the somewhat Impressionistic style of the other illustrators shown here. In this case, the emphasis is on line and detail, the aim being to produce an accurate visual record.

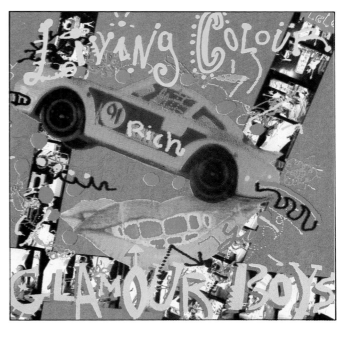

▶ THUNDER JOCKEYS
**Record cover for Living Colour**
Modern computer technology means that found images, photographs and drawing/painting can all be collaged together on a paintbox or similar computer. Here, the Thunder Jockeys, Graham Elliot and John England, demonstrate the flexibility of effect that computer-generated graphics can achieve.

# Negotiating fees and contracts

Negotiating fees is not as complicated or nerve-wracking in book and magazine publishing as it is in advertising or design work; there is often a page rate and it's frequently a question of "take it or leave it". For the novice illustrator it's well worth seeking out some specialist and trade magazines and approaching their art editors. The money won't be great but the chances are that they are not so deluged with portfolios as the nationals and to appear in these magazines is at least a way of getting your work in print. In the UK *New Scientist* magazine has acquired a well-deserved reputation for commissioning exciting illustration from established professionals and newcomers alike, and the cover, along with the *Elle* horoscope, has become a particularly sought-after commission.

Some "prestige" magazines expect illustrators to work for derisory fees because they deem it such an honour to appear in their august publications. This is galling when you know the magazines in question probably have the largest circulations in the world, but someone else will do it if you do not and this, sadly, applies to established professionals as well as newcomers.

In the fields of advertising and design work, negotiating fees is far more problematic. You need nerves of steel

**◀▼ Contract forms**
A successful illustrator needs to have a good head, especially when it comes to checking the small print in a contract or purchase order. The alternative is to use an agent. One of the key issues to resolve is the question of copyright ownership in the actual artwork; many clients like to retain this for potential future re-use.

### BRAGART

<u>A CHECK WILL NOT BE ISSUED UNLESS A COPY OF THIS LETTER IS RETURNED</u>

Dear:                                    Date:

I am pleased to make the following agreement between us regarding Bragart's assignment of illustrations of _____ by _____, which, if acceptable, will be purchased at a standard job rate, or, if unacceptable, will be guaranteed at one-half the job rate. It is understood that Bragart will buy the following rights in the work(s):

a) First periodical publication rights, exclusive to Bragart for a period of six months from publication;

b) Exclusive periodical resale rights in North America and the rest of the world for six months from publication in Bragart, the proceeds from any such resale to be divided equally between you and Bragart;

c) Reproduction rights for the foreign editions of Bragart in Italy, West Germany, Hong Kong and Japan, exclusive in those countries for nine months from publication in Bragart.

d) Non-exclusive reproduction rights in North America for any anthology or collected work of Bragart material for Bragart usual fee;

e) Promotional and publicity rights for Bragart or any foreign edition of Bragart.

You agree that Bragart will receive a "Courtesy Bragart magazine" credit upon the exercise of any of the rights retained by you in the work(s), if commissioned by Bragart.

Your signature below as artist or as agent for same warrants ownership of said work(s), and that exercise of the rights granted will violate no copyright or other proprietary right whatsoever.

This agreement becomes effective when a copy of this letter is returned to me. <u>A CHECK WILL NOT BE SENT UNLESS A LETTER HAS BEEN RETURNED</u>.

Agreed to:_____
artist's signature

By: _____

Dated: _____

Price: _____

ORIGINAL ART WORK WILL BE RETURNED TO YOU

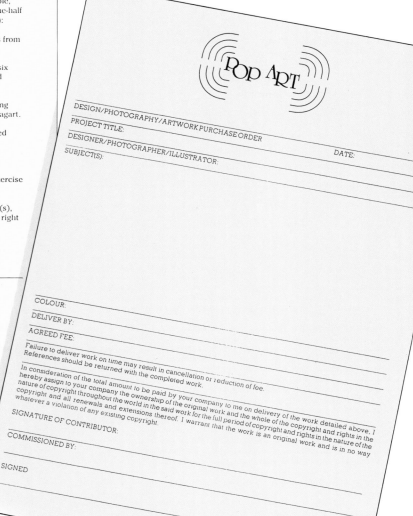

### POP ART

DESIGN/PHOTOGRAPHY/ARTWORK PURCHASE ORDER

PROJECT TITLE:

DESIGNER/PHOTOGRAPHER/ILLUSTRATOR:

SUBJECT(S):                                    DATE:

COLOUR:

DELIVER BY:

AGREED FEE:

Failure to deliver work on time may result in cancellation or reduction of fee. References should be returned with the completed work.

In consideration of the total amount to be paid by your company to me on delivery of the work detailed above, I hereby assign to your company the ownership of the original work and the whole of the copyright and rights in the nature of copyright throughout the world in the said work for the full period of copyright and rights in the nature of the copyright and all renewals and extensions thereof. I warrant that the work is an original work and is in no way whatever a violation of any existing copyright.

SIGNATURE OF CONTRIBUTOR:

COMMISSIONED BY:

SIGNED

but certain tactics can be helpful: always sort out what you're going to be paid before you start work; you obviously have no bargaining power when you have already completed the job.

Often the only way a newcomer has of costing out a job is to consult someone else with more experience: either a friendly agent if you don't have one of your own (and this is where they really come in handy) or your professional organization, (the Association of Illustrators in the UK or the Society of Illustrators in the US). Gradually you learn that different advertisements are more or less well paid acccording to where they are going to appear: a black and white advertisement in a small circulation specialist magazine is not going to get as good a fee as a full-page full-colour one in the so-called "quality " press. Usage plays as important a role in quoting as estimating the work entailed in the illustration, but it is common-sense to realize that, even in a national press advertisement, if all you're supplying is a drawing to be dropped into a predominantly photographic image, you'll be paid only a fraction of the total budget for that advertisement.

In design group work, the money can be almost as high as in advertising and a commission frequently involves a series of illustrations – a brochure cover and four illustrations to appear inside, based around the same theme, for example. Again, with a little experience you'll learn the kind of fees you can expect.

Art buyers are often rather intimidating and, indeed, they are hand-picked for their ability to terrify their suppliers. But keep calm and don't let them reduce you to a gibbering pulp. You don't have to quote on the spot; it's always a good idea to go away and think about the work involved in a more tranquil situation and it's also a good psychological tactic. The process of arriving at a price is almost balletic in its moves and countermoves and the client will make great use of the significantly timed pause. But beware of suggesting a reduction just to fill in the gap. They may well tell you that they have just had to "scrape the client off the window sill" because your quote had such a devastating effect on them and yet, two minutes later, you have compromised on something not a million miles away from your original estimate.

## Charity work

You may be asked to contribute to calendars and other promotional projects for nothing and in these cases you simply have to decide whether you can afford it and whether the resulting publicity will really benefit you: in the case of well-established calendars like Trickett and Webb's there is no doubt that it goes on every client's wall and you will be seen to be among the crème de la crème of your profession. But choose carefully – if you get involved in an untried illustration venture you could end up cursing it, especially if those concerned don't understand how important good reproduction, good distribution and effective publicity are, and if you have had to turn down other paid work in order to do it.

## Options on the original artwork

There are other considerations to take into account when quoting. Try to find out at an early stage whether the client is likely to buy your original artwork (it belongs to you by right and the fee they are paying you is only for the use specified in your agreement with them) and quote for this too. Artists are often surprised to see an image that they produced for, say, a record cover appearing on a T-shirt or as a greetings card, when no such permission had been sought. It may be that you have to provide several different quotes – for example, the first for using your work solely in colour for a national press advertisement, the second for using it additionally in black and white and the third for using it in below-the-line and trade press advertising and sometimes as a "total buy-out" which means that you are granting the client the right to reproduce your work wherever they like, both nationally and internationally (having obtained your permission of course). Clients rarely take up the latter option as it can work out very expensive for them.

## Retainers

One of the most difficult things you may be asked to estimate is the amount you would charge a client to put you on a retainer, agreeing not to work for any of their rivals for a specified period. You need to build in a flat fee for the retainer, taking into account all the work you might have been commissioned to do by their rivals and then get them to agree that they will guarantee to supply you with commissions worth another specified amount over and above the retainer fee. Once you've worked all this out, the amount will probably scare them off, but if you do ever get involved in this sort of agreement, you must first get it approved by a lawyer.

## Contracts and terms

There are numerous pitfalls with regard to professional practice into which the unsuspecting illustrator may fall.

63

Most agents will have a contract, often printed on the reverse of their order, setting out their terms and conditions; your professional association gives guidelines on these. What follows may seem too unwieldy for most commissions but the following points are the ones that you should bear in mind.

If you are presenting your client with an order, you should include the following, clearly set out on the front of the form: the name and address of the artist and the client, the agreed fee, the date the work is to be delivered, where the work is to be reproduced and the agreed terms of copyright. The client must sign it and you must keep a copy. If you are concerned to protect yourself further against being unprofessionally treated, you can include some other safeguards on the reverse of the form.

**Licence**  Unless otherwise agreed at the time of commissioning (and written on your order), the client is usually granted an exclusive licence for specified one-time use in this country only and any further use should be paid by agreement.

**Syndication**  You should be aware that you are granting magazines and newspapers the right to use your work in one issue only and if they wish to sell it to appear elsewhere they should obtain your permission and pay you roughly 50 per cent of the original fee. It is especially galling to discover that your work appeared in, say, a South African magazine when you would have refused permission had it been requested. Sadly, it is difficult to police this particular abuse for obvious reasons.

**Self-promotion**  It should be your right to use your illustration for self-promotion purposes but it is only courteous to inform your client and ensure that the caption you publish is accurate.

**Payment**  You should endeavour to get your invoice paid within 30 days and state this on your order. Several agents now charge interest on any balance unpaid after that date, but in reality most design groups and advertising agencies take three months to pay their invoices. Book and magazine clients are generally more speedy. If you do not have an agent, chasing money will take up a surprising amount of your time: you will be offered countless excuses: they never received your invoice, the person concerned is in a meeting, there's no one here to sign the cheque (the latter excuse is even used in organizations that employ around 500 people). All of this is calculated to put you off because it is company policy to hang on to any money owed for as long as possible for obvious reasons. An agent has more leverage than a lone freelance artist in this situation because when the client wants to commission another artist represented by that agent, the agent can refuse to deliver the artwork for the subsequent job until the cheque for the first one has been received. You can help yourself by being efficient about invoicing: send it in as soon as your artwork has been approved, keep copies and follow the invoices up with monthly statements and phone calls.

**Cancellation**  If a commission is cancelled by a client, it's not your fault, so make sure you are paid. A suggested structure for costing this might be 25 per cent of the agreed fee before delivery of roughs (the chances are you have turned down other work in order to do the job, attended a briefing meeting and done some research), 33 per cent at rough stage, 100 per cent after delivery of artwork, and pro rata at intermediate stages.

**Rejection**  Cancellation fees are straightforward and the illustrator is never to blame if a job is cancelled; rejection fees are more complicated. If you have completed the commission to the best of your ability, taken in the comments your client made at every stage of the job, and executed the job in the style which he or she was expecting, strictly according to the brief, then you are justified in claiming a rejection fee of 100 per cent. Even in this instance, if the fee originally negotiated was high, you may decide that it would be more politic to settle for 75 per cent if insisting on 100 per cent would alienate your client for ever. You have to be flexible, but generally clients will pay between 50 and 75 per cent as a rejection fee and 25 per cent at rough stage. You should include something to this effect in your terms and conditions. If, however, you have produced sub-standard work for whatever reason, you are not justified in claiming a hefty rejection fee. Sometimes an unwise illustrator uses a real-life commission to experiment with his or her style which really is not fair to the client: you may think it fits the brief, but it is not what you have been asked to do.

**Roughs**

Your client will often want some indication at an interim stage of the way a job is progressing and what constitutes a "rough" can vary tremendously. If you work in colour

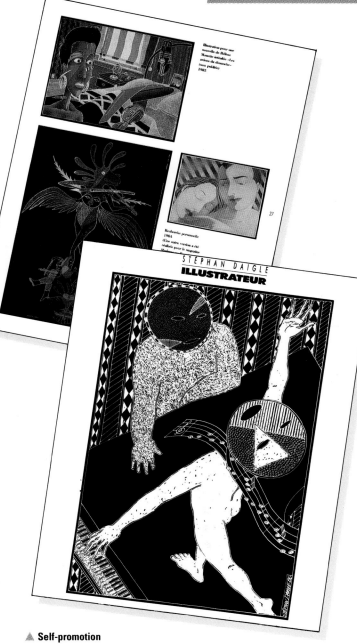

including individually worked-on screen prints, a pencil rough will not look much like your final artwork and it is always worth spelling this out to your client and getting them to present your rough in conjunction with previous printed work to reassure their own client who will be nervous about what they have let themselves in for. Do keep your client informed as it will allay their anxieties and make them feel involved. Sometimes, if your client is particularly nervous, it is a good idea to negotiate a fee for a "presentation" rough (which amounts almost to final artwork) so that they can visualize the end product.

## Artwork and copyright

Artwork belongs to the illustrator. It is very important that your client is aware of this. It is now trade practice that original artwork is recognized as being the property of the illustrator and must be returned to them. To reinforce this, it is advisable to use ownership of artwork stickers on your artwork. Your client may wish to buy your artwork for the boardroom wall or his dining room and, of course, it is entirely up to you to decide whether you wish to sell. As a very general rule, you should expect a price roughly the equivalent of the original fee. However, if, for example, you were paid a large fee, you enjoyed doing the job and it was a smooth-running project, then it is greedy to expect the same money again. If you were paid a modest amount for the work to appear in a magazine and you could sell it in a gallery for a great deal more then you should price it accordingly. You will still come across clients who think they own the artwork and that the fee negotiated at the outset included ownership of the work: this is why it is vital to sort out ownership early and make sure the point is covered in your original terms of contract.

If your artwork is lost or damaged while in the client's custody, you should be paid compensation based on the value of the original artwork.

The artist's name customarily appears in books and magazines, as this is obviously important for your own promotion – check with the art editor if in doubt. It is rare for illustrations in a design or advertising context to include the name of the artist unless it is classified as "art" in a so-called prestige campaign.

You should insist on being sent as many printed proofs of your illustration as possible.

▲ **Self-promotion**
You should insist on the right to use your illustrations for purposes of self-promotion and check that this is clearly stipulated in any contract.

pencil it is probably quite easy for you to provide a fairly accurate pencil sketch of the intended illustration together with some indication of colour but if you use ephemera and found objects to make up a collage it is impossible to provide a rough as such, and you may have to deliver your actual artwork early in case of alterations. You may be able to get around this problem by keeping in close telephone contact with your client and making sure he or she is abreast of your ideas as you go along. If your work is scraperboard or linocut, or involves mixed media

# Using an agent

There are many more artists wanting to join agencies than agents have room for, and most artists who are represented assert that their income has increased by far more than the 25 or 30 per cent which is the usual agents' commission, and that their lives have been made easier too.

Most of today's successful illustrators spent two or three lean years after leaving college, trudging round with their portfolios, living from hand to mouth and getting depressed: it is a very hard world in which to succeed and you need to be both very talented and very determined. When you start out, it is a good idea to spend some time going round meeting clients and presenting your portfolio, however soul-destroying, because it will give you some feel for the market-place and you could make contacts that will stand you in good stead throughout your working life. Although some agencies do occasionally take on students straight from art school, they need to be very impressive both in terms of work and personality.

Agents have a very clear role to play in the lives of their artists. The majority of artists are not good at talking about money, nor do they enjoy it. It is much easier for agents who spend all their time quoting to be au fait with current prices and to build up a personal relationship with art directors (or, more importantly, art

▼ **Directories**
It is helpful to be included in one of the directories of illustrators that are published (often annually).

buyers) and designers. It's also much easier to sell someone else's work. Agents are better placed to promote artists' work effectively and it's a sensible use of resources as an agent can present five or six portfolios of new work to a client in one meeting. Clients often feel more confident if work by an unknown artist is included in a pack of artists whose work they are more familiar with, and obviously there is quite a cachet in being grouped with a list of artists whose work you admire and respect. Art buyers often feel more secure if they have known the agent for years because they are more likely to be dealing with a known quantity.

A busy illustrator would probably choose not to spend half a day going into an agency or design group to collect a brief when an agent can go on their behalf; those artists who are not represented often express the fear that things might get scrambled if they don't attend a brief in person, but if the agent makes coherent notes on the spot and sends the artist a written brief, as well as encouraging him or her to speak to the art director/designer on the telephone, confusion is often less likely to arise. The artist probably does not want to be interrupted six times a day by an anxious client and another advantage of having an agent is that they can relay any essential messages and also monitor the progress of the job, jump in if any unreasonable demands are made and renegotiate should alterations be required. For this reason it is better for artists not to give clients their telephone numbers however friendly the client may appear.

In some cases it is obviously necessary for the artist to attend a briefing session if their input is really required at an early stage in a commission, and in that case a good agent would encourage the artist to attend and would accompany them. It is often easier to turn down work if someone else is actually saying "no" – a surprising number of artists seem to find this a problem and end up taking on jobs they subsequently regret. An agent should always consult the artist about the jobs on offer, even if they think that the work involved is not well paid enough or unsuitable and, as long as everyone communicates, problems should not arise.

It is convenient for an artist to have someone else who is responsible for chasing proofs and artwork, updating the portfolio, sending it out to clients, invoicing and chasing money when the artist is better employed concentrating on the work. The creative world is a battlefield and if you have someone else to fight those battles on your behalf, so much the better.

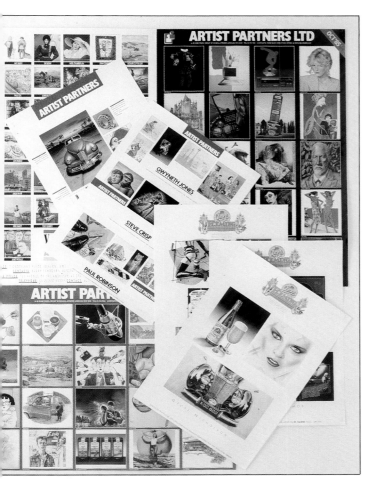

**▲ Agents' publicity material**
Many leading illustration agencies prepare printed brochures and posters to promote their illustrators, which their sales representatives present to potential clients.

The relationship between artist and agent varies tremendously according to the personalities involved. In some cases, the artist comes into the agent's office almost daily and shares the intimate details of his or her private life, and in others the relationship is purely professional and largely conducted over the telephone. In all cases, however, the arrangement is necessarily based on mutual respect and trust.

**Selecting an agent**

An agent may reject an artist for a variety of reasons, the most obvious being that the work is not good enough, or it may be that the work is not appropriate for their agency. A good agent should be able to recommend someone else if they feel you have a good chance of making it as a professional illustrator, whether or not you fit in with their particular set-up.

An agent may like you and your work but simply feel that you are not yet ready – do not be discouraged if this is the response you get and if you are asked to come back in six months' time. You may discover during the interim period that you like pounding the pavements and negotiating fees and don't need an agent anyway.

If an agent does like the work and thinks it's of a high standard, he or she may reject the illustrator on the basis of their personality – perhaps in their view the artist is over-confident, self-opinionated or pretentious or they feel that the artist is not emotionally equipped to deal with the vicissitudes of working as a professional illustrator. Clearly, in the last analysis, the choice of artists made by an agent is based more on personal choice and gut reactions than anything else.

It is equally important for the illustrator to feel confident and happy in his or her choice of agent. If in doubt, contact other illustrators with that particular agent and find out if they are happy with the relationship.

Those who think that agents are unnecessary feel that 25 or 30 per cent of the artist's fee is too high a rate to pay, but the artists who are represented don't seem to resent it. For every smooth-running job involving the agent in no more than a couple of telephone calls, there are countless others that go horribly wrong and involve endless meetings with the client, renegotiations and even, in extreme cases, legal proceedings.

Undoubtedly some illustrators have many of the skills of a good agent: they positively enjoy talking about money and bargaining with the clients, negotiating and taking briefs, are masters of diplomacy and effective self-publicists. They are either willing to drop everything and rush into a meeting with the client at a moment's notice or sufficiently firm to resist the pressure to do so, in which case they may not need an agent and would resent having to pay 25 per cent of their fee to one.

## RECRUITMENT BROCHURE

**CLIENT** *Mischon de Reya*
**ILLUSTRATOR** *Andrzej Dudzinski*
**BRIEF** *To produce illustrations for a recruitment brochure.*

A ndrzej Dudzinski was recently commissioned by the design group, Joint Force, to produce an illustration for a firm of solicitors, Mischon de Reya. The illustrations were to appear in a recruitment brochure, and had to sum up the advantages of training with that particular firm. What makes this commission interesting is the fact that Andrzej is based in New York and the designer, David Lowe of Joint Force, in London, so much of the communication had to take place by fax.

The design group requested various portfolios from the agency but decided on Andrzej because they felt he would be able to encapsulate the various aspects of the law practice in a way that would attract the kind of articles clerks Mischon de Reya were trying to attract.

The type and layout of the brochure had already been designed, and the brief was faxed to him as soon as the fee and schedule had been agreed. He faxed back, asking for confirmation that the client wanted an abstract and sophisticated approach, and it was arranged for the client to talk to him direct. This was an unusual step, but successful in this case. Indeed the client was so pleased with the collage for the main illustration that he bought the original.

▶ **The agent's brief**
Each of the illustrations was to highlight one of the six main topics in the brochure: How the firm is organized; Training and Education; Continuing Education; Pro bono (voluntary charity) work; What you will learn; When you qualify. The roughs shown here submitted by Andrzej by fax.

How the firm is organised

Training & Education

What you will learn

Continuing Education

When you qualify

Pro Bono work

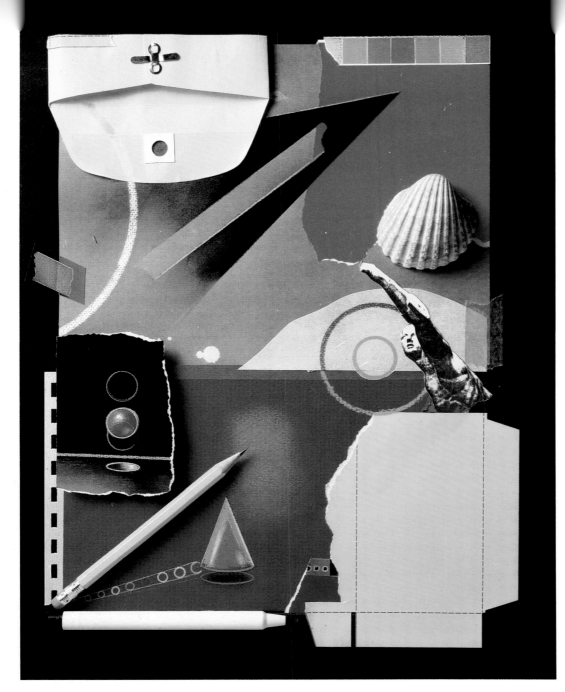

**◀ The final image**
The main illustration, which appeared on its own page in the brochure, with no accompanying type, is a composite of the six topics. Because of the delicate nature of the collage, which features a pearl and a shell stuck on with double-sided tape, the artwork had to be packed with great care, and the artist sent detailed instructions on how to photograph it to best advantage.

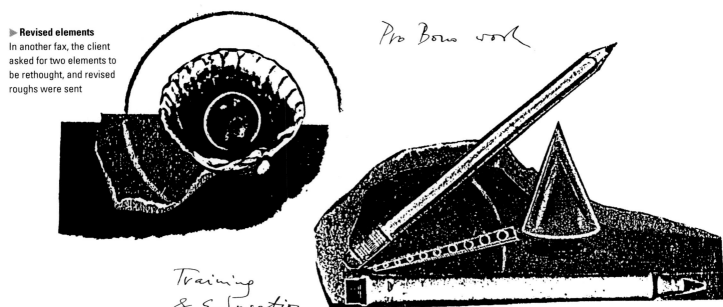

**▶ Revised elements**
In another fax, the client asked for two elements to be rethought, and revised roughs were sent

Pro Bono work

Training
& Education

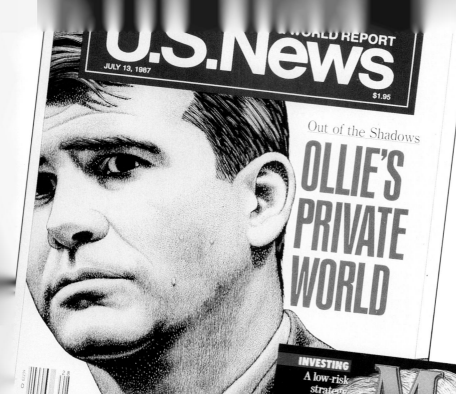

**U.S.News**
&WORLD REPORT
JULY 13, 1987
$1.95

Out of the Shadows

## OLLIE'S PRIVATE WORLD

**INVESTING**
A low-risk strategy to protect your money

**HOUSING**
How to cope in a soft market

**Q&A**
What you must know about Social Security

SEPTEMBER 1988 $2.95

# Money

**CASH**
Money funds with the best yields

**BASICS**
All about zero-coupon bonds

**UPDATE**
Insurance that covers nursing care

BB&K index

S&P 500

## Shhh!

### The Most Valuable Secret in Investing Today

Diversification works. It's the simplest and easiest way to lower your risk without giving up return. Since 1967, the BB&K diversified portfolio index has risen 719%.

# MAGAZINES AND NEWSPAPERS

In these two areas, speed of execution and the quality of the printing process are the two factors that determine the kind of illustration commissioned and the scope to cartoonists and caricaturists. Magazines offer opportunities in a wide range of illustration styles, and their art directors are among the most innovative in the media world, partly because there is less financial pressure – and therefore greater design freedom – in a single issue of a magazine than in a book or an advertisement.

The ability to work to a tight deadline is as important an asset to the newspaper or magazine illustrator as the artist's talent or skill, and no matter how brilliant you may be, failure to meet the deadlines imposed by the paper's art editor, or the magazine's art director, will nip your future career in the bud.

◀ MIRCO ILIC
**Magazine covers**
Much of the impact of this simple portrait for the cover of *U.S. News* comes from the cropping of one eye. Both this and the *Money* cover show that monochrome can work just as well as colour, and can indeed be more suitable for certain subjects.

71

# Magazines

Illustration has always been an integral part of magazine design: it provided a reporter's eye view from around the world, before photography came of age and now that photography dominates magazines, illustration has become its foil.

Only in magazines and newspapers will you see work that was on a drawing board yesterday appear on a book stall or news-stand today. In magazines, in particular, you will find within the covers the broadest range of styles, coping with the widest range of subjects. Historically this has always been so. We've seen the futuristic invention, the world of tomorrow imagined by Dan Dare in *The Eagle* and Norman Rockwell's pie-in-the-sky idealism and instant nostalgia in the *Saturday Evening Post*. The New Frontier feel for the wonder and ingenuity of science was evinced by *Popular Mechanics* (now ripe pickings for parody) and the chic, sleek fashion illustrated in *Vogue* and *Harper's Bazaar* lives on today.

With children's comics at one end and political commentary at the other, the magazine and newspaper spectrum is vast, and growing at a ferocious rate. While this has provided more opportunities for illustration, unfortunately it hasn't necessarily always led to their being used in an interesting and creative way.

**The role of illustration**

Illustration serves many purposes in magazines. On one level it simply decorates a page. Often food or women's magazines give these "light" illustrations a large amount of space, the idea being to vary the visual impact, contrasting the drawings with photography. Fashion illustration is also used in this way, although usually more boldly.

Decorative illustration is also used to "tempt" the reader. A block of print can be immediately enlivened by ornamental borders, illustrated headings, or small drop-ins to break up the text. These can vary from witty cartoons to attractive patterns which tend to reinforce the general style of the magazine, and which change with passing trends.

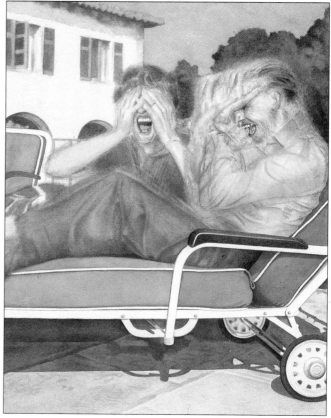

◀ PETER KNOCK

**The American dream**

These illustrations were commissioned by Derek Ungless, art director of Toronto's *Saturday Night Magazine*. They were to accompany an article by Dalton Camp tracing the decline of the American dream and the escalation of a violent society, which the artist says was "one of the finest pieces of writing I have encountered".

"I was given an open brief and the choice of a double-page spread or two single pages. I decided on two separate illustrations, The Dream and The End of the Dream, feeling that turning the page from one to the other would give a more powerful impact.

"I was after the kind of restless and frightening quality seen in Francis Bacon's paintings, and spent some hours studying his work. I had taken some very static polaroid pictures of my brother and his wife for reference, but knew I had to get away from these to achieve spontaneity and movement. To paint these characters, I worked fairly fast, continuing to move across the surface, and drawing a 'secondary' image to convey the movement."

◀ DOLORES FAIRMAN

**Crying in the spotlight**

This illustration was made to accompany a magazine feature on men's emotions, how these are shown in public and in the media. The artist has achieved a strong graphic image with clear reference to the content of the feature but a considerable presence of its own. She describes her working method as follows: "I try to sum up the article in as simple and direct a statement as possible. I work towards a strong figurative composition, independent of time and place."

◀ JANE STROTHER

**Eating well**

Here illustration is used as a luscious visual counterpart to the text. Using it in this essentially decorative way allows full emphasis to be placed on the atmosphere of the piece and the shapes. The overlapping panel fits neatly into the "dead space" below the spoon.

## Humour

Cartoons in magazines can set a very particular tone. The only visuals in the *New Yorker*, for instance, are cartoons and its unique feel stems entirely from this. Glen Baxter and Jules Feiffer's strips were important elements in the *Observer* magazine, especially as they were on the contents page: in Feiffer's case using a liberal, slightly self-mocking stance, and in Baxter's a traditional "Englishness", undercut by off-the-wall captioning. Charles Schultz's Peanuts has also long been the most popular feature of the magazine.

One field that has experienced a boom is comic books. The stunning work of Dave Gibbons in *Watchmen* and the Hernandez Brothers in *Love & Rockets* shows that this particular form of illustration has developed remarkably in the last few years in terms of the quality of the drawing and the complexity of its execution. It is in these comparatively non-traditional areas of illustration that much of the most exciting work is being done.

Caricature sits between cartoons and political comment and goes in and out of favour. It is most effective in newspapers, where simplicity of line often makes for the strongest images.

## Reportage

This has a long and honourable history in magazines. The advent of photography may have meant that less on-the-spot drawing was done, but there were always outlets for it. The success of *The Illustrated London News* was based upon its reportage, Felix Topolski's work in *The Listener* spanned two decades, and *Punch Magazine's* theatre reviews were always accompanied by a sketch drawing made during the play.

The 1960s and '70s saw some of the strongest reportage work. Paul Hogarth worked extensively on location for magazines and Ralph Steadman's stunning work in *Rolling Stone* alongside the writing of Hunter S. Thompson did something that photographs simply couldn't match: he could twist and exaggerate what he saw to match exactly the pitch of Thompson's writing.

Maybe the reason that illustration isn't used more in this way is because of the "safety" of photography which gives the reader "reality". Paul Cox, an illustrator who often works on location explains: "Art directors have to take on board the fact that an illustrator is always going to bring his own method to bear on the location. With the

◀ ROSS THOMPSON (ROSS)
**From Call to Wall**
This humorous strip provides some valuable advice for aspiring cartoonists, many of whom start as amateurs working for no reward other than seeing their work in print.

▶ DAVID SUTER
**The American Prom**
A suitable theme and a long deadline were the factors enabling The Listener, a small-circulation British magazine, to commission a busy American illustrator to produce this cover image for an issue including coverage of the London Promenade concerts of that year, which had an American theme. Reference pictures were supplied, and the idea for the illustration was discussed between the artist and art director by telephone. The illustration cleverly combines details of the concert venue with the Uncle Sam figure as performer.

FROM CALL TO WALL

A BRIEF CAN COME BY PHONE, MAIL OR BY VISITING THE CLIENT. TO START WITH YOU'LL NEED TO HUSTLE.

ONCE BRIEFED, THE CLIENT MAY WANT TO SEE ROUGHS OF HOW YOU ENVISAGE THE JOB ONCE GIVEN THE OK PROCEED WITH ARTWORK.

THE DAY ARRIVES WHEN YOU SUBMIT YOUR CARTOON. TAKE NOTE IF THE CLIENT HAS SPECIFIED A CERTAIN TIME HE WANTS IT DELIVERED.

BUT BE PREPARED TO DO SOME AMENDMENTS TO YOUR DRAWING ESPECIALLY IN ADVERTISING.

IF THE CHANGES ARE WITHIN REASON RETURN ARTWORK AND.....

THEN HUSTLE FOR MORE WORK AND WAIT FOR THE CHECK TO ARRIVE!

BUDDY'S BEER IS BEST

AND THEN HAVE THE SATISFACTION OF SEEING YOUR WORK ALL OVER THE PLACE!

91

photograph you're not immediately aware of the photographer; it's just a fact. What is shown was what was there at the time and you automatically believe in it. But an illustrator, with all the individual 'stylistic' approaches that he brings to a place, will not always give an honest or objective view of the place."

In Britain, only a handful of magazines still commission this type of work, which is a pity as it is a staple of student portfolios. Illustrators are hardly ever given the chance after college to go and draw on location again. Interestingly, to work in this way, some illustrators have taken to "commissioning" themselves. Chris Corr, for instance, spends months on extensive and extraordinary tours drawing continuously, and will often, although the work is primarily for galleries or books, have his illustrations used in magazines.

## Conceptual or editorial illustration

This is, to my mind, the most exciting area of magazine illustration. Here, the role of the illustrator is to give visual form to often abstract concepts and to make that form illuminating, challenging, entertaining and alluring.

Handling awkward and unwieldy ideas is the stock-in-trade of artists like Peter Brookes, Brad Holland, Peter Knock, Robert Mason, Eugene Milhaesco, Bill Sanderson and Peter Till, and magazines are the perfect vehicle for such work. They deal with topical "meaty" subjects and the illustrator can handle them in a tough, uncompromising manner without fear of harming sales. The short shelf life of a magazine means that if an experiment doesn't work there is always another issue just around the corner.

At the heart of great editorial illustration is the relationship between art director and artist – a mutual trust. If the art director sees that a particular illustrator can solve problems week after week, then they can place more and more trust on that illustrator's ability to deliver the goods. This consistency is often the secret behind magazines that use illustration strikingly because the words, pictures and design mesh together. Every piece of the whole fits and the part played by the illustrator is very large. It isn't just a case of filling a hole left in a page or slotting something into a preconceived layout, if the work is good then it is an inspiration to which the

designer can respond. Good art directors are always happy to be surprised, always willing to be taken along a different road. Peter Knock, an illustrator, describes this trust: "It has been my experience to work regularly for a number of art directors who hold particularly powerful positions unencumbered by much editorial interference – their decisions are honoured. From these art directors I have often been given such confidence in my ability to effectively illustrate a given assignment that no prior approval or even discussion has been requested. Under these circumstances I have found that one takes a more responsible view, with the bonus of perhaps coming up with a more inspired or surprising solution.

"I have occasionally worked for magazines that give me their own concepts and are continually demanding approval of rough and then accurate versions for the proposed final art work. This usually results in uninspired work, a loss of personality and an inevitable 'illustrated by committee' appearance."

The finest examples of true editorial illustration today are to be found in magazines such as *Frankfurter Allgemeine* (the colour magazine of a German Sunday newspaper), *New Scientist*, *Rolling Stone*, *The Sunday Times Magazine*, *Esquire*, *The Spectator* and *Business Magazine*.

### Covers

The function of a cover illustration differs fundamentally from that of illustrations that appear elsewhere in the magazine. It is often not enough to have a good idea for a

◄ **PAUL COX**
**The Flat Iron Building**
For his drawings of New York, commissioned by *Blueprint* magazine, the artist had about five or six days in the city, during which he did about 45 watercolours in a tiny hotel room. Paul says the drawing for the Flat Iron Building was one of the hardest drawings he has ever done. He worked on a traffic island on a huge A1 drawing board, and every five minutes there was an invasion of people crossing, all looking at the picture before moving on. Another problem was counting the windows down from the top so that the height was right. While he was working on the line, he had to at the same time build up a mental image of the colours so that he could work on them later that night in the hotel.

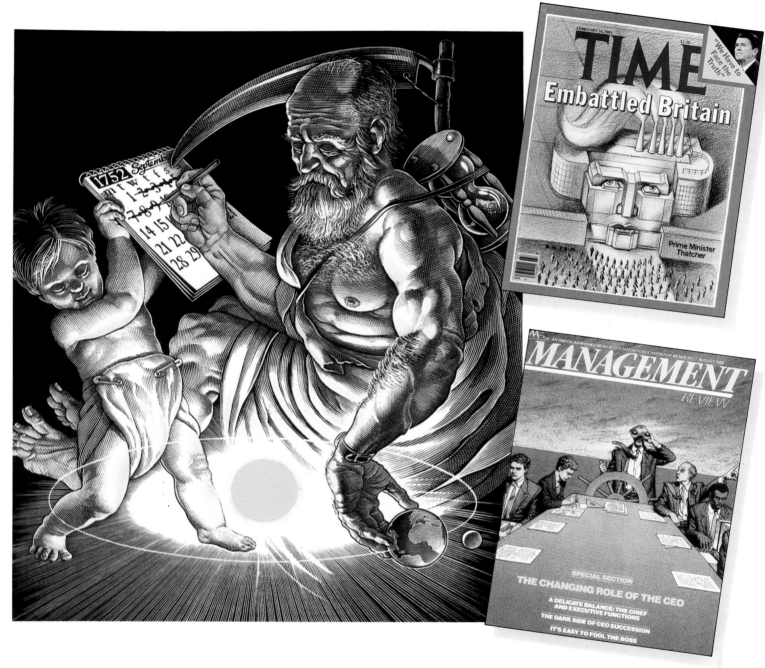

▲ BILL SANDERSON
**The changing calendar**
This illustrates a historical piece on the eighteenth-century change from the Julian calendar to the current system to produce a more accurate recording of time. The black and white work is on scraperboard, which is then coloured. Highlights can be cut through the colour, allowing emphatic modelling of the forms.

▶ MIRCO ILIC
**Changing role**
The article in Management Review illustrated here deals with the changing role of chief executive officers in American companies. Ilíc has used the "helmsman on the bridge" idea, carrying it right through the supporting figures. The table provides both a graphic focus for the figures and a device for keeping the imagery well away from the type.

▲ DAVID SUTER
**Embattled Britain**
Time's covers often deal in large, complicated themes and situations, and they choose illustrators who can cope with such subjects, as well as with short deadlines. Here David Suter has given the theme of Britain's industrial unrest a powerful focused treatment. This is a tricky idea to carry off: not only does the likeness have to work but the elements of the story must come across also.

77

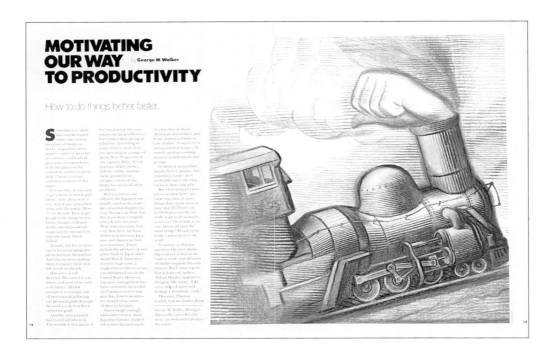

◀ DAVID SUTER
**Motivating Our Way to Productivity**
This is another example of David Suter's ability to give human qualities to mechanical objects, so that the railway's engine powering up a slope also reads as a man flexing his biceps. The concept is conveyed with both precision and ingenuity, in an extremely graphic and arresting way, and the type is used sparsely to allow the illustration its full impact-making potential.

cover illustration – it has to be graphically bold and must work visually very quickly. Technically it has to operate with a logo (the magazine's title) and often not only explanatory cover lines but also further information about the magazine. The illustration does not have the luxury of sitting restfully amongst a page of grey text bleeding gracefully over a single page.

How magazines look on a news stand can influence sales, especially impulse buys. Illustration often gives a particular flavour or character to a magazine, setting it apart. This is important in a field where the predominant cover image is a portrait photograph against a white background.

Often cover illustrations rely on the use of clichés and familiar images. The reason for this is that recognizable images ensure that the reader quickly grasps the meaning of the illustration. The best illustrators turn these clichés upside down or give them a twist that renews their potency, as in Grant Wood's "American Gothic", for example, a turn-of-the-century painting of a mid-western American farmer holding a pitchfork and standing next to his wife. This has been parodied countless times in the service of articles on a wide variety of subjects. Mick Brownfield's use of Mickey Mouse shows how an unusual slant on an old friend gives it a striking impact as a cover.

▼ MICK BROWNFIELD
**The dark side of Disney**
An investigation of how Walt Disney was seen by his employees and friends, as opposed to his public, produced a less than flattering view. The artist had a short deadline, so looked for a simple idea that could be quickly rendered. The image is based on the caption

drawing at the start of the Mickey Mouse films, but subverts this best-loved symbol of Disney by presenting Mickey as a little devil.

## Fiction

Fiction is an area that magazines handle in much the same way as publishers. The best illustrators are those who can accurately evoke the atmosphere of the story but at the same time don't tread on the readers' own imagination. The only real difference is that book covers have some constraints with regard to selling, whereas in magazines those strictures don't usually apply.

## Illustration commissions

Jobs come in all shapes and sizes, with all manner of deadlines. A piece of fiction may be commissioned months in advance, a small drawing to fill a gap in a page in an hour, as the presses wait to roll. On the whole, most are one-offs, specifically required to run with a particular piece of writing in one issue of a magazine. There are also regular "slots" where an illustrator will do a different drawing each week on the same page. Sometimes magazines will keep an illustrator on a retainer to work in-house one day a week, usually near to press day, to fill any spaces that arise.

Some people specialize in either one style, with which they approach every subject, or in a single area such as food or fashion. An illustrator can work with the same subject for almost an entire career.

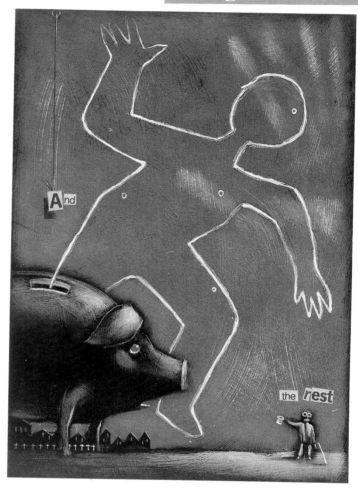

▶ MATILDA HARRISON
**The Marian Year**
This illustrator often works with iconic objects and elaborate frames, so was the natural choice to illustrate a feature on the implications of a year devoted to the Virgin Mary. The artist makes the frames herself, based on detailed research. The deadline allowed only two weeks for what would usually be a month's work, but the project was very successfully realized. Every figure or object in the frame refers to the folklore and symbolism associated with the Virgin Mary. The illustration updates the context by setting an idealized figure against the modern tourist influx into the Vatican City.

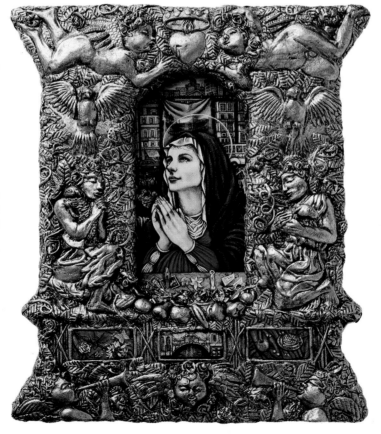

▲ RICHARD PARENT
**Hungerford appeal**
This image illustrated a piece on disaster funds, specifically those set up in response to multiple killings in the English town of Hungerford in 1987. The artist first thought of the chalk drawings made around murder victims, and from this idea created the central figure in the illustration. The other elements represent points made in the text about the large sums of money donated to disaster funds (the "piggy bank") as compared to smaller sums accumulated long-term by established charities (the blind man). A combination of oil pastel and acrylic, sealed with varnish, contributes vivid colour and texture to a dramatic image.

79

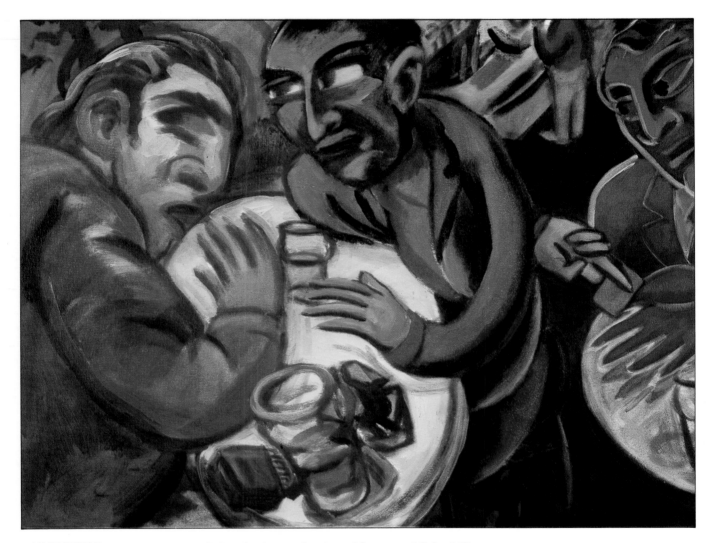

▲ ASHLEY POTTER
**Police informers**
This was intended as a cover picture, but was never published due to legal difficulties over the origins of the story to which it referred. The first version was rejected as too editorial. The artist deliberately made the second more graphic, using limited colour and energetic texture created by underpainting. Washes of colour over the white ground provide luminosity – white paint was excluded – counterpointed by areas of solid paint. Events are depicted from top left to right, the way pages are read. The colours were selected for symbolic and expressionistic values. Shapes and textures were designed to enhance the themes.

Obviously the work of confident, established illustrators has to be balanced with the freshness and vibrancy of new and untried talent. To find this talent it is vital that art departments see as many students and new illustrators as possible and go through their portfolios with them. Talking to the illustrators is as important as seeing their work to get a feel for their approach and how they might deal with a job. Magazines offer more opportunities to break into the field than any other medium. At the *Observer* we generally used the regular features (Wine, Travel and Sue Arnold) as testing grounds. Sue Arnold wrote a commentary every week on various (usually humorous) aspects of life. We would commission an illustrator to do a block of four illustrations so we'd be using twelve new people in a year. This gave a continuity to the look of the page and a means for the illustrator to produce a small series of related images.

The wine and travel illustrations were commissioned using a different artist every week which meant we could

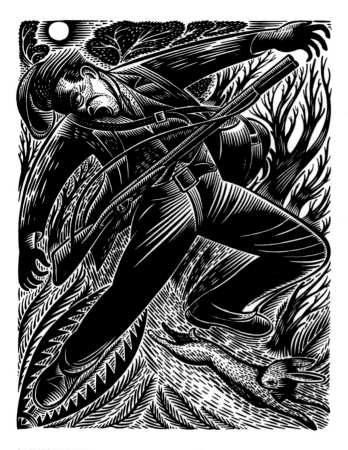

▲ CLIFF HARPER
**The Poacher**
The style and texture of this image suggest that it is a woodcut, but the artist learned to duplicate the effect of the print medium using pen and ink. This is a slow method by comparison, but the illustration achieves the immediacy and graphic impact of woodcuts.

use full colour, but generally their work ends up as "visual wallpaper". Happily there are exceptions like Chris Jones at *New Scientist,* which is still consistently strong after twelve years, and Adam Stinson. During his time at *Car Magazine* Stinson broke away from the prevailing trends of the competition. He introduced portrait and feature illustration in place of glossy photographs of cars, and did it with real style. It is never the subject that is the barrier to good illustration but the spirit in which it is handled.

Secondly, the most influential magazine of the 1980s, *The Face,* chose to have no illustration in it. Neville Brody's typography was deemed to be illustration enough, but this influence has meant that the obsession of post-*Face* magazine designers is typography, leading to problems for illustration. Over-designed magazine pages leave less room for the pictures to breathe. It often looks as though the art director either has no faith in the strength of the illustrations, printing type all over them, or feels it to be subservient to the design and type. As Simon Esterson of *Blueprint* magazine puts it: "I believe that the text and the illustration are integral, but I don't believe that they have to be *physically* integrated."

The other part of the current problem stems from visually illiterate editors. All too often art departments are expected to be able to read and comprehend the thrust of an article and therefore commission work that enhances the words as well as engaging the readers' critical faculties and interest. Yet from the other side, it's rare to find an editor who has any real sympathy towards, or indeed knowledge of, interesting illustration. Often editors are too cautious and distrustful of any new styles or approaches to illustration, and these attitudes are bound to affect the way an art department works. Good results can only come about where there is trust and empathy between the editor and art director. Magazines like *Radio Times* (under David Driver) or *Time Out* (under Pearce Marchbank) in the UK and *Esquire* (under Robert Priest) and *Rolling Stone* (with a succession of art directors) in the US used illustration boldly and innovatively, setting it in well-designed pages or covers. They showed the best contemporary work and a standard of excellence to which others aspired.

use a hundred illustrators in a year. On these pieces we would brief the illustrators very loosely and would generally encourage them to do whatever they wanted whether that meant painting huge oils or building 3D structures. They knew in advance that the reproduction size would probably be between one and two columns wide, and it was often a chance to see whether the work still stood up if it was three inches wide rather than three feet. If it didn't work too well, they'd know for next time. With these pieces we wanted to be surprised; we usually were, and I can't remember ever not using work commissioned in this way.

The major problem for illustration in this field today is the lack of adventurous commissioning. The first reason for this is that specialist subjects can be either impenetrable or visually unexciting. Such subjects need a dynamic art director who is willing to take risks but, more often, illustrations are used to prop up boring design. Illustrators are given full pages and the chance to

## MAGAZINE FEATURE

**CLIENT** *Frankfurter Allgemeine Magazine*

**ILLUSTRATOR** *Brad Holland*

**BRIEF** *Minimal. The paintings were all published in a single issue of the magazine. Brad was given no deadline. "They did call at one point to ask 'what kind of billiards?', and when would the paintings be ready. I told them pool halls and I didn't know."*

▼ **Ballistic Wonderworld**
"The research was hit and miss. I sketched a few details of pool tables, posed a couple of figures and invented the rest. For this painting I went to a billiard-supply showroom in my neighbourhood. I posed the woman but invented the man, positioning him in every conceivable place around the table. In spite of all the effort, I consider this a failed painting; there's a better one than this to be made from the elements."

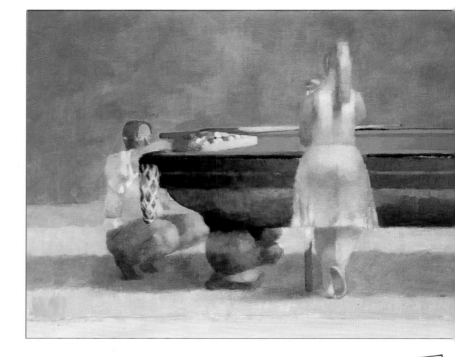

Brad says that the magazine simply called and asked him to do some paintings about billiards. That was all. Saying one word to him like that was, in his own words, "like giving scent to a bloodhound – I took it from there. I never really know where I am going. I usually start four or five pictures at a time. At first they are all different ideas, but after a while elements start jumping from one picture to another. Then for a while they all begin to look different again. Finally, when it begins to look like I'll never be finished, I just abandon them. Every once in a while a picture just comes out with no messing around, but it's usually an accident."

The art directors of the magazine makes no attempt to supervise Brad's work, and they see nothing until he has finished. This is an approach which is unlikely to be successful except in the case of a proven illustrator whose work the art director knows and admires, As Brad says, "It's unorthodox but it gives you latitude. I think it takes a great art director to know which people to leave alone."

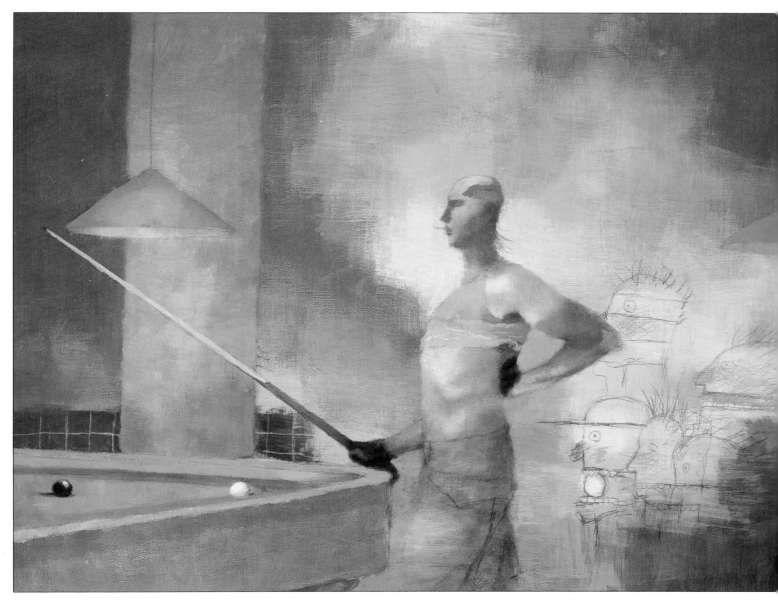

▲ **The Red Poolroom**
In this image, which Brad
calls "Voodoo Carom",
"The main figure was a
bicycle messenger I saw
on Houston Street, and I
drew him from memory.
The sunburn marks on his
arms were pure inven-
tion; in summer a lot of
New York kids roll up
their shirts to their
chests. The hidden
figures on the left came
from my sketchbook, and
the doodles on the right
just appeared for no
reason. Red was the only
colour I considered.

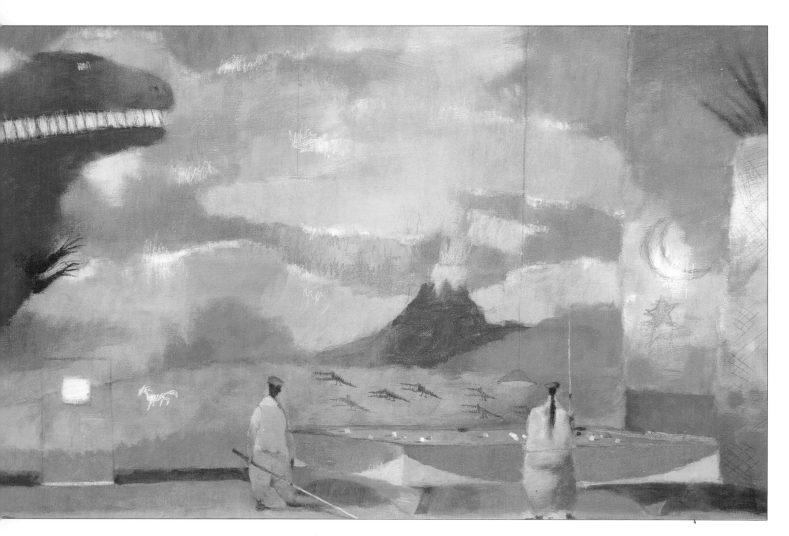

▲ **The Dinosaur Lounge**
This is one of the
paintings in which certain
elements seemed to take
on a life of their own and
drive out the others. Brad
says that "it started out as
a bunch of guys playing
pool beneath a ceiling
fan. The fan made me
think of a Puerto Rican
club I used to know,
which had a volcano and
a picture of Martin Luther
King painted on the wall.
So I put a volcano in my
picture and changed
Martin Luther King to
John F. Kennedy, but he
looked as though he was
having a bad time, so I
took him out and put in a
dinosaur."

84

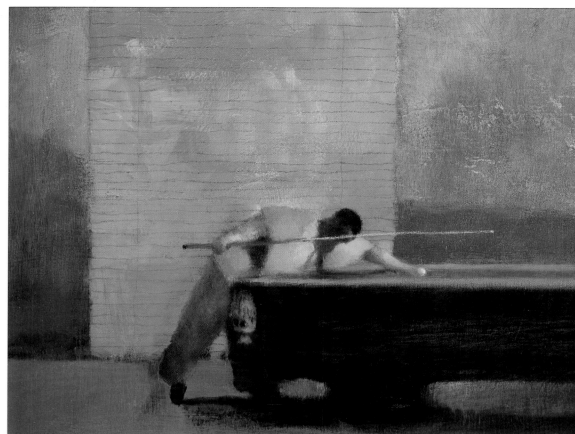

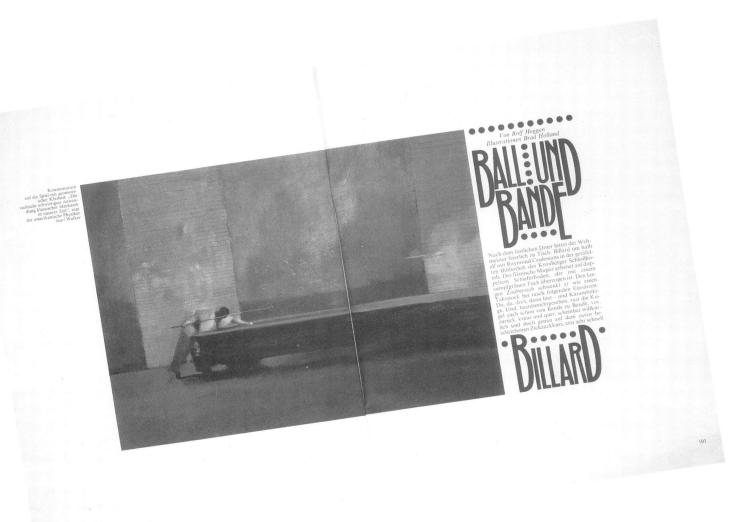

Von Rolf Heggen
Illustrationen Brad Holland

## BALL UND BANDE

Nach dem festlichen Diner bittet der Welt-meister feierlich zu Tisch: Billard um halb elf mit Raymond Ceulemans in der getäfel-ten Bibliothek des Kronberger Schloßho-tels. Der flämische Magier arbeitet auf dop-peltem Schieferboden, der mit einem sumpfgrünen Tuch überzogen ist. Den lan-gen Zauberstab schwenkt er wie einen Taktstock bei rasch folgenden Einsätzen: Da, da, dort, dann hier – und Karambola-ge. Und, hastdunichtgesehen, rast die Ku-gel auch schon von Bande zu Bande, vor, zurück, kreuz und quer, scheinbar willkür-lich und doch genau auf dem zuvor be-schriebenen Zickzackkurs, erst sehr schnell

## BILLARD

100

101

**◀ ▲ The Blue Poolroom**
This painting is "a final layer covering a mess of stratified other intentions. I painted figures in and out again until finally I was left with one. Colours came and went. I don't think I did any research. I never knew where I was going. Each step led to the next.

85

# Newspapers

A newspaper is almost a community. It provides a home for a variety of writers and artists, all of whom come together under its roof to combine their talents afresh every day. In the same way that the text breaks down to news, features, sport, humour and such specialized subjects as fashion or science, so artists and illustrators contribute an assortment of images to meet the needs of a product that must be renewed every day.

The day-to-day running of a design department on a newspaper is quite unlike that of a design department in any other form of publishing. Designs must be produced at the most one day ahead of publication and are very much geared to deadlines. The last page of the first edition to go to the printer is always the front page, the main news or "splash" page, and that goes down at about 9pm, though this differs between newspapers. There are second, third and extra editions at hourly intervals. The time at which design department staff leave depends on the news of the day. On a newspaper, news governs everything. If there is a big rail crash, for example, then journalists, photographers, designers and artists will still be around late into the night.

At morning editorial conference all the various news desks – Home, Foreign, Features, Books, Arts and so on – will have an idea of what the current news is likely to be from various news agencies who supply the same information to all the papers, and from television – though disasters are never predictable. The general form of the following day's newspaper is planned so that each department has an idea of what the others are proposing to cover. The departments are all quite separate and there is often rivalry between them. The overall structure of the paper is held together by the skills of the editor, who has a much broader view.

▼ MICHAEL FRITH
An illustration that is purely descriptive, or that reconstructs a particular element described in the text, helps to create the atmosphere of the story. The drawing is usually made from photographs or from the artist's own reference sketches. Michael Frith's original is drawn with ink line and wash in black and white. Bold brushwork and strong tonal contrasts provide graphic impact. The drawing can be quite accurately reproduced in the printed image, as current reproduction methods give a good range of tonal gradation to newspaper illustrations.

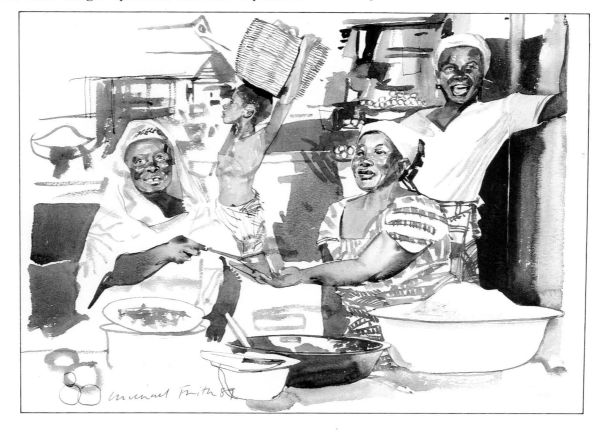

▶ HECTOR BREEZE
**Letters page cartoon**
*The Guardian (UK)*
A cartoon for the letters page of a newspaper, or attached to a feature article, is used primarily to lighten up the text and give the reader another point of entry into the editorial content. It is light relief that readily catches the eye. Typically, the editor of the letters page chooses the letter that will be illustrated and commissions the cartoonist on that basis, although if a contracted cartoonist happens to be in-house at the time, he or she may be able to comment on selecting the topic.

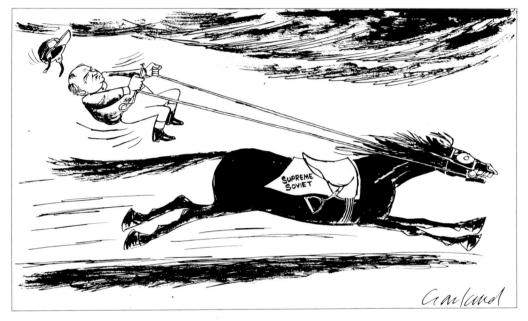

◀ NICHOLAS GARLAND
**Political cartoon**
*The Independent (UK)*
Political cartoons provide a system for conveying extreme points of view. They draw the political issues in black and white and can make startling commentary with great economy of means. The artist may use great subtlety in conceiving and drafting the image, but the visual message that confronts the reader must strike home immediately. This is a method of direct communication in which people become symbols, and are represented in symbolic situations. The cartoonist may also use words quite simply and directly, incorporated within the image.

At morning conference the main news item will be discussed – say, a major terrorist attack. Someone, not necessarily the art editor, suggests that there be a map. How many people have been killed? Where did it happen? Where did the terrorists come from? Is a modern day blitzkrieg happening? Why can't we do a map like one of those war diagrams with black arrows? So the ideas flow. Sometimes there may be no discussion of graphics at all, although simple graphics are useful for many events: for example, in an election or to show the movement of money in the city.

Some newspapers have an in-house team of designers and illustrators, and work on the latest computers. There may be a rota system in operation. Theoretically some people come early in the morning and some stay late but shifts tend to overlap. It is rather like working in a football team in full flight, you are never quite sure to whom the ball is being passed. All that is certain is that someone is going to produce a diagram and they must be free to concentrate on that task.

**Types of illustration**
On newspapers the illustrations may be divided roughly into four main areas: cartoons, infographics (information graphics), conceptual illustrations and reportage.

Up until recently, newspaper illustrations have principally been in black and white, but colour is being used more and more. In the United States, *USA Today*, for instance, all the diagrams are in colour.

**Cartoons**
These are a major part of illustration on newspapers and a paper may use four or more cartoonists in any one issue – political, sport, business and pocket cartoonists.

The political cartoonist is an important person. He or she occupies a prime position in the paper and is rarely competing with more than one photograph on a page. They do not necessarily have to follow the political stance of the newspaper. He or she can be quite independent, expressing a personal veiwpoint. Political cartoonists are usually associated with one paper and will probably have

a contract for two or three years, or even longer. They will be commissioned to provide a set number of cartoons per week. They have to be very news-orientated, listening to the morning news and ploughing through a stack of newspapers before they begin. Their talent is less in the standard of their draughtsmanship than in the quality of their ideas. They are attempting to get across a very simple concept that will be understood immediately. It is not unlike ancient wall paintings in churches or caves, the biggest figure has the most importance, and the artist will often write on the drawings to help clarify the idea for the reader. If the draughtsmanship is too subtle or confused, it will miss the point, so cartoonists tend to find that they have to go to extremes in terms of political message to give the drawing real impact.

Other cartoonists serve a slightly different function to the political one. Giles in the *Daily Express* and Jak in the *Evening Standard*, for example, are not just getting across a funny idea but making a comment on modern-day society.

Another category of cartoons is the profile portraits, a very specialized market of illustration. David Levine's work for the *New York Review of Books* has imitators all over the world. His is a very distinct, though 19th century, style draughtsmanship, using cross-hatching and solid blacks very effectively. Because of the high-speed print runs, simple black and white illustration is still the most effective for newspapers.

On strip cartoons, often an artist and writer will get together and sell an idea to a newspaper. (Peanuts, for example, or Alex in *The Independent*, plus many others.) Strip cartoons form a whole sub-culture of newspaper/comic illustration, frequently syndicated, and often with a worldwide following. Their creators always work freelance. If a strip catches on, many artists may work on it over the years and adapt their style to match the original concept

Pocket cartoons probably started off as space-fillers when the text ran short. They are usually one column wide and a few centimetres deep and are used to lighten up the page. Journalists and designers are very conscious – especially on broadsheet papers – of having a whole mass of grey text on the page and of the need to find ways to interest the reader by giving them windows or doorways into stories. Traditionally each story has a headline, a standfirst (introduction to the text) and then the rest of the story, but the small breaks, like cartoons, may give a very useful lead into a story.

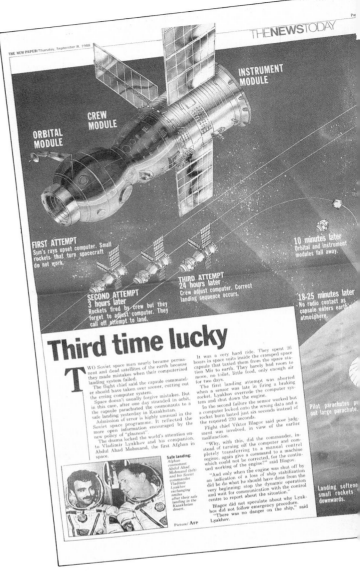

▲ PETER SULLIVAN
**Infographic**
*The New Paper, Singapore*
Computer-drawn colour graphics are a particularly important element of presentation in *The New Paper*, as several languages are spoken in the community of Singapore. To sidestep the language problem, graphic information must be delivered with impact and clarity. In setting up the colour graphics department of *The New Paper*, Peter Sullivan faced the task of adapting local artists' skills to the new technologies of computer design, at the same time introducing the detailed concept of information graphics as it has been developed in the Western media over recent years. In this illustration, the graphics are required to convey the series of procedures involved in the flight of the space module and the parachute landing of the space capsule. The atmospheric background, with a distant view of the Earth's surface, conveys the enormous scale of an operation in space. The illustration encapsulates a lot of information in ways that a photograph cannot.

► JOHN GRIMWADE
**Infographic**
*The Times (UK)*

A map is the quickest way of locating the reader within the news story and can also be treated as a site for different kinds of information. This simple line map relates the total area of Afghanistan to the countries bordering it and also shows the disposition of warring factions within its borders. The information is more specifically developed in the flag and panel below the map.

◄ JOHN GRIMWADE
**Infographic**
*The Times (UK)*

Technological information can be difficult to absorb simply by reading a text. A graphic presentation can isolate the essentials and explain the links quite clearly and simply, at the same time producing a single dynamic image that draws the reader into the feature as a whole.

## Infographics

This category of illustration has been around since newspapers began, but has become much more widely used over the last 10 or 15 years. Infographics are a mixture of illustration and graphic design. They consist of drawings that explain how an event happened and its likely cause – for example, a plane crash in a remote part of the world that is inaccessible to photographers. The journalists can phone the information in, but a visual image is needed to back it up. These kinds of events, usually covered by an in-house team, are a relatively modern phenomenon.

Before photography became common, news illustrations were always provided by artists. *The Illustrated London News,* the first pictorial newspaper, made great use of artists and engravers, as indeed did all papers at the turn of the century, only to be replaced by photography. But photographs, on the whole, do not analyse and this has been the great strength of infographics. It is only in the last 15 or 20 years that analytical illustrations centring on the text have become as popular as they are today.

Harold Evans, when he was editor of the *Sunday Times,* was one of the prime movers in Britain of this kind of back-up to the journalists. The artist who is best suited to this kind of work is an artist-cum-writer, someone who thinks not merely in terms of illustration, but in terms of information. Included in infographic illustration are maps, business charts and graphs, so a technical training is often very useful. Artists such as Peter Sullivan, whose basic training was as a technical illustrator, have pushed information graphics to exciting heights.

Computers have made a huge difference to the ease of production of infographics. Much of the work is now done on the computer, including drawing, which admittedly is not always of high quality. Once on the machine, almost anything is possible: the image can be enlarged or reduced, or the size of the figures altered in relation to each other and coloured. The real use of these machines is that all work is filed on them and so updating becomes simple – a map may be taken out of the storage system and the changes made on screen.

## Conceptual illustration

The third branch of illustration is much closer to straight illustration and is used principally to illustrate feature articles. Maybe a feature has been written on "AIDS in Society", ranging across the whole spectrum of causes, effects, history and how societies are affected by the disease at present and possibly in the future, and an illustration is needed that will illuminate the concept behind the article. It need not be narrative but it must focus and hold the attention, giving the flavour of the article rather than conveying precise information.

## Reportage

Court work is one area where illustration is useful since, in Britain, you cannot send cameras into court, nor are artists allowed to sketch inside the room. So someone with a good visual memory is sent in to make mental notes and bring back some kind of drawing. On big murder trials the details of the case may be fascinating enough to hold the reader's attention, but a drawing of the defendant can help to give atmosphere. Other uses of reportage could be a reconstruction of a riot, a kidnap or a siege, or a hijack where, while both cameras and television may be present, the images coming back are indistinct and lacking in detail, a gap that a good reportage illustrator can fill. Figure artists with a sketchy style are generally best for reportage. The drawing usually does not need to be too precise, as the requirement is to create an atmosphere rather than to convey information which will be carried in the text.

## The scope for illustration

A paper is not treasured in the same way that a book is, but for an illustrator it is still a very good way to have

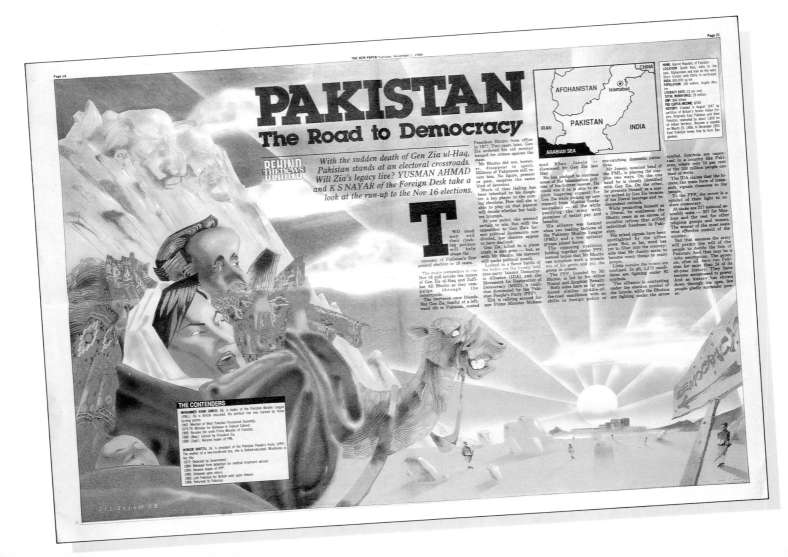

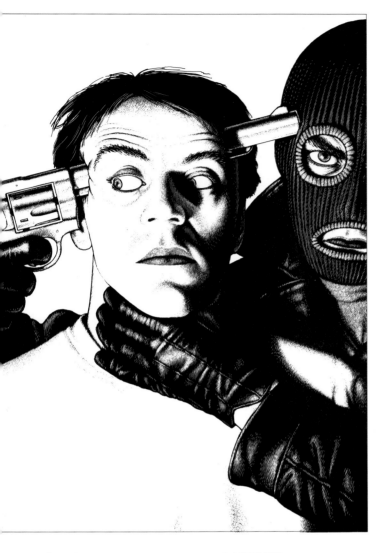

◀ CEL GULAPA
**Feature illustration**
*The New Paper, Singapore*
The technology of computer
illustration readily incorporates
both infographics and conceptual
illustration. Through a stylized
rendering, this image sets up a
sense of place and atmosphere
that gives the background to the
story. The simple graphic map
dropped in beside the headline
deals with the basic geography of
the story's subject. An illustration
taken right across the spread in
this way immediately claims the
reader's attention, leading him or
her into the editorial printed over
the colour. Important statistics and
factual details are flashed up in
the black and white panels at
bottom left and top right.

▲ MIRCO ILIC
**Terror has its own itinerary**
*Los Angeles Times*
Conceptual illustration can sum up
the editorial point of a story
without being too specific about
the journalistic facts. In this
illustration from the Los Angeles
Times, the sense of violence is
brought starkly into focus by the
gun passing right through the
victim's head. This obviously
surreal element of the image
serves to emphasize the horrific
reality. The drama is further
underlined by the style and
composition of the drawing -
powerful black and white
contrasts, with the figures harshly
lit from one side, and discordant
details such as the mouth and eye
pieces of the attacker's ribbed
mask.

your work seen by thousands of people. I see a lot of
illustrators who bring their portfolios to me, and a lot of
work is sent in speculatively. I try to hang on to the better
artists and put them under some sort of contract – or at
least keep them on file. For any gaps that appear in the
pages from time to time, I try out new people. With
young artists the main problem is lack of technical ability,
in the sense that they are not yet able to draw very well –
students don't leave art school able to draw excellently
and experience is difficult to gain quickly. For
newspapers an illustrator needs a strong style, graphic
qualities and instant appeal. So I look for good black and
white work in a portfolio – woodcuts and lino cuts for
example – which reproduce very well in newsprint. The
revival of lino and woodcutting has given newspaper
illustration much more variety and punch, and their
inclusion on the Arts and Feature pages helps to keep
the layouts lively.

The nature of the daily cycle of a newspaper with its
inevitable deadlines is a powerful influence on the
illustrations that finally appear on the streets. An art
editor has to react immediately and think quickly about
the style of the illustration and the likely artist, then
begin to phone around. If I phone at 4pm I shall want the
image by 10am the following morning. Deadlines like
these are very difficult for young illustrators to handle,
and many of those who are sufficiently experienced are
probably already busy on something else. Once an
illustrator has been found it is important that they are
briefed properly about the story. Frequently the event is
still in progress at the time of the briefing, and the words
and picture will not come together until the next day. You
just have to trust that they will mesh. There is very little
time for second thoughts by either the art editor or the
illustrator. The ability to respond instantly and work fast
is paramount.

Illustrators straight from art school would probably be
best advised to approach magazines first – they pay
better. However there is an exciting and glamorous
atmosphere about working in newspapers and, if the
drawing is handed in one night, it is especially rewarding
to be able to see it the next day in print

# DESSERTS

The dessert is as important as any other element in a Cuisine Vivante meal. If the rest of the meal has been well balanced the thought of a dessert will not be daunting. 'Dessert' is not a synonym for very rich, sweet cakes, pastries, creams and such-like creations but can, and should, be light, airy, refreshing and palate-cleansing. Desserts need present the cook with few problems since the majority can be largely prepared in advance. Any decorations that need to be added at the last minute can be completed in the pause that is usually welcome between the main or cheese course and the dessert.

# FISH AND SHELLFISH

Fish and shellfish feature strongly in Cuisine Vivante recipes, and for obvious reasons. Largely delicate creatures they demand a great deal of precision and careful judgement when cooking if the most is to be made of their subtle flesh and absolute freshness. The abundant variety of flavours, textures and styles provides immense scope for innovative sauce combinations that exentuate the nuances and subtleties of the flesh, be it sole, scallops, turbot or lobster.

# BOOKS

Every year thousands of new books are launched into the market place, and more and more of them are illustrated, from children's information books to adult strip cartoons, from step-by-step books on how to knit, sew or cook to delicately decorated diaries.

The scope for the illustrator is endless, and changeable, as new publishing companies burst upon the scene and some of the old ones wither and die. To be successful an illustrator has to find a niche amongst all this variety. Having done so successfully, word of mouth will often then play a large part in securing more work. Although contacts in this particular world make an important contribution to your eventual success, it is the strength of your portfolio that will be the real determining factor.

◀ LYNNE RIDING
**Cookery book illustrations**
These pastel illustrations formed the chapter openers for *Cuisine Vivante*. Lynne Riding's sensitive use of the pastel medium successfully relieves the conventional photography used in the rest of the book. The dynamic composition and the overhead viewpoint were specified in the art director's brief.

# Book jackets

In addition to providing physical protection, the cover of a book has a very specific function – to gain the attention of the potential purchaser as a key step towards their buying it. It is interesting to reflect on the fact that, once it has served this purpose, the average book is sandwiched on someone's bookshelf, and the cover, once so important, is concealed from sight and seldom seen again. This is virtually the opposite of any illustrations within the text, which come into their own after purchase.

So what factors must the illustrator take into account when faced with the challenge of designing a book jacket? Obviously the specific considerations are as varied as the individual books, but the common factors are: the ability to draw the attention, relevance to the subject and a distinctive style.

The average bookshop or bookstall of today is a crowded mass of titles and the task of attracting attention to any particular title seems daunting. Anyone who has bought a book on an impulse, for example from a station bookstall before a journey, will have some awareness of the devices employed by publishers and illustrators to attract attention. The human element – faces, bodies, situations – never ceases to draw our curiosity, and we are accustomed to making evaluations and identifying social "typecasting" at a glance.

Bob Geldof's best-selling paperback *Is that it?* features a photograph of his face on the cover, in the certain knowledge that television will have exposed the image sufficiently for us to recognize it. In this instance, in the broadest sense, the photographer acts as illustrator – an originator of a pictorial statement.

Germaine Greer's *The Female Eunuch* adopts a different approach. Here the illustrator has produced a

EDUARDO GALEANO
FACES AND MASKS

EDUARDO GALEANO FACES AND MASKS

VIVID AND INSPIRED, *Faces and Masks* is a unique fictional account of Latin America, of a New World in the making. Here are the voices of Simón Bolívar and Benito Juarez, Abraham Lincoln and Teddy Roosevelt, echoes of an Inca defeat at Cuzco and the fall of Davey Crockett at El Alamo, piracy in the Sierra Nevada and the pioneering gold prospectors of California. Here is a pageant of cowboys and gauchos, Coca-Cola and blue jeans, Buffalo Bill and Sitting Bull, soccer and the tango, rubber, tin, gold, and all those who lusted for control of the raw materials and the lives the New World had to offer. Eduardo Galeano's spicy blend of fiction, character and political irony brings to life the Americas of the eighteenth and nineteenth centuries with breathtaking imaginative power.

*Faces and Masks* is the second volume in Eduardo Galeano's trilogy, *Memory of Fire*, and continues the epic and moving history of the Americas that was begun in *Genesis*.

"Galeano is an exceptional literary artist. He writes with the intellectual translucency of Octavio Paz, the emotional clarity of the early Carlos Fuentes and the sweeping visual acuity of Diego Rivera... this reviewer awaits the third volume of *Memory of Fire* with rapt anticipation"
*San Francisco Examiner*

"An epic work of literary creation"
*Washington Post*

ISBN 0-7493-9000-X

Illustration:
Miles Aldridge

A MINERVA
PAPERBACK
FICTION
£4.99

9 780749 390006

MINERVA

---

**◀ CHRIS CORR**
**The Joy Luck Club**
This design involved close collaboration between the illustrator and the book's author Amy Tan, who contributed a personal letter that forms part of the large collage. Chris Corr hand-painted patterns on coloured tissue, with dyes and paints. These were combined with paper ephemera gathered during a visit to China – a fan, paper money and other items made for ritual use in Chinese festivals.

truly arresting and memorable image. A female torso hangs like a discarded garment in a wardrobe, as though the outward symbols of gender could be chosen as one would a dress or shirt. The intrigue of the image matches the content: provocative and sharply focused on universal issues, yet not "giving away" the book's message.

In the *Haynes Car Manual* series, the purpose of each cover is identification rather than attention-seeking, the purchaser having already established a need for the information. But here the identification goes beyond the recognition of a particular car: a cut-away diagram also identifies the nature of the contents – the inner workings of the vehicle. Nobody uses the cover for technical information, but it clearly reveals its purpose.

The paperback cover that titillates, seeming to promise endless encounters of the flesh, or the covers of thrillers that depict hand-weapons, are familiar to most of us. There is an interchangeability about these covers as though there was a bank of such images merely waiting for the series to be written, as indeed is sometimes the case. These covers not only tell us what to expect from

**▲ MILES ALDRIDGE**
**Faces and Masks**
The book's content covers the vast span of the whole history of South America and its peoples, so the art director and illustrator quickly decided that the jacket design should focus on a single representative image. Taking its subject from the title, the illustration closes in on an isolated, mask-like face. The image folds right around the book, with the face solidly fitted into the rectangle of the front cover, and the back of the head occupying the back of the book. Brushed acrylic paint on board supplies loose texture to the simple colour blocks.

95

the books but are also appropriate for their intended market – one that does not seek individuality. Two other areas of fiction – horror stories and science fiction – offer a more creative challenge to the cover illustrator, but here, too, the approach is usually presented by stereotypes derived from the cinema or television.

The "serious" non-fiction paperback of today, dealing perhaps with scientific, technological or social matters in an accessible form, presents the publisher and illustrator with many opportunities for imaginative approaches. Here

perhaps relevance is at least as important as attention-drawing qualities, the buyer probably already being involved with that particular subject. Examples range from a Mel Calman cartoon for a book on retirement to a multi-coloured enlargement of a piece of musical score for the *Concise Oxford Dictionary of Music*, from a print by Paolozzi for a treatise on organized knowledge to many covers that do without illustrations at all, relying purely on typography.

The other element – being distinctive – is perhaps the most difficult to identify and define. It is really a question of working with an open mind, clearly defining the need for the illustration and answering it without compromise. In the world of publishing and art direction, most illustration is commissioned under pressure. Key dates and budgets tend to play a crucial role, but it is still the illustrator's responsibility to meet the needs of the job with as much integrity as possible.

To find a new and yet distinguished way of presenting a classic subject is not easy - Paul Hogarth manages it with panache in his covers for Shakespeare's plays. The fresh and potent images attract attention, and are both appropriate and true to the illustrator's established approach.

It should not be forgotten that words as well as pictures are inherently part of book covers - indeed, they are indispensible and ideally all covers should ensure that words and pictures are conceived as an integrated design. Although the illustrator may not always have direct control over the typography, the more the two elements are thought of as complementary to each other, the more likely it is that the cover will succeed in its purpose.

◀ KEN COX
**The Diary of a Nobody**
Ken Cox's jacket illustration for the modern Penguin edition of *The Diary of a Nobody* is both amusing and visually striking. The quirkiness of the drawing is used to excellent effect in portraying the character of Mr Pooter and his suburban Victorian home.

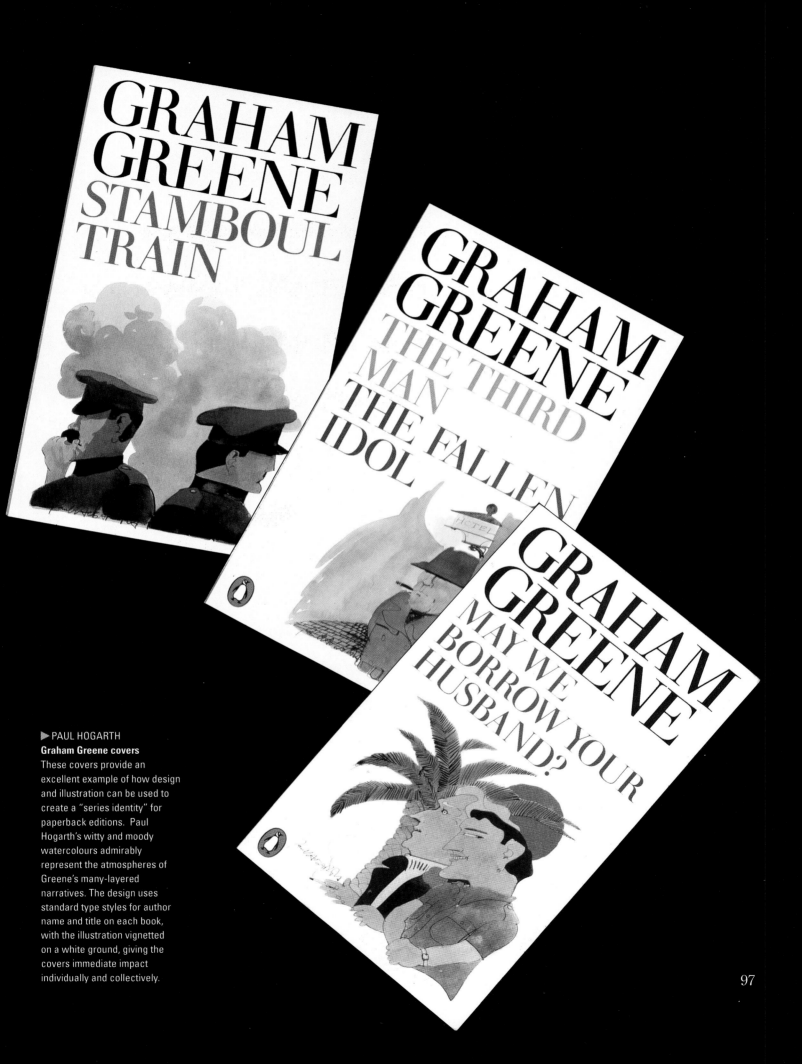

▶ PAUL HOGARTH
**Graham Greene covers**
These covers provide an excellent example of how design and illustration can be used to create a "series identity" for paperback editions. Paul Hogarth's witty and moody watercolours admirably represent the atmospheres of Greene's many-layered narratives. The design uses standard type styles for author name and title on each book, with the illustration vignetted on a white ground, giving the covers immediate impact individually and collectively.

# Narrative illustration

Illustrations that tell a story - usually fiction - can perhaps be grouped in two main categories: those that support or punctuate an existing text and those that are an integral part of the story, in which the words can sometimes adopt a secondary role.

There is a long tradition of stories in which the illustrations have become so famous that it is difficult to imagine them without the pictures coming into mind. Tenniel's illustrations for *Alice in Wonderland* and those of the classics of Beatrix Potter are good examples. Here it can truly be said that the stories come to life because of the pictures. Nevertheless it is still possible to detach the pictures and leave the stories intact, albeit impoverished.

◀▲ WEEDON GROSSMITH
**The Diary of a Nobody**
The pen and ink drawings produced by Weedon Grossmith as decoration for the original edition of *The Diary of a Nobody* (1892) are economical and witty. His drawing style tends to even line and straight hatching. The domestic calamities of the Pooter household described in the book, written by Weedon and his brother George Grossmith, are punctuated occasionally by Weedon's simple illustrations. It is unfortunate that few of the drawings in that edition are located on the same page or a facing page to the text to which they refer.

▶ALAN ALDRIDGE
AND HARRY WILLOCK
**The Butterfly Ball**
There are 28 beautifully airbrushed illustrations in this classic 1970s picture book. They are distinguished not only by the sheer invention of the animal characters and the minute attention to every detail, but also by the technical brilliance of the airbrushing.

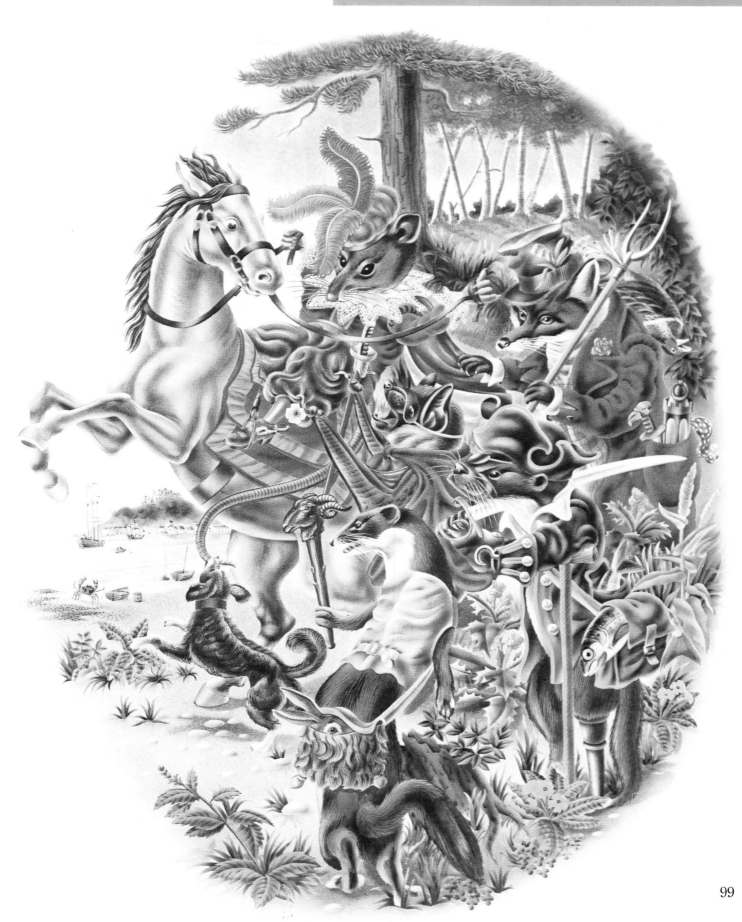

▶ ANDREW DAVIDSON
**The Sea Horse**
In this illustration from Ted Hughes' *The Tales of the Early World*, wood engraving provides a strong black and white image. Andrew Davidson enjoys the craftsmanship demanded by the technical processes of printmaking.

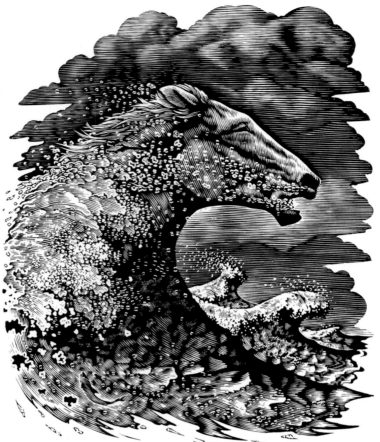

▼ MERVYN PEAKE
**Alice's Adventures in Wonderland and Through the Looking Glass**
Peake's ink drawings illustrating the classic children's fantasy are in all respects very different from those of the original illustrator, Sir John Tenniel, which had established precise images of Alice and her strange acquaintances. Peake followed his own idea of characterization, producing delicately textured, evocative portraits of the inhabitants of the looking-glass world.

The classic works of fiction have from time to time tempted publishers to commission an illustrator, but the exercise can be a precarious one. The prerogative of the readers to form their own idea of the appearance of the key characters is lost. The faithfulness of depicted detail to literal description is also sacrosanct, and can create pitfalls for the unwary illustrator. The reconstruction of a previous era can also be fraught with difficulty and requires careful research. Anthony Gross's illustrations for Galsworthy's Forsyte Saga manage to overcome these problems by using a fresh personal approach that avoids being too specific, yet is strongly evocative.

A few publishers, such as the Folio Society, have established a successful tradition of inspired and adventurous commissioning of narrative illustration by leading artists and illustrators. Examples include Edward Bawden's lithographs for *Gulliver's Travels* and Joan Hassall's engravings for *Pride and Prejudice*. However, many fiction classics remain to this day as words in their own right with few attempts to illustrate them beyond a picture on the book jacket.

Contemporary illustrators of traditional or classical fiction are faced with two questions – firstly, has the work been illustrated previously with sufficient distinction for the illustration to have become indirectly linked with the text? Secondly, does the work possess strong visual descriptive qualities that give readers the satisfaction of visualizing the scenes themselves, without the intervention of an illustrator?

The illustrated book or "picture book" is a field dominated by children's books (discussed on page 112) but as a vehicle for humour and entertainment it also has a place on adult bookshelves. From Thurber and Steinberg to Steadman and Pollock, illustrators have been putting forward their particular viewpoint and vision. The illustrator of narrative books is, therefore, contributing to a living tradition. He or she must have an acute understanding of a text in order to complement it without competing. The original meaning of the word illustrate is "to throw light upon". With this in mind, there are many possibilities in a great variety of texts, from poems to short stories, from novels to plays, and from satire to fable for the inventive illustrator.

▶ MAGGIE SILVER
**The Black Rat (The Plague)**
In illustrating an educational text on the plague, the artist's problem was to devise a realistic scale that would enable her to show both the rat and the plague-carrying flea in detail. She solved this by placing the flea under a magnifying glass. The shading was built up with watercolour washes over which details of form and texture were elaborated.

# Decoration

Illustration as decoration is a function that goes back at least as far as the medieval manuscript. The main purpose of such illustration could be described as visual punctuation.

In the days before colour printing, a wood engraver was frequently employed to create chapter headings, tailpieces, vignettes for title pages, and so on. The nature of wood engraving is that of an intimate craft, and its scale makes it a natural complement to type. It reached its zenith in the delicate and atmospheric illustrations of Thomas Bewick in the 18th century, but the tradition has lasted and is exemplified today in the work of illustrators like Joan Hassall and David Gentleman. Much of this work goes beyond decoration, being full of observation and incident, but it is always subservient to the text. There has recently been a revival of this type of illustration, which can now be seen regularly in magazines and advertising.

Decorative illustration in books can take other forms. For example, many cookery books contain visual material that is not there for functional reference but is used instead to create the appropriate identity and mood for the recipes.

Many cookbooks contain both photography and drawn illustration and the value of illustration is to single out visual information and to decorate the text in a way that is not possible with photography. *The Shorter Mrs Beeton*, a republication of the famous 19th-century cook's *Book of Household Management,* uses the original engavings alongside lush colour photography in a successful combination.

Poetry also lends itself admirably to pictorial accompaniment but this aspect has not been fully exploited. Walter de la Mare's "Peacock Pie", with line drawings by Edward Ardizzone and *The Oxford Nursery Rhyme Book* with engravings by Joan Hassall, are among the rather rare examples.

The illuminated manuscript, or typescript, now seems poised for revival, with today's technology and the emergence of desktop publishing; repeated pictorial and symbolic imagery can be woven into the scheme to create new possibilities for balancing word and image. It is perhaps paradoxical that the new freedom created by the release from metal and ink impressions has not yet been accompanied by a renaissance in the decoration of the page.

Every book illustrator, particularly when tackling decorative illustration, must have a good eye for "totalities" – for unity, balance and contrast. The illustration should never intrude or impair legibility. The aspiring illustrator can rehearse his or her abilities by taking a favourite text or poem, designing a feasible page format and punctuating the words with headings, tailpieces, borders and vignettes, for example.

◀ GLYNN BOYD HARTE
**Edible Gifts**
This evocative coloured pencil drawing creates just the right mood for an unusual recipe book. The delicate pink of the Turkish Delight is complemented by the strong, almost flat colouring of the green container. Gold coloured pencil was used for the ornament and lettering on the container lid. This reproduces only as an approximate colour, due to the limitations of four-colour printing.

▶LESLIE FORBES
**A Table in Tuscany**
This is a charming use of decorative illustration, recreating the effect of a handwritten notebook recording the culinary delights of Tuscany. A simple border surrounding the handwritten text provides the opportunity for the delicate colour drawings to be placed almost randomly, breaking the border frame and cutting into the lines of text. The page has an open feel, the delicious morsels of food providing a tempting way into the text.

▶ **Medieval English manuscript**
As William Morris knew well, the book illustrator has much to learn from illuminated manuscripts and early printed books. Here the exquisite decorative border, although finely delineated and full of intriguing detail, allows plenty of breathing space for the text. The styles of calligraphy and illumination are married in perfect harmony.

# Comic books and cartoons

Under this heading comes a relatively recent development – the adult strip cartoon. We are conditioned to think of the strip cartoon as containing material of little consequence, intended primarily for younger readers with limited reading skills. Nowadays, adult humour in picture book form can be enjoyed by delving into *File Under Biff* with its acute social comment, or Simon Bond's wildly irreverent *Queen's Closet*. Many of Raymond Briggs' picture books achieve their serious purpose using humour and pictures

– his stories of Wally and Gentleman Jim are full of pathos, while *The Hon Lady and the Tin Pot General* is direct political satire. Briggs makes no distinction between child and adult in his methods and one suspects that *Fungus the Bogeyman* (see page 118) has caused at least as many adult chuckles as juvenile chortles.

Humour and mild anarchy can also give birth to very different modes of illustration. Thurber's illustrations for his book on dogs depend scarcely at all on draughtsmanship to tell their tale, prompting questions such as "could Thurber draw?" The answer must be "yes", in that the intentions are conveyed with perfect aptness and clarity rather than a display of skill. As with Lear's *Book of Nonsense* the drawing is a direct extension of the mind (and Lear proved when necessary to be a draughtsman of considerable mastery).

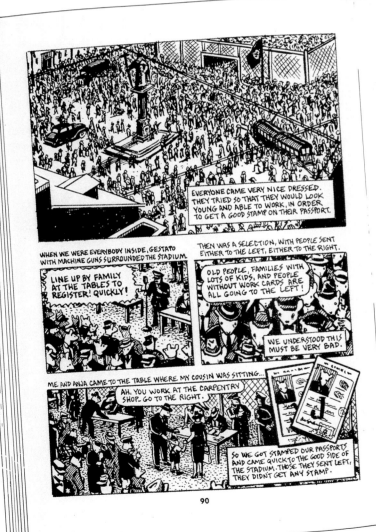

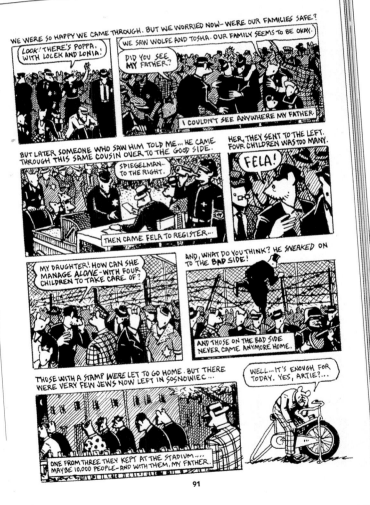

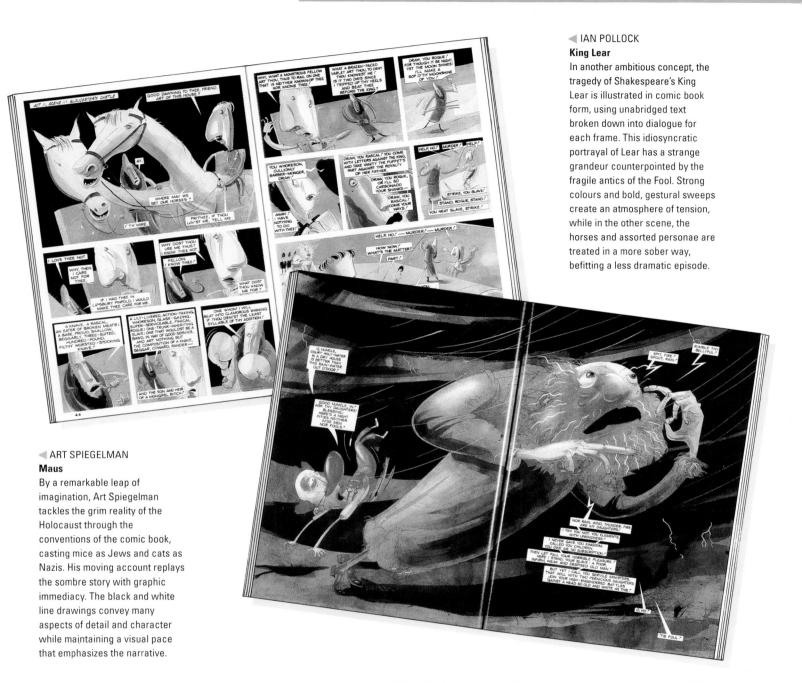

◀ IAN POLLOCK
**King Lear**
In another ambitious concept, the tragedy of Shakespeare's King Lear is illustrated in comic book form, using unabridged text broken down into dialogue for each frame. This idiosyncratic portrayal of Lear has a strange grandeur counterpointed by the fragile antics of the Fool. Strong colours and bold, gestural sweeps create an atmosphere of tension, while in the other scene, the horses and assorted personae are treated in a more sober way, befitting a less dramatic episode.

◀ ART SPIEGELMAN
**Maus**
By a remarkable leap of imagination, Art Spiegelman tackles the grim reality of the Holocaust through the conventions of the comic book, casting mice as Jews and cats as Nazis. His moving account replays the sombre story with graphic immediacy. The black and white line drawings convey many aspects of detail and character while maintaining a visual pace that emphasizes the narrative.

## Comic books

Comic books are much more successful in some countries than others. In France, for example, there are comic books on everything from Napoleon to nature. In America and the UK there are relatively few well-known books of this type. Perhaps the two most internationally successional series are Asterix and Tintin. Both have a cult following in many countries.

Two recent, notable comic books are Oval Project's Shakespeare series and Art Spiegelman's *Maus*. Both show how the comic book format enables a powerful narrative to move with a visual as well as a literary pace.

The Shakespeare series was a stunning attempt to illustrate several of Shakespeare's plays using a comic book format. The text is unabridged, but broken down into typical comic strip frames. Ian Pollock's idiosycratic and strongly coloured illustrations for *King Lear* are a powerful interpretation of Shakespeare's characters.

Art Spiegelman's *Maus* is a moving graphic account of the Holocaust, with mice as Jews and cats as Nazis. Spiegelman's stark black and white line drawings tell the story with a visual pace that complements and emphasizes his narrative.

# Novelty books

Novelty books are an important element of modern publishing. The range of contemporary novelties is quite astonishing, with everything from books with electronic chips that play music as the pages are opened to complex pop-ups such as Jan Pienkowski's hugely successful *Robot*.

The first novelty books were produced in London in the 1760s by Robert Sayer. These were ingenious "turn-up" books that later became known as Harlequinades after the pantomime characters featured in some of them.

Books with moving parts, that later developed into pop-ups, originated in the 1850s, many being produced by Dean's of London. German publishers, too, were very inventive. Lothar Maggendorfer's work was famous throughout Europe until the decline of mechanical books with the onset of World War I.

Today, the scope for commissions to illustrate pop-ups and other novelty books is quite limited as relatively few of these books are produced. Usually a paper engineer will work directly on a project of this kind with the designer and illustrator. The concept for the book has to be tested by producing a working dummy before the illustrations are begun.

The cost of producing novelties is very high, as a lot of hand-work is involved in assembling the various components. Most novelties are assembled in countries where labour costs are low, particularly South America and South-East Asia.

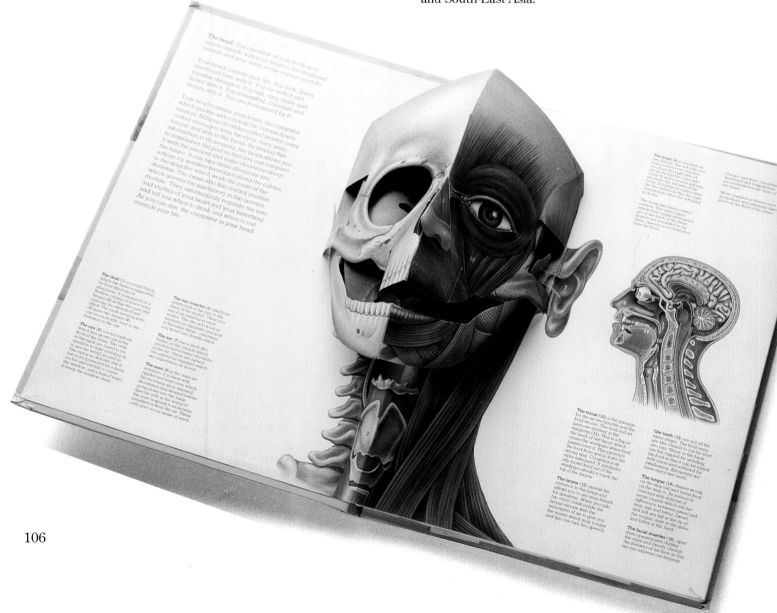

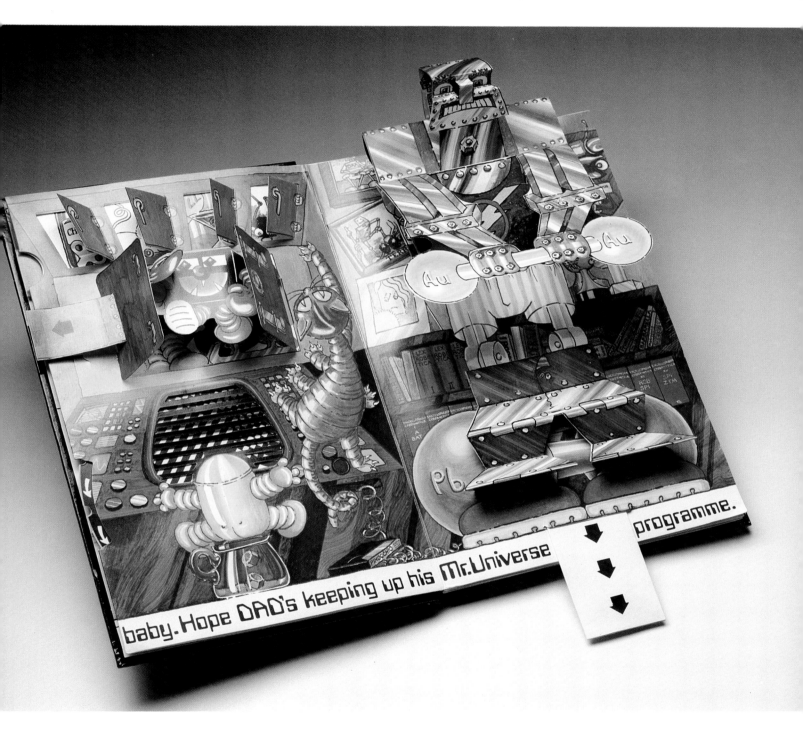

◀ DAVID PELHAM AND
HARRY WILLOCK
**The Human Body**
The human body pop-up pictures
are used to demonstrate physical
functions. Each spread is devoted
to one major part of the body,
which is reproduced by David
Pelham's ingenious designs for
the paper engineering.
Throughout the project, Pelham
worked closely with author
Jonathan Miller and illustrator
Harry Willock. Airbrush
techniques were used extensively
to give the illustrations convincing
colours and textures. The three-
dimensional tabs and pictures are
cleverly designed to show how
parts of the body move, while
different layers are revealed
through cutaway sections.

▲ JAN PIENKOWSKI
**Robot**
This is probably one of the best,
certainly one of the most
eccentric examples of paper
engineering in recent years.
Pienkowski's vivid, imaginative
illustrations are brought to life by
the superb and complex paper
engineering of James Diaz. The
story is almost entirely visual, told
through double-page spread pop-
ups, with the minimum of text.
Among the ingenious devices
used are wheels, tabs, a mirror,
and even a hand wielding a cloth
duster. A magnificent rocket takes
off from the gutter of the final
spread.

107

# Adult non-fiction

Many adult information books are illustrated, particularly "how-to" books on subjects such as DIY, cookery and gardening. The illustrations in these titles are often one of three types: decorations to enliven and beautify the page, such as *Glynn Boyd Harte's* drawings in Edible Gifts (Bodley Head); inspirational drawings to encourage the reader to do something; and instructional drawings, often in the form of step-by-steps, that break the information down into sections.

Illustrators often work alongside several other artists on large-format adult illustrated titles because of the sheer volume of work that is commissioned in a short space of time. Art directors will often split the work so that drawings of one kind, such as step-by-steps, are handled by one artist, or a group of artists with similar styles, and others, such as inspirational drawings, are produced by artists with contrasting styles.

Some of the most successful step-by-step work is produced by artists with a real understanding of what they are illustrating. Although photographic references are often supplied, convincing-looking drawings are often those where the artist has understood the mechanical content. David Day's drawings in the *Collins Complete DIY Manual* are an excellent example of this kind of work.

## Instructional illustration

The special characteristics of illustration as a selective medium make it an ideal resource for instruction, on many levels.

The mechanization of our lives and the consequent need to cope with the plethora of practical tasks have given rise to a large new industry we call DIY. Cookery, the most ubiquitous do-it-yourself task, has long been the subject of illustrated instruction, but today almost all our daily activities, and many quite specialized tasks, have become accessible and are furnished with pictures of "how to do it". We can knit, sew, re-decorate, grow a herb garden, learn how to operate a word processor, or how to keep fit, all from pictures.

Terence Conran's *New Housebook* combines photography for authentic example and stimulus, with illustrations for explanation and instruction – a good example of complementary roles. The Collins *Do-it!* series adopts a modest format and straightforward lucid diagrams on domestic plumbing, electrics, etc. Gardeners are particularly well provided with illustrated instruction and there seems to be no end to their appetite for new material, whether it is read in the armchair or in the potting shed.

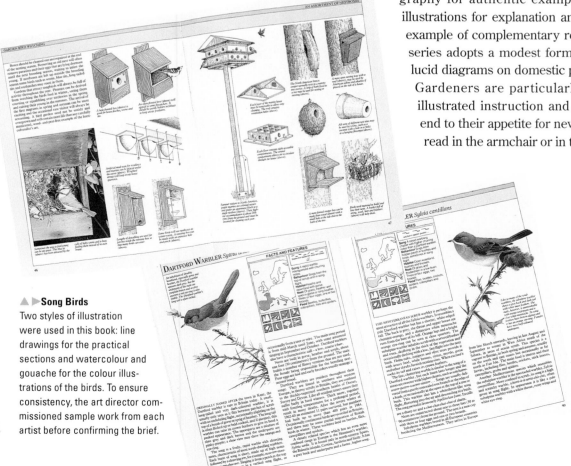

▲ ▲ ▶ **Song Birds**
Two styles of illustration were used in this book: line drawings for the practical sections and watercolour and gouache for the colour illustrations of the birds. To ensure consistency, the art director commissioned sample work from each artist before confirming the brief.

**▼ ▶ A Guide to Royal Britain**
This book combined a free style of pencil and wash illustration for the portraits of the historical characters with precise line drawings with airbrushed colour for the diagrams. Both types of illustration required a clear brief from the art director, who supplied reference from contemporary paintings in the first case, and a detailed schematic rough in the second.

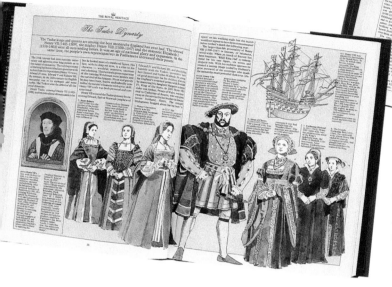

**▼ ROB STONE**
**Collins *Do It!* Series**
In these step-by-step drawings for a DIY series, the illustrator was given precise reference for each of the steps, The style with its clean lines and flat tints is designed to convey the information required with a minimum of extraneous detail.

Television has some-times been accused of lessening our inclina-tion for reading. But whether or not this is true, the shelves of bookshops are full of books featuring familiar faces from the screen, and the fact that a book can easily be picked up and carried a-round clearly offers some advantages over television, giving the two media a kind of mutual depend-ence.

## Locational illustration

Yet another long-standing role of the illustrator is that of reporter. Before the invention of photography, such pub-lications as *The Illustrated London News* went to great trouble to depict the significant happenings of the day. Far from rendering reportage illustration redundant, photography seems to have given it a special place, if only because it can testify to an individual's immediate reac-tions on-the-spot in the same unique way as the radio com-mentator does when reporting anything from a race meeting, a Royal wedding, or perhaps the scene of a tragedy. The official war artist acts in this capacity and, there are many fine examples from 20th-century conflicts.

The delights of life on Earth can be equally as well portrayed. David Gentleman's publications celebrate the variety of Britain's topography, and Paul Hogarth's give a sense of presence of place as he roams the world.

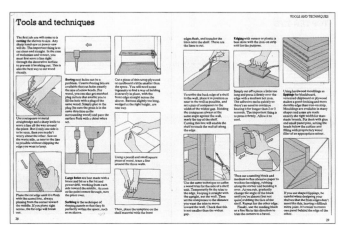

## CHILDREN'S BOOK

**CLIENT** *BBC Enterprises*
**ILLUSTRATOR** *Eric Tenney*
**BRIEF** *The artist had to follow a tight designer's visual and produce a double-page spread of natural history illustrations, all reproduction size and in position.*

The pictures on these two pages show the sequence of events in the production of a typical double-page spread of full-colour artwork. The illustrations were for a children's non-fiction series of books called *Fact Finders*, each supporting a television programme.

The grid for the series was designed to allow for the close integration of text and pictures as well as to accommodate a variety of subject matter – from wildlife to ancient history. It also had to enable commissioned illustrations to sit comfortably alongside photographs.

The book shown here, *Wildlife Safari*, was illustrated by several artists. This meant that the whole project could be produced far more quickly than would be possible with only one.

Part of the illustrators' briefing was to ensure that nothing that would have to be changed for a foreign-language edition was painted in colour. Any hand lettering, for example, had to be drawn in black on an overlay so that it could be printed as a text black rather than a full-colour artwork black.

▲ **The rough layout**
First the art director produced a pencil drawing of the spread, working from the text and the editor's roughs. All the type areas are keyed in. Notice the detail in the bottom right-hand corner, still to be resolved.

▶ **The artwork**
Eric Tenney was supplied with the rough, the text, and useful picture references. His illustration was drawn S/S (same size) and painted in watercolour, using very fine brushes. The greatest detail is in the animals and figures, as these had to convey as much information as possible.

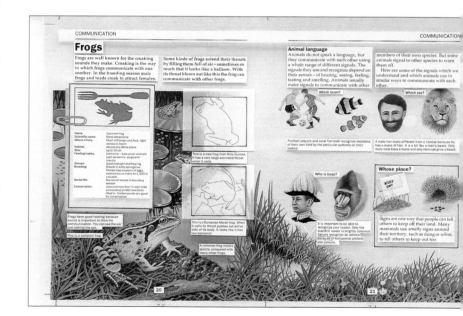

▲ **Typographic overlay**
The final text was typeset, and the bromide was pasted down in position on an acetate overlay directly on top of the illustration. This allows the reproduction house to shoot all the text at once, making a piece of line film which is later matched to the four pieces of artwork film.

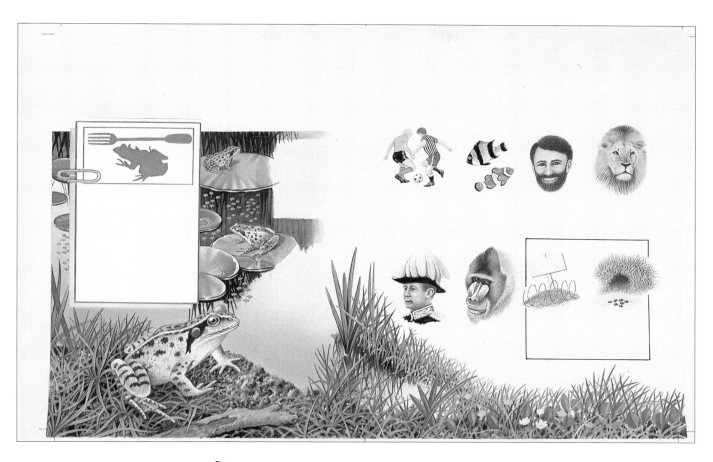

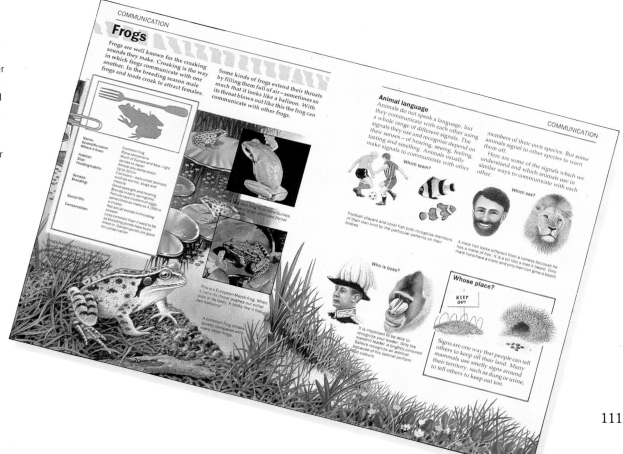

▶ **The final product**

This is a colour proof of the final double-page spread, showing the text printed in black over the four-colour artwork. The colours have varied a little from the original, but the overall effect was found satisfactory. Note that the two colour transparencies have been dropped into the illustration as specified on the original design.

111

# Children's books

Thousands of new children's books are published every year, many of them illustrated, often in full colour, and in a wide variety of styles. There are, perhaps, more opportunities for illustrators here than in adult illustrated books, which often tend to use photographs rather than illustrations.

There are two main routes to an illustration commission – either by getting an idea of your own accepted by a publisher or by being asked to execute a specific brief. How this happens depends very much on the nature of the book.

This section covers some of the main areas of children's book publishing, including picture books, illustrated fiction, pop-ups and other novelty and information books.

There are three things which separate children's from adult publishing: approaches to the text (beyond the scope of this book), the design and illustrations and, most importantly, the reader.

Some illustrators will say that they are illustrating for themselves and do not have their reader in mind. This may be so, but others in the team involved in putting together a children's book – often the editors – will see it as their responsibility to represent the reader's interests in shaping and developing a project.

There is no such thing as a typical seven-year-old, any more than there is a typical adult. But most children have the capacity to develop intellectually and emotionally in fairly well-defined stages. Children of the same age reading a particular book will not all have reached the same point of maturity. Some may read fluently, others may not read at all, for example. Many children's books reflect this fact, being capable of being read on a number of different levels. Rod Campbell's *Zoo*, for instance, is great fun as a guessing game, but equally as good as a story for novice readers, who are helped by the repetition of words and flaps over the pictures.

## Interpretation

With all children's books, the interpretation of the story or the information presented to the reader in the illustra-tions is crucial. But you have to consider the purpose of

▲IVAN BILIBIN
*The Princess in the Tower*
A popular graphic artist and stage designer, Ivan Bilibin drew on the medieval and folk art traditions of Russia, as reflected in the jewel-like patterning of this watercolour illustration to a Russian fairy tale

▶RON BROOKS
**The Bunyip of Berkley's Creek**
Winner of the Australian Picture Book of the Year Award in 1974, this story of an enigmatic creature who does not know what he is conveys a suitably strange atmosphere, with colour washes laid over heavily hatched and stippled textures.

the illustrations when thinking about how they will be interpreted. Are they there for the child to enjoy a story, discover the name and size of the largest dinosaur that ever lived, or learn how to make a paper plane?

If a series of illustrations carries a story line, or is the story in itself, such as in Raymond Briggs' *The Snowman*, then an understanding of the sequence of the plot is a vital element. But if an illustrator shows the size of the largest dinosaur by drawing a bus next to it, then the child must be able to understand the concept of a visual comparison for the drawing to succeed.

▶ MITSUMASA ANNO
***Anno's Journey***
Mitsumasa Anno re-creates a
journey through Europe in a series
of delicate and atmospheric
watercolours. The spreads are
linked to give the impression of the
path taken by a horseman and the
events witnessed along the way,
together with visual puzzles for the
reader to ponder.

Interpretation never depends solely on the illustration
itself. There are many factors involved in children's
understanding of complex visual information. In books,
this can involve the relationship between picture and text,
the reading order on a page (the order in which the
designer intends that the reader should follow text and
images), understanding of visual conventions (per-
spective, diagrams, step-by-step, scale and so on), and se-
quencing of story or information, etc.

At the simplest level, illustrators should always ask
themselves, "Does this drawing seem to do what is
expected of it, given the target age range?" With books, it
is worth bearing in mind that the rest of the team in-
volved will probably be asking the same question and will
want to discuss it with the illustrator.

## Covers

With so many new children's books published each year,
there are always opportunities for artists to do cover
illustrations. As well as new titles, publishers often follow
a re-jacketing policy whereby books get new covers every
few years (unless the maxim "if it works, don't change it"
prevails), or when sales of a title start to drop.

Covers can sometimes be a good opportunity for an
illustrator to break into children's books, as those com-
missioning them are more prepared to take a chance on a
one-off piece of work and can well use it as a test piece
prior to commissioning a whole book.

As with adult books, the cover is the publisher's main
vehicle for persuading a prospective purchaser to pick up
the book or select it from a catalogue page. Children's
book covers are generally bright and busy, and have a
strong design and illustrations, so creating a cover that
will stand out from all the others can be very difficult.

Some publishers have an overt house style for their
covers; others adopt an individual approach for each title.
Many children's books are sold in series, which means
that a strong series identity for the cover is vital if it is to
have any meaning to the consumer or retailer.

Typographic or graphic devices are frequently used to
create a series identity. But art directors will also

113

commission illustrations in pursuit of this objective. Ian Butterworth's designs for the Collins' Tracks series is a good example of bold typographic and graphic styling, allied to innovative commissioning of artwork.

### Picture books

Very often these titles stem from an illustrator's idea for a story, which they then write and illustrate themselves. Artists such as John Lord, Raymond Briggs, Eric Carle, Mitsumasa Anno, Tony Ross and Charles Keeping produce highly original and idiosyncratic work in this way. But sometimes a publisher will commission an illustrator to work on an author's text.

Because they are for young children, and many people are concerned about what young children read, picture books can be the subject of fierce criticism and debate. Care should always be taken, therefore – by authors and editors, as well as by illustrators – to ensure that the illustrations match the level of experience, and expectations, of such young readers.

### Narrative illustration

There is a wide range of illustrated children's books – from picture books to novels and traditional tales – in which the role of the illustrator is to respond to an imagined event. The first point of departure for the illustrator is usually the text, and the success or otherwise of the drawings depends very much on having a good story to illustrate. The artist John Lord once commented at a conference,"...I do think there is a tendency for virtuosic draughtsmanship alone to overwhelm some adults' appreciation of pictures, without any regard for whether the picture's content truly relates, in a complementary way, to a story worth the telling".

Many children's novels are illustrated, often in line or line and wash. Mervyn Peake's illustrations for Lewis Carroll's *Alice in Wonderland* is a particularly fine example of this genre.

Here the opportunities for developing a plot through a sequence of narrative illustrations is often quite limited, but the impact in the reader's mind of the portrayal of characters or an atmosphere in the story can be profound and long-lasting.

### Children's non-fiction

Illustrated children's information books are one of the best sources of work for many book illustrators, with everything from dictionaries and encyclopedias to activity books to choose from. Nearly all children's non-fiction is illustrated, much of it in colour, using a variety of techniques and in a wide variety of styles.

Children's non-fction usually falls into two distinct categories: trade books and educational books. Many trade books – those that end up in shops and book clubs – are educational in the sense that children will be able to learn something from them, but unlike those primarily destined for use in schools, they do not have an overt curriculum content.

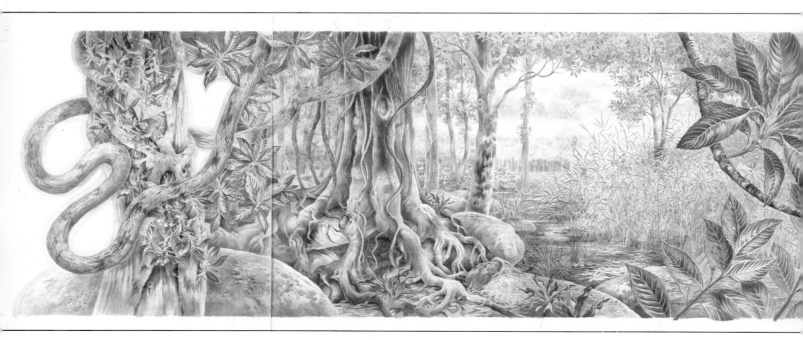

Everybody said the little princess was clever and would grow up to be a wonderful queen.

"The potty's the place!" said the little princess proudly.

▲ TONY ROSS
*I Want My Potty*
This book is not only a tour de force in potty training, but also an excellent story for reading aloud to toddlers. The watercolour illustrations are full of character, a highly imaginative approach to a problematic subject.

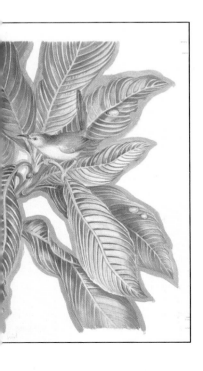

I see a green frog looking at me.

Blue horse, blue horse, what do you see?

◄ KEVIN DEAN AND JOHN NORRIS WOOD
*Jungles* (Nature Hide and Seek)
In this book, children discover animals camouflaged in their natural habitats, some disguised within the painting, others hidden under flaps. Kevin Dean painted the elaborate environments; John Norris Wood added the animals, birds and insects.

▲ ERIC CARLE
*Brown Bear, Brown Bear, What Do You See?*
Eric Carle's classic picture book uses torn tissue to excellent effect, forming simple, vividly descriptive shapes. Children enjoy anticipating which animal will appear when they turn the page, while learning about colours.

Because of the cost of producing four-colour books, most information books destined for a trade rather than an institutional market have to be sold internationally as co-editions (although this is increasingly true of many other kinds of books too). This means that a publisher will try to pre-sell the rights in a title to other publishers around the world before making a commitment.

This has two significant implications for illustrators. Firstly, many books of this kind start their life as a dummy cover and a couple of presentation spreads for display at one of the major international book fairs – usually the children's book fair at Bologna in April and the Frankfurt Book Fair in October. Many publishers will commission a great deal of work prior to these fairs, although often on a speculative basis only.

Secondly, illustrators have to be very careful to produce internationally acceptable drawings. The pitfalls are many and sometimes surprising: triangular ice-cream wafers may look fine in Europe, but not in America; electric plug sockets look different just about everywhere; road signs and car steering wheels are always a hazard, for obvious reasons, as are wild flowers in background scenery. Lettering, too, is a big problem – never draw lettering directly on your artwork; always draw in black on an overlay so that it can be changed easily for a different language. The publisher will want to change only the black plate for international editions (to save money). The colour plates remain common to all languages and are not changed.

## Working on non-fiction titles

The illustrations in information books are nearly always carefully planned for the illustrator by a team of people – usually at least an editor and a designer. The illustrator is often expected to work to a detailed rough, particularly if the book is heavily integrated, and to follow a brief. Sometimes an illustrator will be given more opportunity to interpret the text in their own way by being given a layout with spaces left for the drawings.

Very often the illustrator will not be in charge of the look of an illustrated information book – quite contrary to the case on fictional titles. The designer and editor will usually choose an illustrator whose work they think will fit the job in hand. So, if the book calls for lots of step-by-step illustrations, and cut-aways, then an illustrator with a range of these in his or her portfolio will stand a better chance of being commissioned.

By the time the illustrator sees the layout, someone else will have considered what kind of illustrative approach is suitable in a particular context, whether it be a cut-away, a diagram or a cartoon.

The overall design and layout of the page should enable the reader to follow the reading order intended by the designer, but it is the illustrations which ultimately

TERESA FOSTER
*Things that Balance*
Teresa Foster was commissioned by Collins to design and illustrate four children's activity books, written by Robin Wright. This illustration shows one of the more complex objects that Teresa had to illustrate, working from models and sketches provided by the author. Her layouts were transferred directly to a good white watercolour paper. She then coloured in with watercolour and pencil.

▶ROBIN LAWRIE

### See How it Works – Planes

These pictures show pages from an unusual series of four books illustrated by Robin Lawrie and written by Tony Potter. The idea of the series was to show young children the insides of machines such as planes and diggers by using acetate overlays. By turning successive transparent pages, the reader can "peel away" the mechanical parts of the machine.

The airport scene shows good use of aerial perspective, where warm colours are used to make an object appear close to the viewer, and cooler colours are made to make objects appear to recede.

All the drawings are rendered in gouache, using Frisk film to mask out the individual planes. The small details were painted after the backgrounds by peeling away the film after the paint had dried.

Although the acetate pages posed very difficult printing problems, they were illustrated in the same way as the rest of the book.

create visual interest and pace on the page. This is becomingly increasingly important as children become more sophisticated in interpreting complex visual information, through exposure to television.

Illustrations can not only add pace, but also serve to emphasize a particular point. Emphasis is important because it provides instant clues as to the most significant elements on the page. Size, shape and colour are probably the three most important tools at the illustra-

tor's disposal, although small details, such as eyes staring out of the page, can be a potent instrument for emphasis.

A good children's illustrated information book has a close relationship between the text and the pictures. The whole point of these books is usually to explain something to a young reader, so it is vital that the pictures support and expand on the text. In children's books especially, every picture is worth a lot more than a thousand words.

## CHILDREN'S BOOK

**PUBLISHER** Hamish Hamilton Ltd.
**ILLUSTRATOR** Raymond Briggs
**BRIEF** A strip cartoon-style children's book, written and illustrated by the artist, using hand-drawn lettering and watercolour artwork.

▼ **The overlay**
All the lettering for the book was hand-rendered by the artist. This was done in position on drafting film using Indian ink.

▶ **The illustration**
This picture shows Raymond's full colour illustration for a double page spread. Note the various remarks and doodles around the edge

of the work – another story quite apart from the main plot! The artist produced many sketches and colour roughs prior to drawing the finished piece.

Raymond Briggs' hugely successful *Fungus the Bogeyman* was the result of over two years' hard research. The drawings for the book are just the tip of a massive iceberg of material. Raymond spent several months compiling lists of "bogey words" from a dictionary – anything and everything that seemed relevant to "Bogey" life-style. From this he invented the mirror-world of Bogeydom, with files on everything from Bogey sport and social manners to Bogey education and lavatory habits. Eventually, Raymond compiled enough material for several Bogey books, although no sequels have appeared or are planned so far.

Raymond prefers not to spend time producing hundreds of pencil roughs, but goes almost directly to the finished drawing. A rough pencil dummy of the whole book was produced first to get the spacing and flow right for the story. Then each spread was accurately drawn in pencil, with the lettering included. The spreads were photocopied and pasted up into a blank dummy for the publisher to approve. Once this was done, Raymond inked the outline and filled in with watercolour. Any tidying was done with crayon, with the outline redrawn in ink.

▼ **The final product**
This shows the illustration
and text combined in the
final printed version. By
keeping the text on a
separate piece of film it is
possible to print editions
in many different
languages by changing
the black plate.

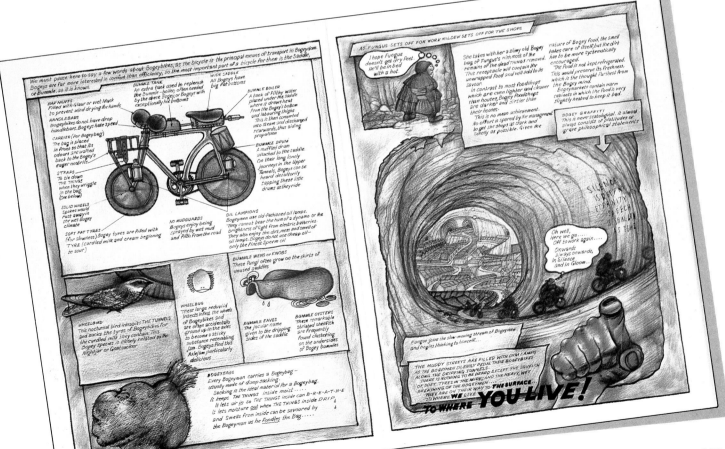

119

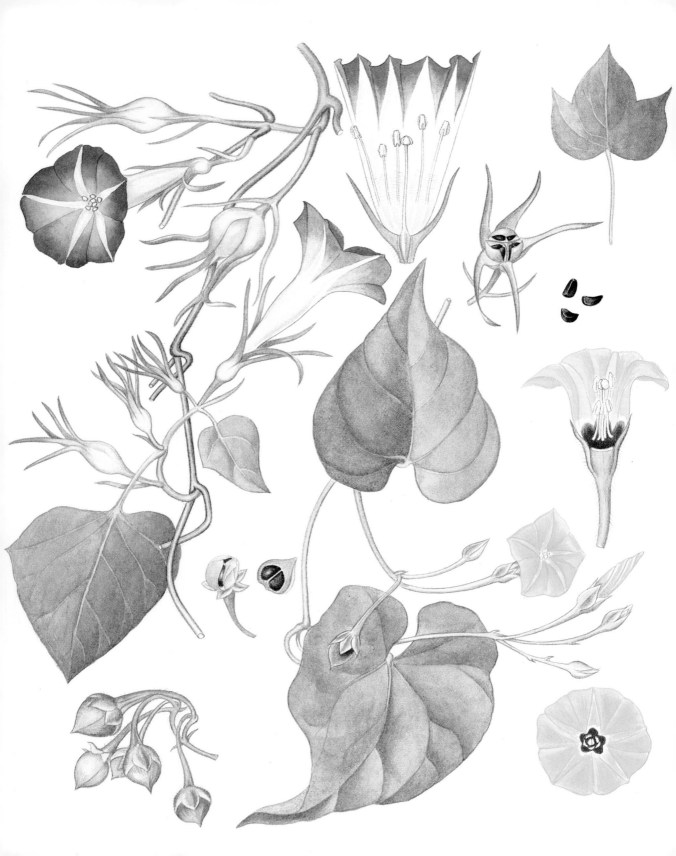

# 5

# SPECIALIST ILLUSTRATION

In a sense, almost any form of illustration becomes specialized as the illustrator gains experience at working in a particular field, but there are a few areas, notably in technical natural history, medical and fashion illustration, where the artist needs to serve what amounts to an apprenticeship in order to hone his or her skills.

Although the four disciplines mentioned all make different demands on the artist, they do have the following elements in common: the artist must be a skilful draughtsman, and be prepared to do meticulous research, and also to make a genuine study of the subject.

It takes considerable talent, and skill, as well as a high degree of intelligence, to present information-based illustration attractively, and as the writers in this chapter attest, it can be a very rewarding area for those who have the right attributes for the work.

◄ SUSANNA STUART-SMITH
**Plants of Dhofar**
This meticulous watercolour illustration combines scientific accuracy with decorative composition.

121

# Technical illustration

Technical illustration is not new but the depth and scope of this area of illustration leads it to mean different things to different people. At best, it is recognized for the skills and understanding that are pre-requisites for those practising it. At worst, especially if the subject is highly technical in content, it is classified as just another function of the mechanical draughtsman. Very simply, technical illustration is a means of conveying specific information for either a clearly defined audience or a wider, more general one. In many cases this involves the preparation of a three-dimensional representation of an object using two-dimensional information as a primary reference. The value of such an illustration is measured by its usefulness in communicating the information required and the way in which it is used.

## The development of technical illustration

It is an oft-quoted cliché that we live in a world which has shrunk as a result of constantly improving communications between countries and continents. Modern industry has had to keep pace in order to survive. As a result, the demand for effective information illustration has expanded enormously over the past two decades. Added to this are the growth of the leisure industry and an increased desire for knowledge.

The origins of technical illustration date back at least to Leonardo da Vinci's design drawings of various mechanical devices and indeed, like their modern counterparts, they show what the objects look like, or are intended to look like, at the initial design stage. The late 18th century saw a gradual increase in illustrations designed solely to convey information, usually of a "how-it-

▼ STEPHEN ORTEGA
**HMS *Warrior* 1861**
**Bournemouth and Poole College of Art and Design**
The original is a very large 3.5m x 1.5m (10' x 5') illustration rendered in a single weight ink line with transparent washes of watercolour. This modern drawing is very much in the style of that used extensively in the 19th and early 20th centuries. This technique allows for maximum technical accuracy as well as a realistic colour representation. The original is on view at Portsmouth, not far from where the ship herself is now preserved.

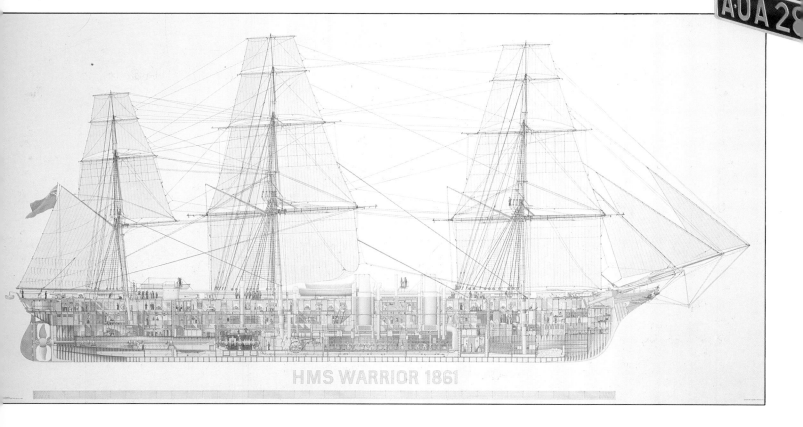

HMS WARRIOR 1861

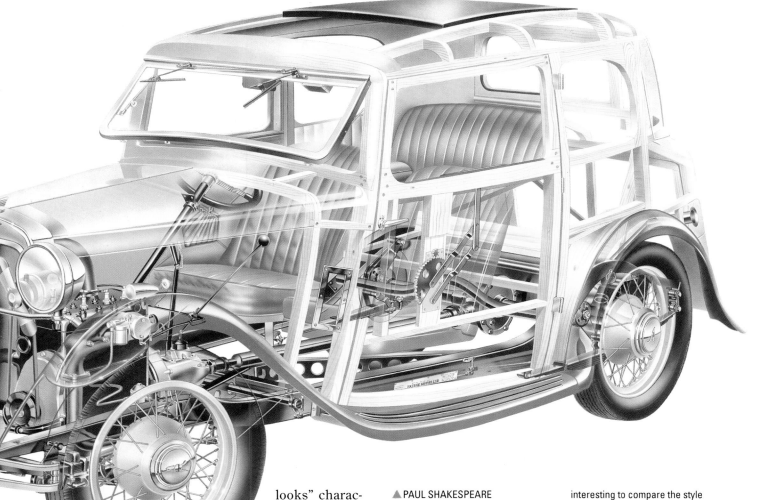

looks" charac-
ter, and even as
early as the late
17th century, in the
fields of naval architec-
ture and ship-building, the use of
such illustrations was not unusual. These illustrations
were often used to complement a text that was highly
technical and if read without illustrations would probably
prove meaningless to all but the trained expert. This
usage continued into the 19th century, with develop-
ments in both techniques and accuracy keeping pace
with the demands of the Industrial Revolution.

With World War I came mass-production on a pre-
viously unprecedented scale. Companies not normally
associated with the production of armaments and
associated equipment were drafted in to assist, and illus-
trated manuals were produced for mechanics so that they
could carry out spares replacements, general main-
tenance or even major overhauls. The illustrations were
often prepared by mechanical draughtsmen with a flair
for three-dimensional work.

▲ PAUL SHAKESPEARE
**1937 Austin Seven**
A traditional style airbrush
illustration which relies extensively
on the ghosted technique to
maintain external form whilst
allowing internal detail to be
clearly shown. The use of hand-
painting has been applied to linear
detail where an airbrush would
have been impractical. It is
interesting to compare the style
of highly polished and sometimes
chromed surfaces with that of
the Ford Cosworth Sapphire car
reproduced on page 126. Note
the illustrator's "trade mark" – a
spanner, which is in the driver's
map pocket!

Once the war was over, with increased private ownership
of cars, drivers needed manuals to explain the workings
of their vehicle, whilst garages needed repair manuals.
Magazines and books were also much in demand as the
public became more interested in what was going on
around them. By the late 1930s there was a steady
increase in the number of people employed as illustrators.
Many illustrations from this period contain awful drawing
errors, but nevertheless the subjects illustrated are
technically correct, and some images demonstrate an out-
standing use of pen-and-ink work, with a special charm all
of their own.

# THE HISTORY OF TECHNICAL ILLUSTRATION

The development of technical illustration reached a peak during the latter half of the 19th century through the extensive use of "presentation drawings", such as the one reproduced here of the paddle-steamer *Persia*. Whilst these are accurate, 1:96 Imperial-scale orthographic views of the ship, they were never intended to be used as a reference source in its building because of the errors which would occur in scaling-up the dimensions for full-size construction. This was quite simply a presentation drawing, commissioned by the ship-builders, and exemplifies the draughting skills and excellent medium control of the artist, David

Kirkaldy, who executed it in 1860. It is worthy of detailed study, as it contains about as much information as is possible for its scale and the type of paper.

A further three examples of historical presentation drawings are included to demonstrate a small cross-section of differing styles and approaches. All are from the collection held by the Science Museum, London. The steam-beam engine and Mogul Neilson steam locomotive are from almost the opposite ends of the 19th century, whilst the Italian torpedo boat destroyer *Nembo* dates from 1901. The beam engine has been taken from a book, the base drawing having been engraved, with the colour washes added afterwards.

This example is not as highly finished as the *Persia*, but it does serve to show another application of this type of drawing.

The drawing of the locomotive is a good example of what was considered the norm in the large drawing offices of the many railway companies, at least until the advent of dye-line printing. To the uninformed it may appear as just a straightforward sectioned elevation and plan with unrealistic colour washes overlaid to enhance the drawing's appearance. In fact the colour was primarily to convey what materials were to be used in the building of the locomotive. Regardless of the branch of engineering, conventions quickly developed during the 19th century

▶ DAVID KIRKALDY
**Paddle-Steamer *Persia*, 1860**
A beautiful example of the high level of hand-skills required to render a subject in transparent watercolour, especially without the use of an airbrush. Furthermore, both the tone control and use of gradated cast shadows not only enhance the three-dimensional effect, but enable all of the information contained to be clearly understood.

▼ RAPHAEL PISCELLARO
**Italian Torpedo Boat Destroyer *Nembo*, 1901**
This is an exquisitely hand-rendered monochrome wash illustration showing a longitudinal sectioned elevation above a half-sectioned plan. The obviously thorough understanding of shadows and tone control gives this illustration a distinctive three-dimensional effect.

which standardized such things as the use of particular colours to represent particular materials.

The destroyer *Nembo* makes an interesting comparison with the *Persia*. Again it is rendered in ink and watercolour wash, the latter primarily monochrome. It shows the same high degree of control as for the *Persia* and uses incredible depth of contrast to give the drawing a three-dimensional effect. It is again worth studying the original as an illustration rather than as a ship.

In order to be able to produce drawings of this quality it was necessary for the draughtsmen to acquire highly developed skills in the use of ruling pens and the manipulation of watercolour. Many of today's draughtsmen are incapable of handling a brush, which is why technical/information illustration has come into its own, answering a need for accurate, highly finished and neat work.

Interestingly (and encouragingly), the 1970s and '80s have seen a resurrection of this type of illustration. The modern example reproduced here is by Stephen Ortega and shows the brigantine *Leon*.

◀ **Stationary Steam Beam-Engine**
This illustration is typical of those used in early to mid-19th century books on technology. It shows a hand-rendered engraving with flat Payne's Grey washes and cast shadows of solid black. The tones are the result of engraved line shading.

◀ STEPHEN ORTEGA
**The Brigantine *Leon***
Illustrations such as this require a high standard of technical skill as well as a thorough knowledge of the subject. The artist must be prepared to spend time researching into contemporary sources.

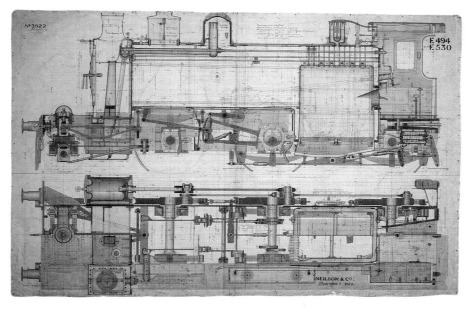

◀ MOGUL NEILSON & CO
**2-6-0 Locomotive, 1878**
This illustration is a typical example of an engineer's drawing from the late 19th century. The base drawing has been completed with multi-coloured ink lines, over which transparent washes of watercolour have been laid. The use of colour is limited and conforms with drawing conventions in use at the time and up to the period when dye-line printing was universally adopted for such drawings. Each colour represents either a different material and/or different system, according to the eventual and designed use of the drawing. The enhanced clarity which colour gives the drawing is obvious and demonstrates a stylized, but effective, technique on curved or circular surfaces. All the annotations and dimensions have been written by hand.

World War II had much the same effect on information illustration as World War I, except that industry was on a larger, more intensive scale. The quality of handbooks, instructional wall-charts, training and maintenance manuals and so forth improved considerably. Retouched photographs and monochrome wash drawings were increasingly used in these manuals, and today the specialist museums, like the Imperial War Museum and the Science Museum in London, often hold excellent examples. The Germans were fine exponents of the re-touched photograph, as can be seen from many of their surviving aircraft manuals from the pre-war and war years. In the USA, companies were formed for the sole purpose of producing relatively sophisticated technical publications for the war effort.

By the time peace arrived, technical publications and the widespread use of technical illustrations had become the norm, with major companies slowly introducing their own publications departments. Again, as in the 1930s, the post-war period also brought about an increase in both general and specific technically based publications, which has continued to the present day. This has given some illustrators the opportunity to establish themselves to the point of being almost household names (at least to those within the relevant profession). The demand for inform-ation/technical illustration has spread across nations too. Besides the UK and North American markets, such illustration is now equally commonplace in countries like France, West Germany, South Africa, Australia and Japan.

**The skills of a technical illustrator**

In choosing a career as a technical illustrator there are certain identifiable qualities that are essential for success.

First comes self-discipline, then follows the ability to ob-serve, understand and record an object and its environ-ment for the purposes of both information retrieval and to be able to draw it accurately. Following closely is the need to be able to read quickly an orthographic (or two-dimen-sional) drawing and convert this into a three-dimensional image appropriate to the requirements of the client. Without a thorough knowledge and understanding of the theory of perspective and its application, an illustrator would have difficulty producing convincing three-dimensional illustrations. A knowledge of perspective and of projection methods allows the illustrator to interpret reference material more accurately, besides allowing him or her to make adjustments to an illustration by eye and so, in some cases, save valuable time which can be more profitably spent on the finished artwork. Intensive training and practice are also needed in order to master the skills of using different techniques and media. These include pencil, ink, watercolour gouache, acrylic, the airbrush and all the accompanying drawing aids used at different times on different commissions. These can be summarized as "acquired drawing skills", although not all illustrators use all the available media; many specialize in a particular one and develop a distinctive style. Regard-less of the direction chosen, however, every illustrator should be able to produce accurate and neat linework which must always be to a standard suitable for reproduc-tion. An illustrator continues to develop the skills intro-duced during training long after entering the profession; ideally, every new commission should be an improve-ment on the previous one.

It is essential for illustrators to be familiar with, and have a good working knowledge of, graphic design,

◀ TERRY COLLINS
**Ford Cosworth Sapphire**
This illustration demonstrates a particular style of rendering a modern vehicle using the airbrush as the primary tool. Limited use has been made of hand-painting and ruling-in, principally in and on those areas requiring sharper delineation. Of particular note is the exaggerated use of secondary colours and reflected light, which accentuates the positive state of the car. Tone values are very highly controlled ensuring each detail of the illustration is clearly defined and not lost in its neighbour.

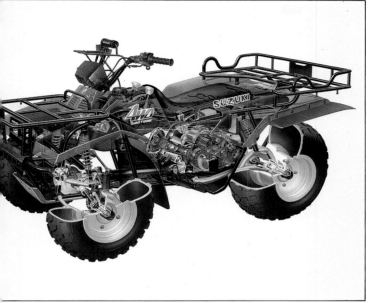

◀ **HIDE NAKAJIMA**

**4 Wheel Drive Quad Runner**

This fully-detailed cutaway and ghosted illustration typifies the outstanding quality of illustration being produced in Japan today. It contains extensive airbrushing with hand-painting and shows an overall sensitivity in the control of both medium and colour value. The balance between matt and polished surfaces ensures an even composition with each detail in sympathy with its neighbour. This is further enhanced by the limited choice of colours. As with many of these illustrations in this section, it is worthy of prolonged study.

▼**PAUL SELVEY**

**McDonnel-Douglas F4K Phantom II**

An illustration which contains both airbrush and hand-painting in approximately equal parts. Rendered in acrylics throughout and following the colour scheme of the full-size aircraft, it was produced to a tight brief by the Fleet Air Arm Museum, who required a comprehensive cutaway perspective illustration. It is one of the most complete illustrations of a modern military jet aircraft yet produced.

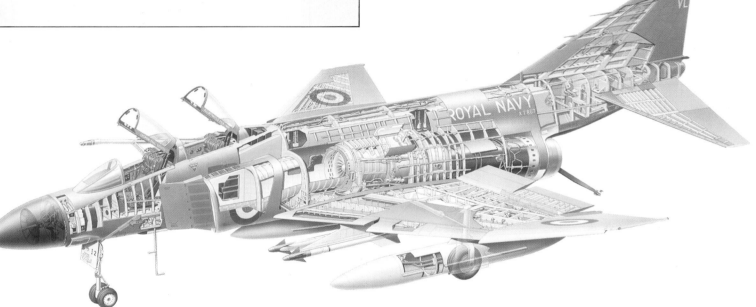

typography, photography and printing processes. These subjects are an integral part of an illustrator's overall working environment. It must never be forgotten that every piece of commissioned work will be reproduced in some form or another, and this imposes certain restrictions which must be understood by the illustrator.

The final quality that every technical illustrator should possess is an enquiring mind. It is not necessary to become an expert in every subject being illustrated, but it is helpful to be interested in how things work and their functions. It will then be possible to produce illustrations in a variety of media compatible with the subject. Nothing looks more amateurish than an illustration in a style that is not in sympathy with the subject matter.

## Types of illustration

Different types, or conventions, of illustrations can be adopted to represent a particular subject.

**Cutaway and exploded illustrations** These are considered the traditional methods. Cutaway illustrations are invariably three-quarter, perspective views of the exterior of an object, sectioned to show internal or hidden details. Ghosted illustrations have the same function, with the exterior being shown as a transparent surface in those areas where internal detail is required. Cutaway and ghosted techniques are often combined in one illustration. Cutaway illustrations are usually the most time-consuming and therefore the most expensive to

127

commission. However, in the case of Clive Thomas's British Aerospace Hawk, for example, it has been possible to show such an extensive amount of information in one three-dimensional projection – which in manufacturing terms requires many thousands of orthographic drawings that could not be read by many of the lay-public – that the cost of the illustration has become relatively low. The value of such quality illustrations is now recognized by industry and they are being commissioned by companies which, only a few years ago, would never have thought of employing illustrators, either full-time or freelance.

As a marketing and publicity tool, the cutaway illustration serves a useful and important function too. The full-colour airbrushed illustration of the Rolls-Royce RB211-524G turbofan aero engine, drawn by Eric Webb, an in-house illustrator at Rolls-Royce, has not only advertised a new engine but has also served a useful and successful public relations function. This illustration has been reproduced on nearly every Rolls-Royce colour document related to their aerospace activities, up to A1 poster size.

The exploded illustration, usually completed in ink line, is a means of showing the relationship of one constituent part against another and is drawn in the sequence in which the object would be dismantled or assembled. The various parts that comprise the completed assembly are drawn so that each is clearly recognizable and identifiable for replacement purposes, but not to the extent that they are drawn in isolation to their immediate neighbours. This means that even though the object is shown in a "dismantled" state, an impression of the completed, fully

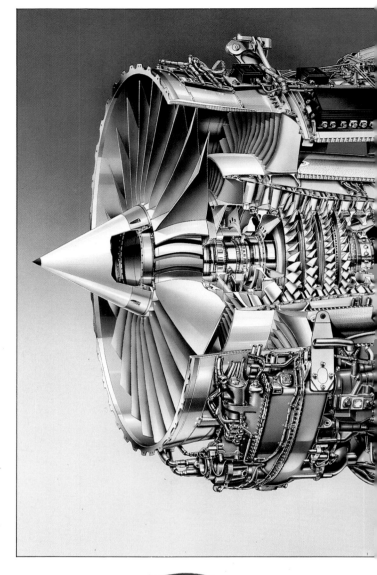

▶ KEITH HULME
**Travel alarm clock**
After numerous pencil sketches investigating possible angles, an accurate perspective drawing was prepared, also in pencil. This was followed by a number of tone-value drawings to establish a constant light source while maintaining detail and contrast. The perspective drawing was transferred on to CSID line board in readiness for airbrushing, which was done with waterproof inks. Constant reference was made to the clock as work progressed, and the final stage was hand-painted with designer's gouache.

assembled object is still possible. In cases where the object comprises too many components it is often necessary to produce a series of illustrations, each being a sub-assembly of the overall object.

Orthographic views, schematic diagrams, flow-diagrams and wall-charts, sequential drawings and free-hand illustrations should also be within the capabilities of the average illustrator. Each fulfils a particular purpose and conveys information in a different way. Again, these may be executed in either black-and-white ink line, half-tone, monochrome or full-colour. The monochrome and colour may be laid flat or with form and can be rendered by hand, with film or with an airbrush.

**Orthographic views** These are often used to explain accurately the external, profile shape and/or particular colour scheme of the subject. The difference between the type of orthographic drawing an illustrator would undertake and that produced by a draughtsman is that in the former case there is no requirement for measurements to be extracted or production processes to be identified. This type of illustration is extremely popular in nautical, aeronautical and military publishing to demonstrate variations in colour schemes between ships of the same class or the differences between the same aircraft used by different squadrons or countries.

**Schematic diagrams** As the title implies, these show the scheme of things in a logical and often stylized manner. In some cases there is an overlap between this type of illustration and flow-diagrams. Both could be

▲ ERIC WEBB
**Rolls-Royce RB211**
A classic example of the technical illustrator's art, this illustration shows a full-colour airbrushed rendered cutaway of a modern aero engine. The sensitivity and control with which it has been both drawn and airbrushed has made an extremely complex and technical subject come alive and full of interest. It is particularly noteworthy the way in which the illustrator has clearly shown the many different surface textures and shapes without detracting from the clarity of the information contained within the engine as a whole.

◀ PETER JARVIS
**Semi-detached house**
This illustration, commissioned by *Good Housekeeping* magazine, shows the effective and balanced use of transparent watercolour with gouache. The base colours for all the principal parts of the house were rendered in watercolour with pointing detail, window frames, slates and curtains being detailed on top with gouache. All highlighting and linear detail were also executed using gouache through a ruling pen, with the slants being hand-painted in both mediums.

129

orthographic or three-dimensional in projection. An example of a schematic diagram is an illustration that shows a typical coal mine and the relationships between the pit-head, the various tunnels and shafts, the coal seams and the surrounding rock strata. A flow-diagram could show the direction of the oil system of a vehicle, for example. Not all schematics and flow-diagrams are as complicated as the two examples described; one has only to look at a newspaper or the television to see simple and effective usage of this type of information illustration.

**Wall-charts** These are used for publicity purposes, quick reference (such as in a workshop), as instructional aids at a lecture or promotions meeting or at a more general level to convey specific information. Because they are designed to be seen at a greater distance than books, magazines and manuals, the detail is often simplified, with an illustration style appropriate to the wall-chart's function and eventual usage.

**Sequential illustrations** These could be described as another form of schematic or flow-diagram. The two illustrations shown here, by Sam Manning – an American freelance illustrator – are from a series of six illustrating the various terms and parts of a small wooden boat. They are a good example of an illustrator developing a style and technique suited to the subject.

**Freehand illustration** A style that has become increasingly popular, especially in leisure and enthusiasts' magazines, can loosely be described as freehand illustration. This type of illustration is decorative and informative, without being rigid. Freehand illustrations do not usually convey specific and technically accurate information to the reader, but they still have to be identifiable as a specific item or object described in the text, for example, the illustrations produced for the box tops of plastic construction kits fall under this heading. Although, on first impression, they may appear to come

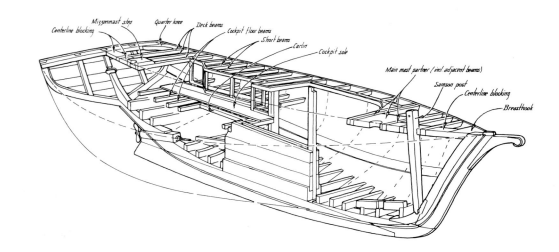

▶ SAM MANNING
**Building a wooden boat**
*Wooden Boat Magazine, USA*
These two illustrations are part of a sequence of six commissioned by an American boat magazine to explain the terminology and methods used in the construction of a wooden sailing yacht. Whilst the technique is of a free-style, the base drawing on which the finished artwork is founded was an accurate measured perspective. The variation in line weight, one of the few conventions in line work in technical illustration, improves the clarity of each component. The hand-written annotations complement the illustration style adopted – which is also a trade mark of this illustrator's work.

under the heading of advertising illustration, the brief always requires an accurate representation of the subject, but shows it in its natural environment. (The Japanese have set very high standards in this area and manufacturers' catalogues are worth purchasing for the ideas and inspiration they contain.)

**Computer-aided art and design** It is appropriate to close this section with computer-based technology and computer-aided art and design (CAAD) as applicable to information illustration. The introduction of document-ation processing and draughting systems has re-volutionized the technical publications industries in particular and publishing in general. Publications which must conform to international standards are produced much more quickly using computers. In some instances, such as in the production of IPC s and simple instruction-al manuals, computers are equally as effective and fast at producing the illustrations as more traditional methods. However, before an illustrator is able to produce commercially acceptable work on such systems, it is essential that he acquires the necessary "drawing-board" skills. The quality of a computer-generated illustration lies in the skill of the operator, not in the computer, even though it may have built-in limitations from a drawing point of view. CAAD systems are developing at an incred-ible pace, especially in their application in film and tele-vision, and are now an established and accepted part of the industry's requirements. There will always be limited openings in this type of illustration work and only the most talented will achieve it, but in all cases a thorough foundation followed by practical experience in traditional methods is advisable.

**Prospects for information illustrators**

Many information illustrators are full-time, salaried staff. There are also a vast number of illustrators who prefer the freelance world and obtain commissions either by direct negotiation or through an agent. Employment outlets include major commercial and industrial com-panies, the civil service (at both national and local level), local government, technical publications and general publishing houses, advertising agencies, museums, the leisure industries and television and film.

Unfortunately there are still many people who, whilst they may appreciate the benefits of using information illustrations in their business, do not appreciate the skill and time required to produce them. This can have the

THE GOLDEN HINDE

▲LYNN GREGORY
*Golden Hind* **Figure-head**
A carefully controlled watercolour illustration showing the figure-head and immediate surrounding area of the reconstructed *Golden Hind*. This illustration demonstrates the differing techniques used to render a variety of surfaces or textures. The composition as a whole is maintained via the extensive, but subtle, use of reflected and secondary colours. The toning down of primary colours also helps to balance the illustration.

effect of illustrators being offered unrealistic fees and, in the case of some full-time openings, derisory salaries. The situation is further exacerbated when illustrators are not given the credit they deserve on completion of a commission; such credit is essential, if only as a means of promoting the illustrator's work. If illustrators voiced their objections to such treatment, their profession might acquire the standing it deserves.

131

# Natural history

The natural history illustrator must be well prepared if he or she is to succeed in making a debut in print. It is an increasingly popular and highly competitive field to enter and specialist training is advisable. A portfolio showing a range of subjects depicted in line, half-tone and full-colour is an essential prerequisite. So is an understanding of the publishing world, and the role the natural history illustrator plays, in order to select the right group of publishing houses to approach with appropriate work.

Any natural history illustrator must be aware of the function the image performs: whether to communicate information, or decorate or embellish the text. It is not simply a matter of painting flowers, birds or animals. The same subject may appear in a children's book, a text book or a scientific paper; but the purpose dictates the treatment of the subject.

The illustrator's first obligation is to fulfil the commissioning editor's brief. Examining the variety of work available, an appreciation of the subtle differences will highlight the need not only to demonstrate a high standard of drawing and technique, but also the ability to interpret a brief, prepare artwork and incorporate text. Traditionally, natural history illustration was defined in categories of botanical, zoological, marine and ornithological illustration and there is still a demand for such expertise and traditional techniques. But today many young illustrators with aspirations to work exclusively in one area will be disappointed. Most find it necessary to establish themselves as general natural history illustrators before they are recognized as an expert in any one area.

Trying to find full-time employment as a natural history illustrator is likely to prove a frustrating experience, particularly as many museums and zoological and botanical gardens have had their budgets cut over the last few decades. Only a few institutions and trusts are in the fortunate position of employing in-house designers and illustrators. Most posts now require additional skills: design, typography, photography and even mural painting. (Even if not directly employed, a knowledge of these skills is still desirable.)

Unless the illustrator intends to focus on the decorative application of natural history illustration, which will be dealt with in due course, examples of work showing ability to communicate information should feature in any portfolio. Informational illustration is used in a wide range of publications. Many scientific papers, educational text books and special interest books dealing with facts use images to explain the information. Step-by-step gardening instructions, butterfly distribution charts, immigration maps with flow-lines, and ornithological silhouettes, as well as geological strata and more complex ecological diagrams, are all examples of the type of work available. This highlights the need for the natural history illustrator to have a good grasp of perspective and

▲SYDNEY PARKINSON
Before the invention of
photography, artists had an
essential role in recording
scientific discoveries. Parkinson
was one of the illustrators who
accompanied Captain James Cook
on his first voyage to Australia.

▲SHARON BEEDEN
**Apples and plums**
This is one of a series of
watercolour illustrations for a
book describing how culinary and
ornamental fruits, vegetables and
herbs were introduced to Great
Britain. Finding the old-fashioned
varieties relating to particular
eras of history involved difficult
and time-consuming research,
but each specimen was drawn
from life.

structural drawing as well as their specialist abilities.

A brief for a gardening book could include plant pots, tools, garden sheds and greenhouses, as well as plants, trees and shrubs. The techniques used in such artwork can vary from simple line to the use of tints and letratone. Obviously, more opportunities will be available to those demonstrating these skills. In some instances the use of a rapidograph for line and stipple is appropriate but for most natural history subjects the traditional "dip" pen provides a more sensitive solution although it does demand more skill.

### Essential technical skills

Knowledge and research skills are prerequisites of scientific illustration, as is the ability to select the relevant information and present it with clarity. There is a misguided notion that tight rendering and excessive detail distinguish a scientific illustration when, in fact, the opposite is often true. A simple fluid illustration may convey far more scientific truth. Illustrating a field guide with highly detailed portraits of individual specimens, no matter how accurately they have been copied, may result in misleading information peculiar to that specimen being included. For an identification guide the artist must

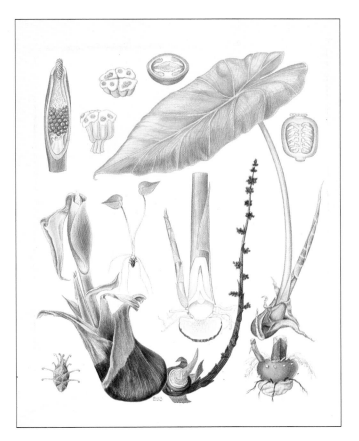

◄SUSANNA STUART-SMITH
*Rematusia vivipara*
The illustrator made five visits to
the mountains of Dhofar, a region
of Oman, to sketch and record the
wild plants. Dissected plants were
drawn with the aid of a portable
microscope and specimens were
preserved for later reference.
Back in the studio, all the
reference materials and sketches
were reassembled and tracings
made from them to fit the page.
The final illustrations, forming a
series of 149 images, were
executed in watercolour on
Arches hot-pressed paper.

▶ CAROL ROBERTS
**South American rainforest**
A comprehensive wildlife study of this kind requires the illustrator to solve complex problems of composition. The difficulty is in showing so many creatures within their environment in a way that informs the viewer of their interrelationships but at the same time presents an apparently realistic image. The reference for this artwork was gathered from a wide range of sources, including studies from life and photographic reference. The piece resulted in commercial sponsorship for a trip to study the rainforest in Belize, Central America.

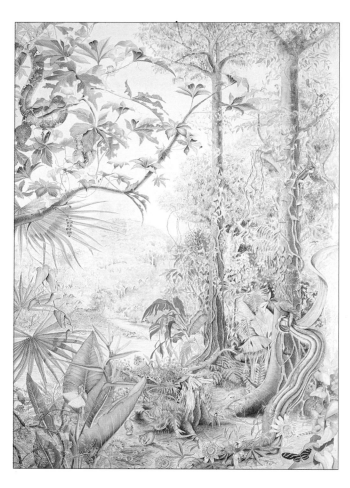

▲ MARGARET MEE
*Heliconia chartaceae*
Margaret Mee gave 30 years to studying the plants of the Amazon. Her sketches, botanical studies and diaries have been compiled in a book, *In Search of the Flowers of the Amazon Forest*. This elegant study shows her fine control of her medium and thorough scientific understanding of the subject.

present only the common factors of a particular species and it is also his or her responsibility to present an accurate solution although the authors, usually experts in their field, are willing to collaborate in checking the artwork before it goes to press. (Incidentally, a good quality magnifying glass or microscope is essential for close observation in this kind of work.)

**Types of illustration**
There are many different types of natural history illustration and each presents a different set of challenges. For example, illustrations of habitats showing relevant wildlife are designed to aid the naturalist in the field. They normally include an average of twenty different species never normally seen together at one time. This presents the problem of creating a convincing solution. Considerable research is needed to ascertain the correct relationship between the individual species, both one to the other and to the environment. Even experienced illustrators struggle to achieve the correct scale and perspective and many fail to develop the illustration to its full potential. Too often the animals and birds look as if

they have been cut out, flattened and stuck on. Obvious profile views are used instead of interesting angles, and static poses rather than attitudes which convey behavioural information, bringing vitality to the scene.

Normally these illustrations include annotations or number keys. It is usually the illustrator's responsibility to prepare the artwork in such a way that when the two are married in print, the annotations can be clearly read against the image. This emphasizes the need for the illustrator to understand the principles of design and typography.

On a larger scale, similar types of illustrations are produced as educational posters – another specialist area of the market. No matter how well you draw on a small scale, be sure you can produce the same standard of work on a larger scale. Your technique may work in one instance, but prove totally unsuitable in the other.

A natural history subject may also be set in a historical context – for example, "Medieval Falconry" or "The Black Rat" (see p. 101). Again, it is the illustrator's job to present accurate facts. Background research will reveal that only peregrines, merlins and goshawks were used for hunting

in Britain at this time. The subsidiary details of costume and architecture must also be checked if these are included.

Whatever the context it is the illustrator's duty to consider the reader and portray the subject in an appropriate manner. This is essential when illustrating children's books, whether fact or fiction; the age of the reader must be considered in educational children's books; slow learners have different needs from an intellectual pupil. It is too simplistic to define formulae to distinguish the differences but an illustrator is a communicator and must use visual language to good effect. "The Life Cycle of the Butterfly", for example, should be treated quite differently when presented to an eight-year-old rather than an advanced biology student or entomologist, even though the facts remain the same.

## Markets for natural history illustration

A market worth investigating for possible work is the magazine sector where specialist magazines on bird watching, gardening, farming or even cookery present good opportunities for budding natural history illustrators. Do not assume that only full-colour artwork is of interest; research may reveal that the budget runs to no more than line and half-tone. Magazines also present opportunities for producing an eye-catching image for the front cover and suitable ideas are always welcome.

There are a few companies who have a particular interest in nature and they, as well as several trusts and societies, produce annual calendars. There are additional challenges to be met in this field. The choice of images

▼ DAVID BOYS
**Pygmy marmosets**
This is part of a series of lively sketchbook studies intended to add interest to information labels for zoo exhibits. The illustration was drawn from life after two or three days of observing the animals. Prolonged study is necessary for the illustrator to be able to convey a constantly moving subject with complex forms and expressions.

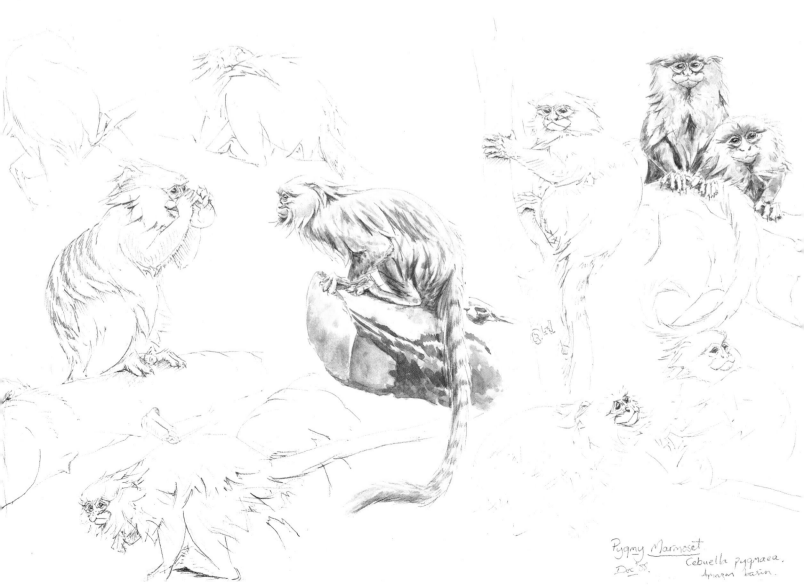

Pygmy Marmoset
Dec 88.
Cebuella pygmaea.
Amazon basin.

must convey the essence of the theme and yet show sufficient variation and individuality to create interest over a long period. To secure this kind of work, it would be advisable to present a "dummy" showing the front cover, together with roughs for at least six months and a piece of finished artwork.

Closely related to the calendar market is the "gift" market. A trip to any appropriate trade fair will help the illustrator to see the range of work available although this is not an occasion to present portfolios. Cards, gift wrap, stationery, address books and illustrated diaries are examples of some of the paper products awaiting decoration. In this area illustrators have the freedom to develop their own ideas and stylized illustration will be acceptable. Realistic treatment is also popular but remember that the emphasis is on attractive designs and commercial potential as much as factual accuracy.

## The value of natural history illustration today

The scope for natural history illustration is greater today than ever, but whatever function it performs, accurate observation, vitality and selection of detail remain the fundamental qualities of the best natural history drawing. No matter whether we look at decorative screens from Japan, illuminated manuscripts from Europe, Egyptian

▶LAURA WADE
**Macaws**
The birds' brilliant colours and delicate textures are rendered in gouache, watercolour and coloured pencil. The illustration, one of five for a guide brochure to a garden bird habitat, took about three weeks to complete. Drawings from life and photographs were used as reference for the finished artwork.

▼JOHN BUSBY
**Gannets**
For illustrations to a book describing the behaviour of gannets, John Busby worked with the author studying the body language of the birds in their natural habitat. Omitting all irrelevant details, he has conveyed the postures and movements of the birds through subtle line drawing that expresses internal form.

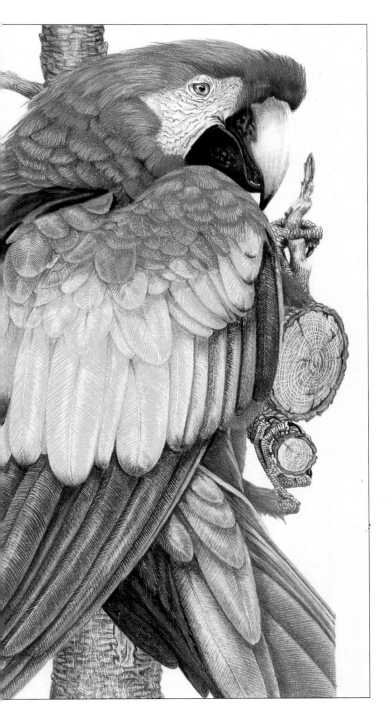

▲ ERIC ENNION
**Spotted Redshanks**
This composition proves the artist's thorough knowledge of his subject, re-created in a single scene with expert control of line and colour detail.

▼ CLARE ROBERTS
**Oak and Company**
The translucency of this image was achieved through building up layers of pale watercolour washes overlaid with delicately stippled detail.

wall-paintings, Indian miniatures or scientific illustrations, each bears witness to these principles.

The natural history illustrator has an important role to play – the visual image must not be underestimated in its ability to increase our awareness of important issues. The delightful watercolour illustrations by Clare Roberts in Richard Mabey's book, *Oak and Company*, not only tries to inform youngsters about their environment but stimulates in them a desire to go out and use their own eyes to find and identify the creatures of the oak wood.

The world we live in is gradually waking up to the dangers and effects of poor management of natural resources and a very pressing task now confronts natural history illustrators, as the list of endangered plants and animals continues to grow. There is now an increasing need not only to discover new species, but to record for posterity the animals, plants, birds and marine creatures currently under threat of extinction.

## NATURAL HISTORY MURAL

**CLIENT** *Smithsonian Institution, Washington D.C.*
**ILLUSTRATOR** *Kevin Dean*
**BRIEF** *To design and paint a mural of tropical foliage as an entrance frontage to the exhibition "Tropical Rainforests, a Disappearing Treasure".*

The designers of the exhibition, which opened in Washington D.C. in 1988 and then toured America, had been impressed by Kevin's illustrations in the children's book *Jungles Hide and Seek* (in collaboration with John Norris Wood), and consequently approached him for this project. The mural was to introduce the theme of the exhibition, showing extravagant tropical foliage, which was to be cut away along the contours to form an arched entranceway.

To obtain the visual information, Kevin made extensive sketches and photographic studies in the tropical houses at Kew Gardens, London, combining these with book references and his own earlier drawings done during a trip to Borneo.

A detailed rough was submitted to the clients, who made a number of suggestions for alterations. When these had been carried out, a transparency was made of the finished drawing, and the image was projected onto the painting surface, watercolour paper dry-mounted on board.

The whole commission, including the preliminary studies, took about six weeks to complete. The original plan had been to air-freight the artwork, but to give Kevin more time, it was agreed to have a large transparency made in London and sent by courier to the United States.

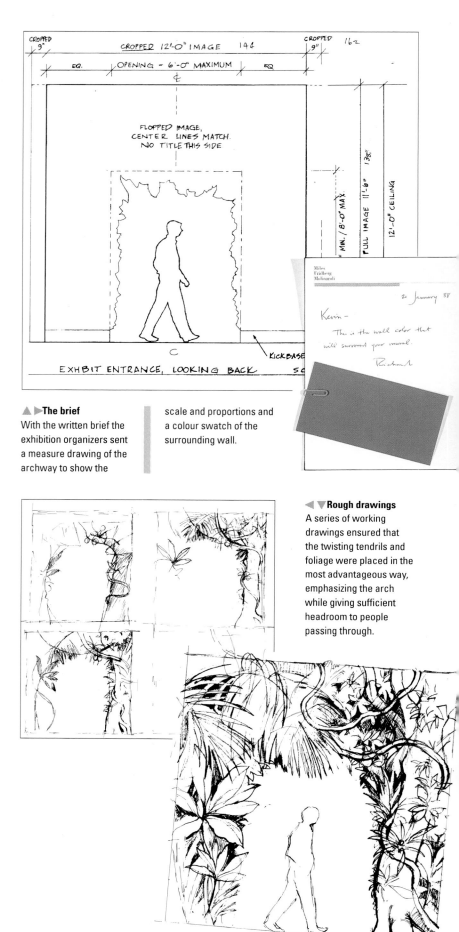

**▲▶The brief**
With the written brief the exhibition organizers sent a measure drawing of the archway to show the scale and proportions and a colour swatch of the surrounding wall.

**◀▼Rough drawings**
A series of working drawings ensured that the twisting tendrils and foliage were placed in the most advantageous way, emphasizing the arch while giving sufficient headroom to people passing through.

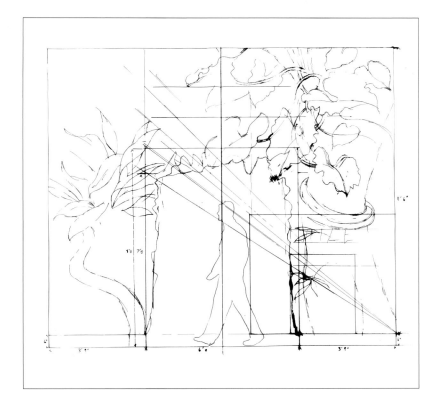

### The scaled-up image
For a commission like this the artist needs to be familiar with the process of scaling up complex shapes with complete accuracy.

### Mounting the image
The finished image, enlarged photographically to the correct size, was fixed onto boards before being put into place.

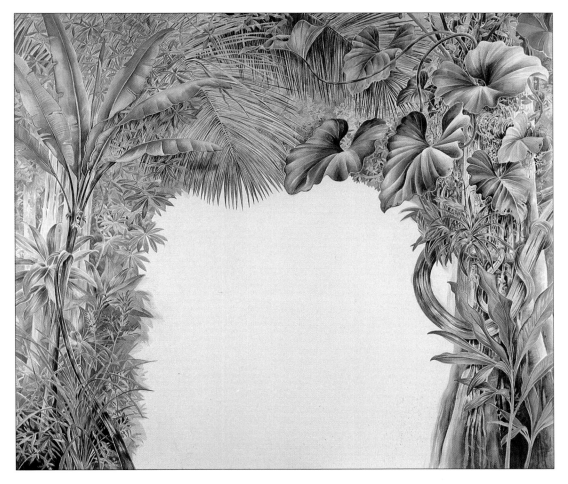

### The final artwork
Kevin was asked to provide artwork one quarter of the actual size, which would then be photographically enlarged to the required size. Most of the initial painting was done in watercolour and then overpainted with gouache and acrylic to give stronger contrasts and greater depth of colour.

# Medical

The structure and function of the body in health and disease has always been a collection of fascinating puzzles. It was Leonardo da Vinci (1452–1519) who said that it was impossible to describe the complexities of the human body without the aid of drawings: "The more thoroughly you describe, the more thoroughly you will confuse." Five hundred years later, that statement is perhaps even more true. As science reveals more answers, the puzzles become more intriguing and, for the teacher and illustrator alike, their elucidation becomes a more complex task.

There are some 60 qualified medical illustrators in this country who have braved the lengthy postgraduate training and are practising in hospitals, medical schools or in a freelance capacity. Their work encompasses an enormous range of activities from traditional anatomical illustration and the pictorial description of surgical operations, to the design of health education material for public and patients. Every communication medium is utilized from print to interactive videodisc technology. Every artistic skill and technique is involved from graphic design and typography to the very highest quality of watercolour painting. It is this great variety, together with the intellectual challenge involved, that makes the job so attractive and stimulating.

A medical illustrator may, for example, be required to create a three-dimensional representation of the intimate structure of a virus from microscopic evidence, devise a sympathetic but honest explanation of cancer treatment for afflicted patients or illustrate the stages in a complex operation of the brain, all of which require considerable scientific knowledge and a highly developed visual imagination and great attention to detail.

Hours of drawing in the operating theatre or autopsy room, strict adherence to the laws and disciplines of science and the modest financial returns are not for everyone, but for some this is a profession full of interest and its own special rewards.

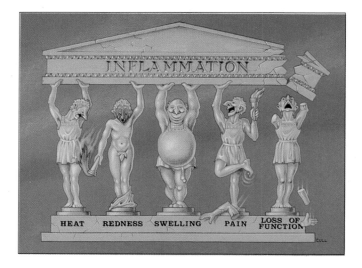

▲PETER CULL
**Inflammation**
Medicine and disease are serious subjects, but occasional humour lightens the burden of scientific study. Provided that it is in no way offensive, a cartoon can make a concept more easily memorable.

▶**The Sobotta Atlas**
In anatomical illustration, the body is portrayed as though "alive", although the artist's source of information is the cadaver. The clarity with which structures are depicted – an essential feature of the work – is far removed from the actual subject which confronts the illus-trator. This superbly informative image is a classic of its kind.

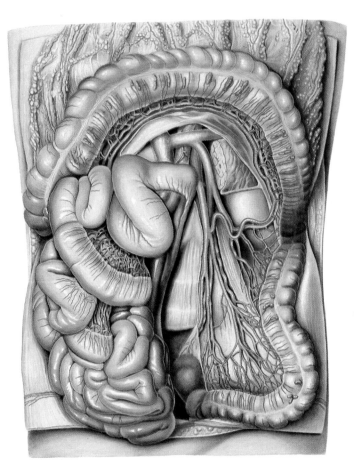

**Phillips Popular Manikin**

The printed anatomical manikin has been popular over several centuries, in recent times more in the public domain than for scientific study. By progressively "peeling" the layers, it helps the viewer to gain a three-dimensional understanding of body structure and the relationship of one organ to another. The accuracy needed for this work is both a technical and intellectual challenge to the artist.

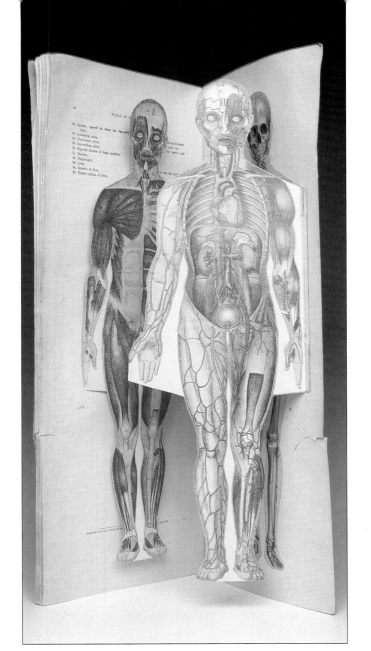

▲ PETER CULL
**Surgical removal of the gallbladder (details)**
The unusual technique of "painting" with carbon dust on a textured ground, removing the highlights with a blade, is almost entirely confined to medical illustration. It is excellent for depicting the moist textures of living tissues.

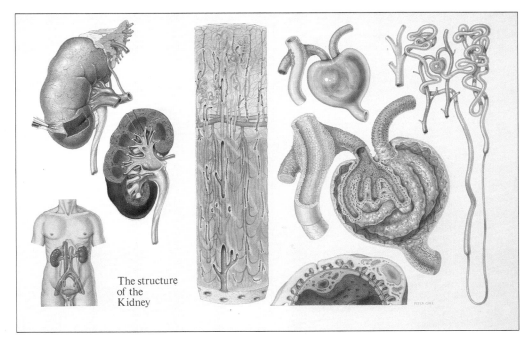

The structure of the Kidney

◀ PETER CULL
**Structure of the kidney**
The illustration moves from the location and appearance of the organ to progressive dissection of the components down to the level of individual cells. Much detailed research was involved, including microscopic observation. The work combines opaque and transparent watercolours with graphite and coloured pencils.

141

# Fashion illustration

Over the past decade the use of fashion illustration has declined because of the interest in and creative use of photography. However, this is now beginning to change and there is again a more positive outlook for those wishing to take up fashion illustration as a career. Many exciting and innovative magazines, such as *Vanity* in Italy and *La Mode en Peinture* in Paris, use illustrators as well as photographers, creating a demand for and a new interest in this very creative area.

The main purpose of fashion illustration is to sell a look or a product, so it is important to be aware of the requirements, possibilities and pitfalls of this occupation.

Although the new look of fashion illustration is about ideas, it is still important to be able to draw the figure really well. Clothes are best seen on the body, to show the movement and drape of fabric, correct proportions, and details of garments. Studying the work of fine artists is a very useful guide to drawing and painting the human figure in a creative way and other illustrators, past and present, can be a source of inspiration.

◀ CLAIRE SMALLEY
**John Galliano catalogue**
Pencil and ink wash with gouache highlights have been used for this illustration for the catalogue of the Autumn/Winter 1987/88 collection. The contrasting use of wash and spatter for the coat and dress respectively show how a fashion illustrator needs to develop techniques to distinguish different fabric textures.

▼ CLAIRE SMALLEY
**John Galliano catalogue**
This formed one a series of pencil and spattered ink illustrations for the Spring/Summer 1989 catalogue. The simplicity of line as well as the pose are used to complement the shapes of the garments in order to convey the "designer's direction". It is usual for the illustrator to employ the model, but the designer is likely to specify hair-style and accessories.

▶ HOWARD TANGYE
This ink and gouache illustration of knitwear by John Galliano, used by the artist for self-promotion, employs an impressionistic style that conveys the shape and "feel" of the clothes rather than every detail of the garments.

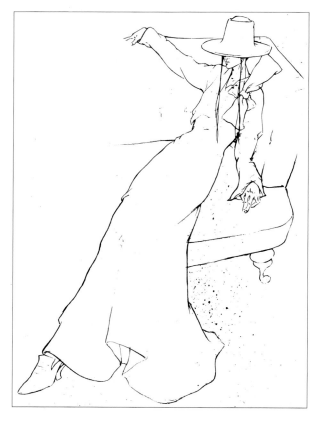

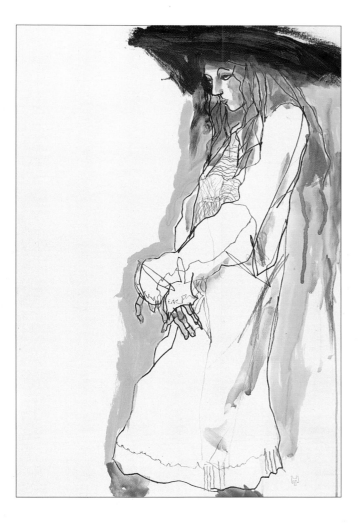

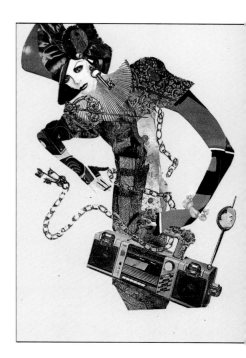

▶ HOWARD TANGYE
**Carrier bag illustration**
This illustration originally formed part of a series of illustrations for the in-house magazine of Glamourette, a designer clothes shop in Singapore. This image, representing the "English look", uses collage to convey a zany atmosphere.

▼ HOWARD TANGYE
The artist used ink and gouache for this unpublished illustration. This combination suits a free style that emphasizes the exaggerated elongated silhouette of the figures. Fashion illustration often requires a front and back view to be shown, and in this case the artist has used this to enhance the composition.

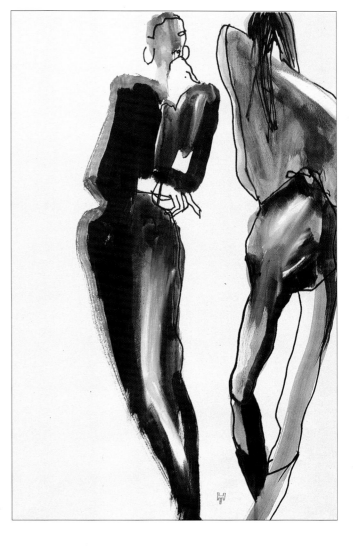

Few colleges teach fashion illustration alone on full-time courses. It is usually part of a design or communications degree. There are part-time courses available in life drawing and fashion and if one is not considering a full-time course then it is essential to take a course of life drawing.

A fashion illustrator must also have a strong sense of colour and texture and the ability to work to a brief and meet deadlines and, as in any other field of illustration, it is necessary to build up a good collection of illustrations for a portfolio.

The main areas of work are within advertising and publishing, packaging, fashion forecasting and department stores in categories of menswear, womenswear and children's clothes. These categories are further divided into hair and beauty, evening wear, day wear, sports wear, suits, separates and accessories.

The sources of work for fashion illustrators are limited and there is a lot of competition. However, if you really have a love for fashion drawing, don't be put off by any difficulties in the beginning.

# COMMON GROUND

"AND THE END OF ALL OUR EXPLORING
WILL BE TO ARRIVE WHERE WE STARTED
AND KNOW THE PLACE FOR THE FIRST TIME.
*Little Gidding* T.S. Eliot

# KNOWING YOUR PLACE

THE EXHIBITION *is* PART *of* COMMON GROUND'S PARISH MAPS PROJECT. *Its* AIM *is to* ENCOURAGE COMMUNITIES *to* CHART *the* FAMILIAR THINGS WHICH THEY VALUE *in* THEIR OWN SURROUNDINGS, *and* GIVE ACTIVE EXPRESSION *to* THEIR AFFECTION *for the* EVERYDAY *and* COMMONPLACE WHETHER *in* TOWN *or* COUNTRY. ARTISTS SPECIALLY COMMISSIONED *by* COMMON GROUND *are:* *Norman* ACKROYD, *Conrad* ATKINSON, *Adrian* BERG, *Helen* CHADWICK, *Hannah* COLLINS, *Stephen* FARTHING, *Tony* FOSTER, *Antony* GORMLEY, *Pat* JOHNS, *Balraj* KHANNA, *Simon* LEWTY, *Ian* MACDONALD, *Garry* MILLER, *David* NASH, *Roger* PALMER, *Judith* RUGG, *Len* TABNER, *Stephen* WILLATS.

AN

EXHIBITION

*of*

ARTISTS'

PARISH

MAPS

FUNDED *by:* *The* ARTS COUNCIL *of* GREAT BRITAIN, TOM BENDHEM, *the* COUNTRYSIDE COMMISSION, J. PAUL GETTY JNR CHARITABLE TRUST, *the* LONDON BOROUGHS GRANT UNIT, *the* ORDNANCE SURVEY, *the* PTARMIGAN TRUST, *the* PUBLIC ART DEVELOPMENT TRUST, *the* CAFE PELICAN (*St. Martin's Lane*), *and the* RAMBLERS ASSOCIATION.

AT

*The* GROUND FLOOR 45 SHELTON STREET *Covent Garden* LONDON WC2

ON

17TH MARCH *to* 25TH APRIL 1987 - 11 AM *to* 6 PM TUESDAY *to* SATURDAY

# ADVERTISING AND GRAPHICS

Illustrators can be commissioned for almost any type of work in advertising. The difference between advertising and design group work is largely one of scale. Advertising agencies tend to handle large advertisement campaigns whereas design groups tend to handle much smaller projects – for example, corporate identities, brochures, logos and so on. Packaging tends to be handled by both advertising and design groups.

In all these areas the illustrator is likely to work closely with an art director and for most jobs the demands of the client will be paramount. In many cases the brief will be very strict, specifying subject matter, dimensions and even medium, but the opportunity for imaginative and innovatory approaches nevertheless exists among enlightened agencies and design groups.

◀ CAROLINE GAUDY AND DAVID HOLMES
**The Common Ground**
This poster for an artists' exhibition was created as part of a campaign for the preservation of the British countryside. Advertising is without question an extremely lucrative field for the professional illustrator. At the same time, it can be a frustrating one in which to work, since the amount of creative freedom allowed can often be restricted by the demands of an agency art director, or those of the ultimate client.

# Advertising agencies

Advertising agencies cover printwork of all descriptions: press advertisements, posters, television. They can be used within these categories in a variety of ways: for example, if an agency is making an animated film as a commercial, an illustrator can be used to style the film – in other words, create the key frames – which would then be put together by a specialist animation company. For example, the British Advertising Agency DDB Needham put together an animated film for the Tate Gallery in which 18 different artists were used to style the commercial before the job was passed on to the animators.

Most of the exciting work in illustration over the last decade has come from editorial commissions. Ten years ago, advertising used illustration as a simple alternative to the ubiquitous photographic pack-shot. The style generally sought after was skilful, but anonymous. In fact, there were only a few illustrators in the late 1970s who seemed to get away with loose "arty" commissions that were not conventionally rendered.

At the time, the only art director to use unconventional illustrators was, perhaps, David Holmes of Holmes Knight Ritchie. For the others, the style was slick, smooth and well-wrought. The illustrator merely rendered the art

director's ideas, as exemplified in the work of Mick Brownfield in the Heineken "Refreshes the Parts" series of posters.

Nowadays illustration is used freely by design groups and magazine houses but advertising still fails to use illustrators as creatively as it might. There are interesting illustrated advertisements around, of course, but few have the guts that a good illustrator can give to a commission if he or she is given a free hand.

There is certainly no shortage of illustration talent. The last time illustration looked as vibrant and diverse as it does today was fifty or sixty years ago. In those days, illustration was the prerogative of a small group of people who could afford to go to college. Art education has become more accessible and the design world now seems to be reaping the benefits. New illustration agencies are springing up every day and the list of talented new illustrators is constantly growing.

### The art director's role

It is a shame that many art directors seem unable to make the most of their illustrators. To do so, an art director has to encourage an illustrator to go further than just re-draw his rough, but in most cases the illustrator is never asked for his or her ideas because the art director does not want them. What he is looking for is someone to make his drawings stylistically acceptable. In fact, most agency art directors would find it threatening to work in the same way as a magazine art editor: in other words to give the illustrator an open brief to come up with an

IN-CAR ENTERTAINMENT AT MOTORFAIR.

*The London Motor Show. Earls Court. 22nd October ~ 1st November.*

▼MARK REDDY
**London Motor Show poster**
Though some advertising art directors are still strangely reluctant to make full use of the potential power of illustration, there is little doubt that, in certain instances, it scores over the conventional photographic approach in terms of power of impact and conveying the chosen message. Here, for instance, this powerfully drawn image immediately captures the eye. The trick here was to deliberately enlarge the original A3 woodcut to create an extremely effective rendering, with the marks made by the woodcutting tools amplified to increase the poster's overall impact.

IF YOU'VE EVER THOUGHT OF STARTING YOUR OWN BUSINESS AS A SECOND CAREER, TALK TO US FIRST

3i
A WEALTH OF EXPERIENCE

illustration which is simply appropriate for the subject matter. In this approach, the art editor or director does not sketch out every last detail of the commission. Instead, the artist is allowed to make a real contribution. Above all, it means taking a risk. Unlike many of my colleagues in the advertising business, I find this approach more exciting. You never know exactly what you are going to get. Sometimes you will be disappointed, sometimes you will be surprised, but in my experience you will rarely be disappointed.

There has been the odd occasion in the past when I wasn't sure if I liked an illustration (which is not the same as thinking it is bad), but I have actually found it pleasurable and stimulating to learn to live with that work. In a campaign I commissioned for the financial company, 3i, I gave all the illustrators involved as much flexibility as possible, and I was never let down.

In fact, illustration is frequently used wrongly in advertising precisely because art directors often fail to give their illustrators enough scope. Most illustrators are

147

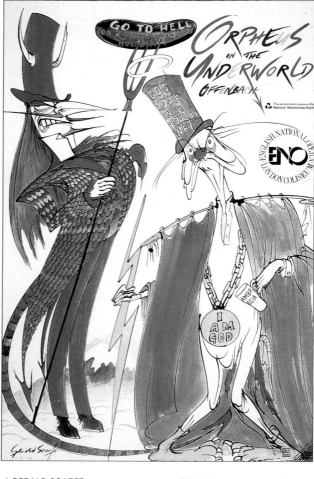

▲ DAN FERN
**London Transport underground advertising poster**
The illustration here has two functions – to promote London's underground transport systems and London's cultural heritage. Because London Transport's logo is so well known, this could be used to convey the first element, leaving the illustrator free to construct an eye-catching central image. The classical collage Fern created emphasizes the wide range of exhibits in one of the city's museums. The message is clear – travel by underground for an interesting day out.

▲ GERALD SCARFE
**Poster for Orpheus in the Underworld**
Gerald Scarfe designed sets and costumes for the English National Opera's production of Offenbach's Orpheus in the Underworld, and his designs for the latter form the basis for this eye-catching poster. He had to overcome an interesting technical difficulty – the brief was for a poster that would retain its effect while wrapped around a pillar outside the ENO's London headquarters at the Colosseum theatre.

better thinkers than most art directors. When I was an illustrator (before becoming an advertising art director), I deliberately avoided advertising work because I did not want to be told how to think. I didn't want to be used just for the way that I rendered a picture. That is not what drawing is about. Drawing is about ideas.

Although some people might worry that giving the artist a lot of scope will mean that they may come back with something inappropriate, this does not happen if the art director uses his skill to pick someone whose work is appropriate for the job in a particular medium. For example, last year I did a series of posters for the London Motor Show, with ten posters that were blown up to 20 x

10ft from drawings that were A3 size. They were very rough woodcuts, and by enlarging them so much, the impact was increased, because the enlargement amplified the marks made by the woodcutting tools.

Trust is again important in how you use the artist once you have commissioned them. Take a project, say, for the International Wool Secretariat. I might, perhaps, commission an illustrator who was particularly good at drawing sheep. After he or she has been given a brief, and has had the client's needs explained to him or her, all the illustrator would then get from me is a brief to fill a particular space. Whether an illustrator does roughs or not depends on which illustrator it is although I do not

usually ask for them. If you have chosen somebody because you like their work, you must trust them to carry it out. The vast majority of art directors might well give the artist a very specific badly rendered rough to follow and then ask to see interim roughs as well. In this way, they kill the artist's creative instincts and are then, not surprisingly, disappointed with the result.

## The client's needs

To keep a commission open and loose as I am suggesting means that the art director has to work much harder. He has to coax the client along, and most clients do not differentiate between an illustration and a scribbled rough. Tell a client that the rough in front of him is destined to become a photograph, that it will inevitably undergo major changes, and he will accept your argument. But most clients see a magic marker outline and the finished illustration as one continuous process. It has not been translated into a new medium and the client may feel cheated when he sees the final illustration. "This is not what I first saw", is the general reaction.

Another problem is that in advertising every commission has to be sold to a whole committee of people. The magazine art editor, on the other hand, has far more personal control over the finished project than any advertising art director can usually lay claim to. Another reason why advertising is a difficult business for illustration is that clients find it easier to understand photography, although even then it can be hard to sell the idea to the client, and when using a photographer you need to allow them to use their imagination in the same way as you do an illustrator. Last year I did a poster campaign with Don McCullen. He produced 16 posters for me, but if you employ someone of his calibre you must give them enough room to experiment and use the talents they have. I spent six months fighting tooth and nail with the client in order to maintain a free framework in which he could operate. My job was really to keep the client away from the photographer, and exactly the same set of guidelines applies when using an illustrator.

## Posters

Perhaps the biggest opportunity lost to illustration over the years has been the absence of great poster work. A poster is a graphic and simple medium: at its best, it delivers a single message, powerfully. Yet all too many amount to nothing more than a giant press advertisement.

Posters are the most visually intrusive form of advertising we have. They impose themselves on any environment. A magazine art editor has to make the best of a few

▼ SIMON PACKARD
**Lynx billboard**
Here, the illustrator has mirrored the strong message conveyed in the words on the billboard. The end result is a powerful statement of the conservationist cause, expressed clearly, directly and in a way that will immediately catch the attention of the casual passer-by. The billboard's one message is delivered with utmost power and to maximum effect.

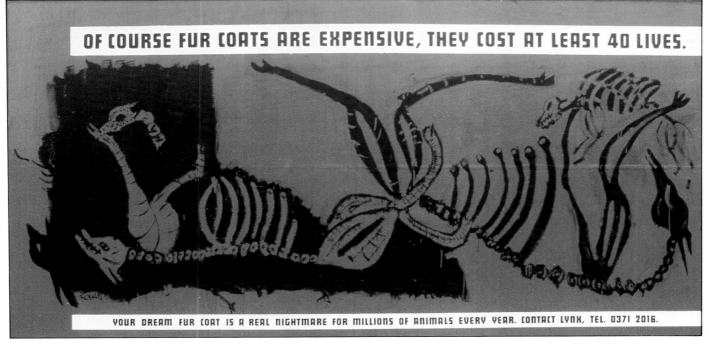

97% OF THE CROPS GROWN BY THE ETHIOPIAN GOVERNMENT DON'T FEED ETHIOPIANS.

IF YOU'RE ON OUR SIDE, SAY SO.

inches of space, whereas the ad-man works on a canvas 10ft high by 20ft wide. His work becomes part of the landscape. So it follows that the art director has quite a responsibility when it comes to contributing something to the environment. This doesn't mean that every poster has to be a thing of great beauty, but it should have real impact and meaning.

This directness of approach was easier thirty years ago when a poster was rendered by one hand – the art director and artist were one and the same, and the poster was the work of one individual who had to convey an idea and render it dramatically. People like Edward McKnight-Kauffer, Paul Nash and Ben Nicholson did not have any tricky little puns to work with, but the strength of the image was often riveting.

The 1980s, on the other hand, have given us bland poster campaigns, like Cadbury's Creme Eggs. They amount to illustrated one liners – which is fine – but unfortunately the actual rendering of them has no impact.

## Corporate work

A ray of hope for illustration in advertising lies in the growth of corporate work. By its very nature, this kind of advertisement deals in abstracts, not pack-shots. Often the nuances and concepts employed in this form of advertising cannot be suggested by a simple photograph. But illustration, on the other hand, can be as complex or as direct as needed. Financial advertising, like 3i, has shown what illustration can do for advertising generally. It is now up to the art director to push the use of illustration in advertising still further.

## The scope for illustrators

Despite the lack of adventurous commissioning in advertising, from an illustrator's point of view advertising offers more scope than many other fields. The prime advantage is that it pays far better than any other outlet. A single illustration in an advertising campaign can easily earn the artist large sums of money. This leaves the artist with time to experiment and work on areas of his or her own interest, and to develop his or her creative talents.

PURE NEW WOOL    PURE NEW WOOL

third of the fee. They do protect the illustrator to some extent, although I think, on the whole, photographers' agents do a better job and work harder for the money. Some illustrators' agents tend to represent too many people. You would rarely get a photographers' agent who looked after more than five or six photographers, whereas an illustrators' agent might have up to 40 on his books. In fact, an agent is probably most useful when you are already established and want to spend your time on your work, rather than on seeing numerous clients.

▼ JANE STROTHER
**Toiletries packaging**
Jane Strother is a versatile illustrator who is able to work in many different mediums. For these packages for Farrow and

Humphreys toiletries, she has used delicate watercolour and crayon. The brief included the precise dimensions of the packaging. The artwork for each item was commissioned as a single piece.

Illustration today is healthier than it has ever been. The illustrators I see come from art schools all over the country. No one art school predominates, as perhaps it did 20 or 30 years ago. Today good illustrators come from all areas and their style is satisfyingly disparate.

If a student comes to see me with a portfolio, the process is always the same. I look at their work, and then I file the best ones – usually about 50 per cent of those I see. To do my job well, it is important to have a very good filing system and to remember everybody whose work you liked. Because advertising is such a long-winded process, it's important to be able to pull the names you need out of the file when you want them.

It can be dispiriting for young illustrators to take their portfolio around, and many of them use agents although they take a large cut of money for the job – around a

## ADVERTISING

**CLIENT** *3i*
**ILLUSTRATOR** *Andrew Mockett*
**BRIEF** *All the illustrators involved in the campaign were given an open brief: little more than the wording and the space to be filled.*

3i, a financial corporation that specializes in venture captial funding for new businesses and so on, has always had a tradition of using illustrators. Previously, a campaign had been running for some years using the illustrator Jeff Fisher, but since few agencies want to tie themselves exclusively to one illustrator it was decided to try a new approach for this campaign. Mark Reddy, then the art director, wanted to create a look that would hold together whatever the medium – whether a fine ink drawing or a woodcut, and commissioned nine separate advertisements from different artists. He had worked before with Andrew Mockett, who makes large black and white woodcuts, and asked him to try his hand at colour.

None of the artists was given a detailed brief. After an initial meeting at which agency and illustrators agreed on rough areas of subject matter, they were given the words and left to come up with their own solutions as to how to fill the space. In Andrew's case, he then simply went away and did it, getting it right first time despite it being his first attempt at a colour woodcut.

▲ **Rough sketches**
Andrew Mockett describes how he arrived at the final illustration. "After initial briefing discussions with the art director, I mapped out some rough ideas in my sketchbook. These concentrated on details of the idea I was working on; I do not usually do a full compositional rough. The image was to be a seven-colour woodblock print.

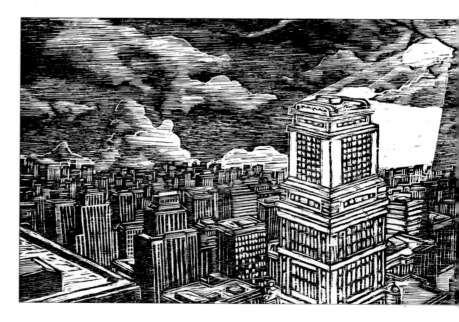

▲ **Black line block**
"Once I was happy with the idea, I produced a black line block. A hand-coloured print from this served as a presentation rough for the art director and client.. I used prints from the block as a base for the colour blocks, outlining in chinagraph on cel the area to be printed in each colour. These areas were transferred to the new blocks by rubbing down the chinagraph image.

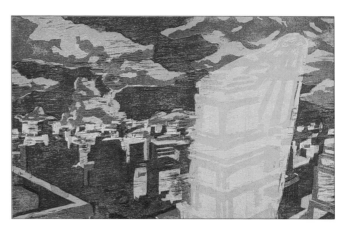

**▲ Printing stages**

"The image was then printed starting with yellow and then overprinting with orange. Further colours were added in the following order: red, royal blue, dark blue, brown. I was able to increase the colour range by printing one on top of another, for example, greenish tints appear where I overlapped the blue with the yellow. For the brown, I used the original black block with the areas to appear black masked out."

**▶ Finished poster**

The finished poster has a strikingly original design of its own, the effect the art director was aiming at throughout the advertising campaign.

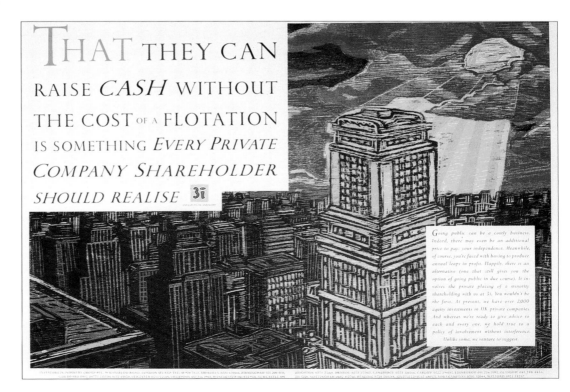

THAT THEY CAN RAISE *CASH* WITHOUT THE COST OF A FLOTATION IS SOMETHING *EVERY PRIVATE COMPANY SHAREHOLDER SHOULD REALISE* 3i

153

# Design groups

There was a time, perhaps twenty years ago, when commercial illustration was regarded as the poor relation of the arts world: an option taken by failed painters who weren't quite good enough to make it as fine artists, and so were forced to "sell out" to commercialism.

No longer reliant upon the fine arts as the source of its roots, this form of illustration has come of age. It has found its own niche within the arts, and so become a recognized profession in its own right. And innovative illustrators have the opportunity to satisfy their creative needs as more and more designers, art directors and (ultimately) clients are willing to push forward the boundaries of "acceptable" commercial imagery.

Design is considered a revolutionary process, or so a lot of people would have us believe; but the truth is that it is evolutionary. It is impossible to cut off the past and plot

▼ GUY BILLOUT
**Building as an adventure**
Guy Billout achieves a strikingly luminescent quality in his illustrations, using watercolours airbrushed into detailed outline drawing. The flawless surface finish and even gradations of colour produced by the airbrush enhance the natural translucence of watercolour, giving each hue and tone its clear value. The paint is applied to quite heavily grained cartridge paper that contributes a texture particularly appropriate to this image. The subject of this illustration for an architect's brochure readily breaks into flat colour areas, the balance of tones being carefully judged to emphasize the three-dimensional solidity of the buildings, but a sense of extraordinary possibilities is represented by the windows of the main building scattering outwards like so many playing cards, and the car careering on two wheels towards the viewer.

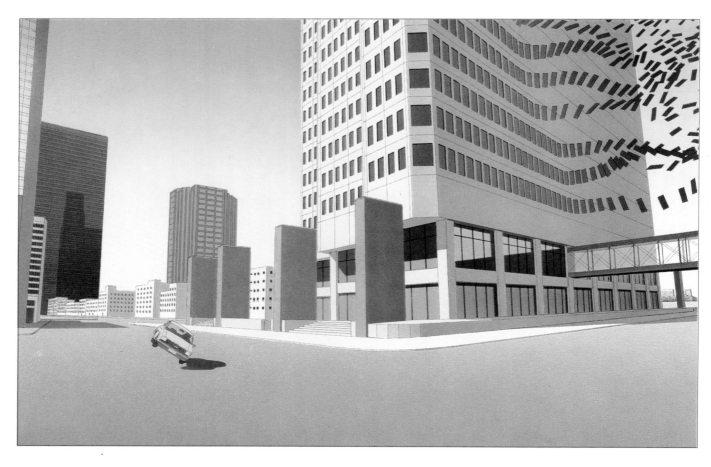

▼ PAUL DAVIS
**Brochure for Epigram**
This was commissioned by the design group Fielding Rowinsky for the public relations company Epigram. British Airways had produced a tape for their employees instead of the more traditional magazine, and this forms the theme of the illustration, done in ink and masking fluid.

▲ BRIAN GRIMWOOD
**1987 ABSA awards report**
This illustration brings a lively touch to a straightforward business document – the financial report of the Association for Business Sponsorship of the Arts. The simple silhouette executed in gouache has a complex rhythm created not only by the varied shapes and edge qualities but also by the subtle touches of red introduced into the mainly black shapes. The image can be read in this context as having either a specific theatricality or broad reference to many aspects of artistic presentation.

155

▲ WALTER VAN LOTRINGEN
**Hewlett Packard brochure**
The computer company Hewlett Packard has recently implemented new guidelines for corporate design worldwide, and the design group Samenwerkende Ontwerpers were asked to design several brochures for them. The end result was a bold graphic style, initially developed as woodcuts. On Hewlett Packard equipment the images are generated in crude computer graphics ideally suited to the client's needs.

a future without an awareness of what's gone before – a discernible thread of influence which filters down to the best contemporary illustrators working today.

Whilst acknowledging the contribution made by great Victorian line artists such as John Leech and George Cruickshank, the beginnings of commercial illustration came at the end of the previous century with the Beggarstaff Brothers, William Nicholson and James Pride. They had an enormous influence on the development of the modern advertising poster. At a time when manufacturers bought works of art to advertise their wares (the Pears "Bubbles" poster by Millais being a prime example), the Beggarstaff Brothers conceived the idea of images created especially for, and unique to, a particular product. More than that, they actually foresaw the changes that the motor car would impose on social conditions, and simplified illustrations into graphic shapes which would not only be legible at speed, but could also be mass produced, thanks to the advent of lithography.

Unfortunately, the Beggarstaff Brothers were less than successful in commercial terms, although their influence was to spread beyond Britain to Europe, and prove inspirational to great artists and illustrators in the generations to come. The likes of McKnight-Kauffer, for example, one of the best known poster artists of the 1920s, '30s and '40s, and Claude Lovat Fraser, also an admirer of the very simple woodcuts of Joseph Crawhall (who previously had been inspirational to the Beggarstaff Brothers themselves). The list goes on to include Paul Nash (himself a friend of Lovat Fraser), who in turn went on to teach Edward Bawden and Eric Ravilious – both of whom are generally regarded by many as the founders of modern illustration.

◀ WALTER VAN LOTRINGEN
**Reliability**
PTT Mail (recently privatized), gave four artists an open brief to come up with visualizations on three main topics: reliability, speed and expertise. Van Lotringen's treatment, in a style similar to the Hewlett Packard designs on the facing page, was the one chosen. For this image he aimed to show a post office as a "technological beehive". He says: "Since bees are highly organized, disciplined and efficient, this seemed to be the right symbol."

There are many more, like Edward Ardizzone (a great storyteller in pictures and words) and fine artist/printmakers such as Wadsworth and Nevinson. These artists represent not just a potted history of illustration, but a collection of personal heroes whose ground-breaking work of the past still inspires innovation in illustration today.

### The scope for illustration

Designers work with illustrators for a multitude of different reasons. Generally speaking, illustration can go where the camera lens never penetrates – recording an event that hasn't happened yet, a building still to be erected, or a service which is intangible. It can be used to make complicated things understandable – an exploded view of a car engine within a parts catalogue, for example. Or in the case of corporate brochures, a map showing a company's whereabouts, illustrated in a style which is sympathetic to the overall design.

In terms of packaging, illustration can show off a product to its best advantage, while still telling the truth. Or it can actually enhance the product; many illustrators owe much of their success to their ability to make dull products look interesting. It can demonstrate the use of a product, or perhaps depict an item which is still in the prototype stages, and so unavailable for photography.

Equally, illustration can be used to express a mood or a feeling. One of our packaging products for Marks & Spencer comprised a range of American cakes with such tantalizing names as Mississippi Mud Pie. The brief was to produce packs which conveyed the feeling of America, but from an English point of view, in an immediately recognizable and understandable way. Our solution was to set photographs of the cakes against an illustrated

157

background that depicted the kind of American ephemera picked up by a tourist. A kind of illustrated "Have a nice day!"

Few designers would argue that the most interesting design and illustration often results from the need to solve a client's problem, rather than from a determination to be innovative for its own sake. At the beginning of the 1980s for example, most brochures produced by banks and financial institutions tended to be rather staid, relying to a great extent on photography. However, when Midland Bank approached us to design a series of brochures advertising their international business services, there simply wasn't sufficient budget to send a

photographer (or illustrator) abroad. So our alternatives were to opt for stock photographs, which would have led to a pretty unexciting result, or to go for illustration.

Even though Midland was a corporate client, what they offered in each country varied according to local conditions. So we needed to select illustrators who would be able to evoke local characteristics without setting a foot on foreign soil. When it came to illustrating the French brochure, for instance, Glynn Boyd-Harte was the ideal choice, because of his knowledge of the country and his ability to draw ephemera and buildings. With the brochure for Canada, we worked with Chris Corr, because through his work as a travel illustrator, he was able to adopt the kind of approach which would convey the feeling of breadth that we wanted.

There is an irony in the fact that part of the reason for the emergence of illustration as a recognizable creative force stemmed from a shortage of cash. In the early days of design groups, illustration was simply so much cheaper than photography. To be fair, this is only partly the truth. For many designers it was (and still is) so

▼ JEFF FISHER
**Wonders of the World**
This illustration comes from a Trickett and Webb calendar called Seven Year Itch and illustrates the seven wonders of the world, but the artist has been allowed to represent his own, rather than the conventional view of what the

wonders of the world might be. The images combine whimsical and philosophical viewpoints creatively mixed in an effective composition, with an inventive use of texture in the design. The calendar was printed as silkscreen, so the illustration was produced as separated artwork.

much easier to work with illustrators because of the common grounding at art school. At that time, photographers tended to come up through a different background, and were more used to dealing with advertising agencies and magazine editors than with design groups. Illustrators, having gone through a similar art education, were more likely to "speak the same language", making the personal relationship that much easier.

These days, those barriers between photographers and designers have broken down. But for many designers, photography still presents difficulties. How do you art direct a photograph without constantly looking down the lens, for example?

### Briefing the illustrator

Whatever the job, the designer has to gain the confidence of the client that the concept is going to work. The client takes an awful lot on trust, but the designer still has to help them visualize the finished result. One of the difficulties is that the designer often can't get the

illustrator to draw specific roughs at such an early stage, and so is faced with a choice. The designer can present the client with examples of an illustrator's existing work, in order to give a feel of style and approach, though obviously not a detailed idea of what is being proposed. The alternative is for the designer to prepare imitation roughs for the client, stressing all the time that this is just an indication of what the illustrator might do. The inherent danger here, which is not unknown, is that the client can end up preferring the designer's roughs.

Having a good working relationship with an illustrator means that problems are avoided, because of involvement at the crucial development stages. However, since

▼CHRIS CORR
**The Pompidou Centre, Paris**
For a calendar illustration commissioned by BTH, a Parisian design group, Chris Corr was given the theme of the Les Halles district of Paris in which the company is based. He chose to focus on the forecourt in front of the arts centre where there are often informal performances of various kinds. This colourful, crowded image is the result. The final version was spontaneously produced although the artist had previously done many sketches and scribbles at the site to capture atmosphere and detail.

for many reasons this isn't always possible, the designer also needs the confidence that the illustrator isn't just going to copy the roughs, but actually make a contribution. In other words, not just to decorate the page, but add that something extra which justified the client's trust in the designer from the outset.

It comes down to the question of how do you tell an illustrator what to do without telling them what to do? There are those illustrators who need to be briefed down to the last detail, who do need to be told, "I want it like this". But for us, the most successful and exciting re-lationships are those which result in a two-way dialogue: each acting as a sounding board for the other's ideas, and together pushing the boundaries further. In the case of New York-based Philippe Weisbecker, the dialogue is via the fax machine – but just as effective.

## Finding the right illustrator

Choosing an illustrator tends to be rather subjective – you either admire their work or they're suitable for the job (and more often than not, a combination of the two). What you're actually buying is a recognizable style, and/or an individual approach to problem-solving that is unique to that illustrator.

▶ KEVIN DEAN
**Elephants**
This is one of a series of six images of animals in jungle environments produced by the artist for reproduction on tin boxes designed to hold pencils. The containers measure 180mm (7in) by 75mm (3in) and are sold through a variety of retail outlets including the gift shops of zoos and wildlife parks. Details for the jungle environment were drawn from the plants in the greenhouses at Kew Gardens, London, the animals were mainly taken from photographic reference. The media are watercolour and gouache.

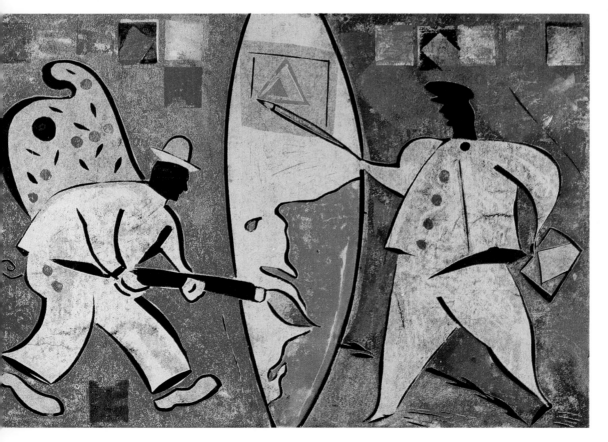

◀ ANDREW KULMAN
**Kleur**
This coloured lino cut on Japanese paper was one of a series of limited-edition posters done for the Dutch paper manufacturer Burhmann Teterode. The design group Top Drawer commissioned five artists to produce one each, showing elements of design and typography as related to specific papers. The theme here is colour.

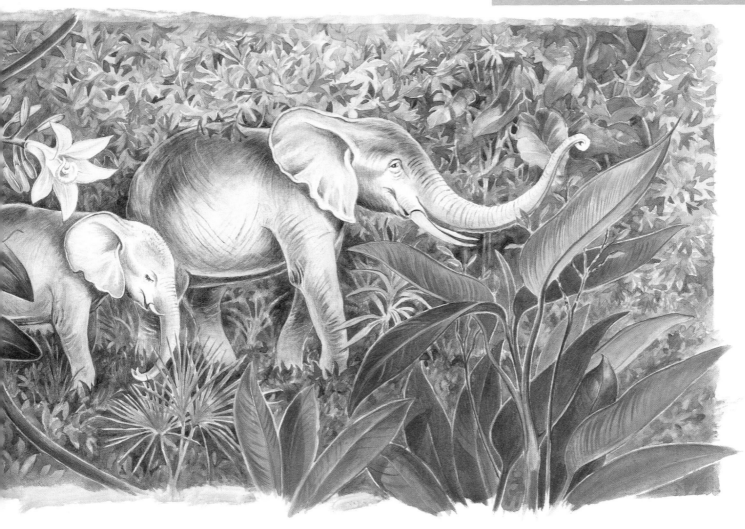

A recent job involved packaging a series of disparate products loosely termed "men's gifts". The products themselves could not have been more varied – anything from a box of hankies to a car- cleaning kit. The idea was to link them in the form of a "library" of books. Hence the shoe polish set became "Shoe Shine Outfit", illustrated by Mark Thomas in the style of an American paperback thriller, and the car-cleaning kit became "A Chauffeur's Reflections", and featured an evocative period illustration by Paul Leith. What was particularly nice about the job was that we were able to explore the history of book illustration and at the same time incorporate an element of wit. Other packs in the range were illustrated by Tony McSweeney, Debbie Cook, George Hardie and Paul Cox, each of whom brought their own style to the individual "book jackets", without the need to resort to pastiche.

Just as the best illustrators all have a very clear personal identity, a commitment to professionalism is equally important. In most jobs there is a time element,

which usually leaves no room for mistakes. Inevitably, this often leads to designers using the same tried and tested illustrators, because you know, to an extent, that you're going to get a guaranteed product. This is not to say that a guaranteed result is the same as a known result. If you know from the outset what you're going to get at the end, there's really no point in commissioning an illustrator.

**Commercial pressures**

One of the biggest problems of being an illustrator is that you've only got one pair of hands. And you can guarantee that if you take on a commission on Monday, the most wonderful job in the world will come along on Tuesday and you might have to turn it down. Renegotiating a different delivery date can sometimes present an option, depending on the nature of the job, and the degree of give and take between designer and illustrator. (This notion of give and take can be extended to varying degrees). We commissioned Ian Beck to produce

△ **JEFF FISHER**
**Unusually good haircuts**
This extraordinary image is a poster for an exhibition of work by British illustrators held at the Minneapolis College of Art and Design. The artist was given an open brief to produce a wild and entertaining image. Each of the exhibiting illustrators is shown, with an appropriate haircut, in the panels along the bottom of the design. The image is worked in acrylic, with strong colour values contributing to its graphic appeal.

illustrations for a promotional brochure for a client/ friend's hotel-cum-restaurant in Kent. He, like us, agreed to be paid in dinners!

Commercial pressures undoubtedly place limitations on the types of job that designers can offer untried illustrators, which is part of the rationale behind the Augustus Martin/Trickett & Webb calendar. An annual collaboration between design group, printer and illustrator, the calendar represents a testing ground by which we can work with old friends and younger illustrators. It enables us to commission illustrators whom we wouldn't normally have the chance to use, and establish a relationship in which we discover how that person works best.

**The way ahead**
What today's most innovative illustrators share, in common with heroes from the past, is a personal vision which continues to expand the parameters by which we define good design. Safety equals boredom, which is why such illustrators are constantly moving on, taking risks, and developing their styles. So when we take up the dialogue of such long-standing relationships, the object is not to repeat what has gone before, but to go on to a new chapter in a continuing story.

▽ ANDREW DAVIDSON
**Stamp designs – Transport**
Travel posters of the 1940s are evoked in these stamp designs by both the style of the illustration and the device of having one corner of the image peeling back as if coming away from a wall. Strong shapes and clean, flat colours make for powerful images even though these illustrations are designed to be seen reproduced on a very small scale.

**▲ MILES ALDRIDGE**

**CD covers for Boots Classical Collection**

For a brief to produce covers for a complete new range of compact discs, The Ian Logan Design Company commissioned many artists to provide the images. The basic layout of austere black and white was already designed (by Alan and Stuart Colville) and the illustrations were intended to add jewel-like colours. Miles Aldridge researched the music and the composers before starting straight in on finished illustrations, using acrylic paint and working at a size of about 300mm (12in) width. The images are kept bright and clean, with no blacks used at all, to contrast with the overall design.

**▶ ANDREW DAVIDSON**

**Station Gate**

A vividly graphic effect is achieved here by the apparent simplicity of form and strong tonal contrasts. The style is perfectly suited to reproduction of the illustration as an enamelled pub sign. The artist was required to submit the original as separated artwork after approval of colour roughs.

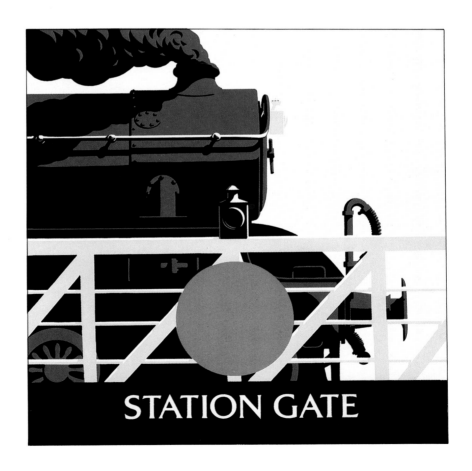

STATION GATE

163

case study

## STAMPS

**CLIENT** *The Post Office*
**ILLUSTRATOR** *Graham Evernden*
**BRIEF** *To design a set of colourful stamps to commemorate England's defeat of the Spanish Armada in 1588.*

**Early planning**
One of the most important considerations was the style of the illustrations, so Graham went to the National Maritime Museum to hunt for contemporary visual references. Some of these are shown on the following pages. Once he had a clear idea of the subject and how he was going to treat it, he began to sketch out ideas, first on the backs of envelopes (left) and then on stamp blanks provided by the Post Office (below).

Graham says that he found this commission a particularly stimulating and exciting one, not only because the set was one of the most important issued for some time but also because it was to be produced as a se-tenant (printed in one) strip, a rarity in the field of philately. However, this does have its limitations, the main one being that there are only seven colours for all five instead of seven colours for each stamp.

As Graham began to read up on the Armada, a design solution quickly presented itself, which was to show the progress of the Armada as it moved up the English Channel, looking towards England, so that it would be moving from left to right across the strip of stamps. Each one could show an important stage in its progress, and each could be captioned with the position and date, to add to the feeling of movement. The five stamps together would present a panoramic view of a great sea battle. Graham wanted the stamps not only to progress in time but also from soft colours to harsh darks and lights; from smooth seas to a raging storm at night; from the flag-waving atmosphere to the battered fleet that was driven off up the North Sea.

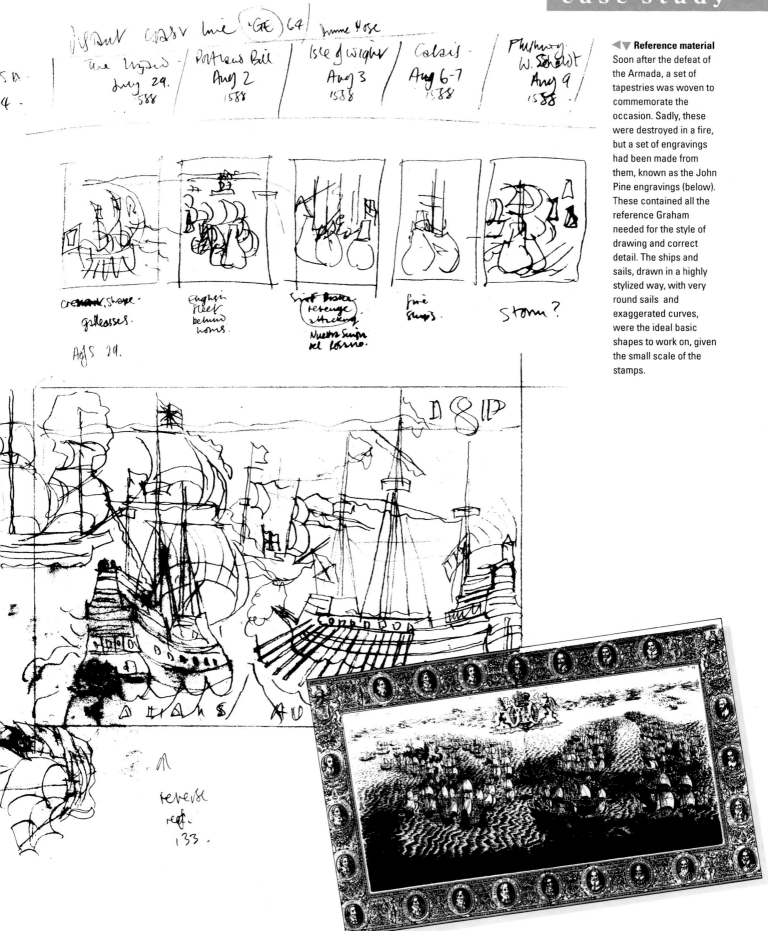

**▶▼ Reference material**
Soon after the defeat of the Armada, a set of tapestries was woven to commemorate the occasion. Sadly, these were destroyed in a fire, but a set of engravings had been made from them, known as the John Pine engravings (below). These contained all the reference Graham needed for the style of drawing and correct detail. The ships and sails, drawn in a highly stylized way, with very round sails and exaggerated curves, were the ideal basic shapes to work on, given the small scale of the stamps.

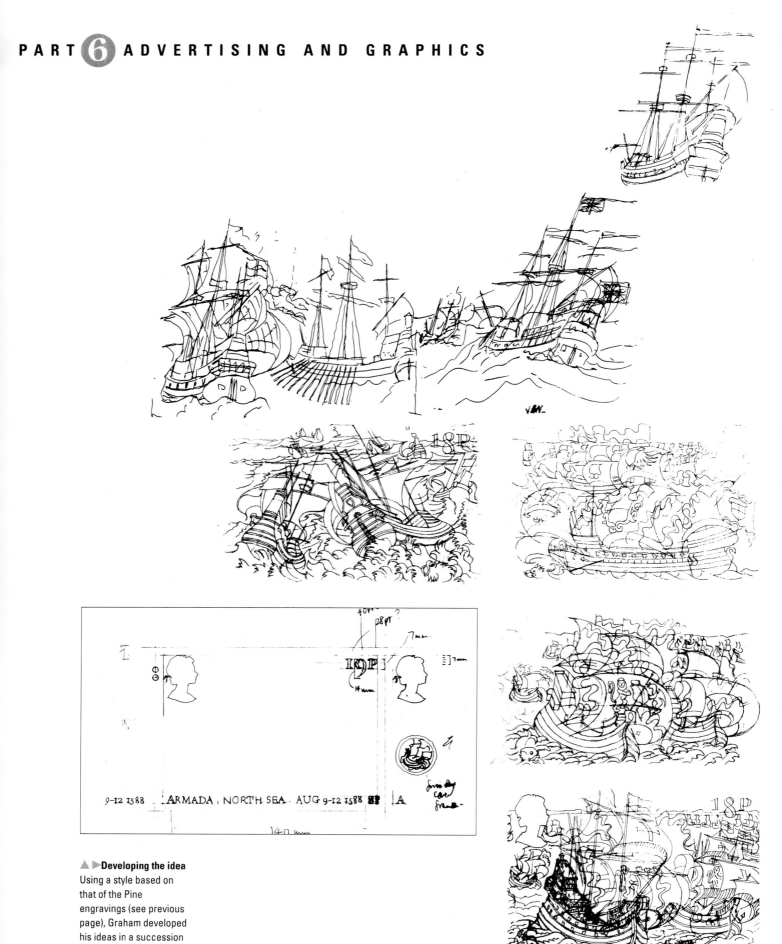

▲ ▶ **Developing the idea**
Using a style based on
that of the Pine
engravings (see previous
page), Graham developed
his ideas in a succession
of line drawings.

166

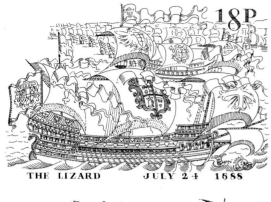

THE LIZARD    JULY 24  1588

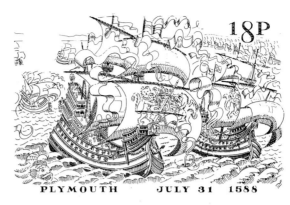

PLYMOUTH    JULY 31  1588

**▲ The Queen's head**
The original PMT supplied
by the Post Office was
reversed to face right.

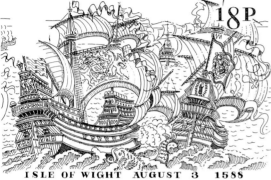

ISLE OF WIGHT  AUGUST 3  1588

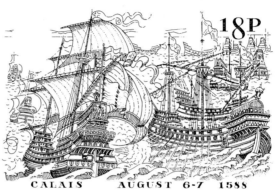

CALAIS    AUGUST 6-7  1588

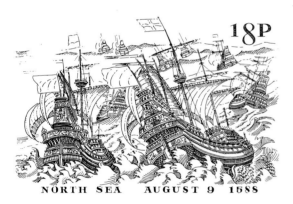

NORTH SEA    AUGUST 9  1588

**▲ Line drawings**
The first presentation of
the designs was in the
form of colour-tinted
versions of the line work
shown here.

**▼ The finished artwork**
The artwork was painted
in watercolour as one
single piece 107cm (42in)
long, four times the length
of the finished stamps.
The final artwork is shown
below. The printed stamps
are reproduced at the
bottom of the page.

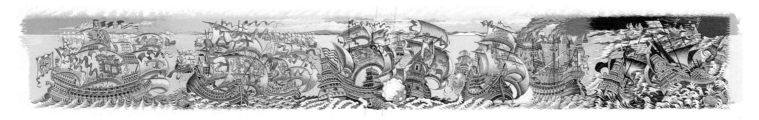

# THE MOVING IMAGE

In many ways, animation is different from the other sources of illustration discussed in this book, because it not only embraces the skill of the drawn image but the technique of film-making as well. To succeed as an animator you need to be skilled in many diverse ways – as a draughtsman, as a story-teller and probably as an entrepreneur as well.

Animation is used more widely than people often imagine, for example in the commercials and in graphics for films, and it is becoming increasingly popular and gradually more valued as an art form in its own right.

Because animation today cannot be divorced from the animated films of the past, in which their existence is rooted, this chapter also contains a brief guide to the history of animation as well as more direct advice on how to become a successful animator.

◄ BOB GODFREY
**Henry's Cat**
Bob Godfrey and Stan Hayward worked together as an animation and writing team to create this popular children's series in 1982. Godfrey's other success include *Rhubarb and Custard*. His work demonstrates the varied skills an illustrator needs to succeed as an animator – as well as the ability to draw, you need to be able to tell a story visually.

# Animation

To animate means to breathe life into, to inspire. By making drawings (or 3D objects) move, animation makes fantasies believable: animals talk, dreams come true. Through advertising and cartoons, animation is normally associated with entertainment or com-mercialism, but it can be as much a pure art form as painting or sculpture.

Animation is based on illustration, because traditionally it involves drawing, but it is much more than that. While your drawings are the cornerstone of the idea in animation the element of movement means that what the picture looks like is only one factor in the aesthetics of animated film; timing is equally important and can never be divorced from the look of the work.

The other key element in animation is film. Even if it is the most sophisticated 3D computer-generated film, it is still film. Though animation was invented before cinema, the theatre of film, it has adopted cinema's classical forms. Just as D.W. Griffith was more or less solely responsible for the grammar of cinema, its visual and dramatic structures such as montage and parallel action, so Walt Disney developed the language of animation.

Disney was a great artist and a great manipulator, which is after all what artists do. Other brilliant animators – Norman McLaren, Frederic Back or Yuri Norstein – have greater intrinsic genius, but Disney is notable for his coherence in expression even though thousands of people were involved in creating his vision.

Disney dazzled – and still dazzles – cinema-goers by building a perfect world. In Disney's films you never find surprise and shock; but this aesthetic, a form of make-believe which is astonishingly rewarding and beautiful, became one of the main animation languages in the 1930s and 1940s.

A completely different but equally important facet of animation's artistic identity was developed by Norman McLaren, a Scot working for the National Film Board of Canada. He developed his own technology – scratching images directly on to film – to create some of the most beautiful abstract films ever made. His great ear for music helped him convey a particular audio-visual quality in his films; sound and pictures connect perfectly. He didn't use

▼▲▶ YURI NORSTEIN
**The Overcoat**
Based on a story by Gogol, *The Overcoat* is Norstein's current work. After eight years, some 20 minutes of this feature length film have been completed. The sketches (above and right) are studies for a sequence showing the main character, Akakii Akakievich, writing a letter. In the finished image (below) he is returning home in a snowstorm. Norstein's innovative use of a multiplane camera that allows a greater depth of perspective to be used than is achievable with a conventional 2D animation camera enhances the ability to render subtle facial expressions. He has said, " In making *The Overcoat*, I have made lots of progress towards discovering what exactly is the phenomenon of animation and I have found it can present the most precise psychological exposition of a character of which acted cinema is not capable." (*Direction*, November, 1987).

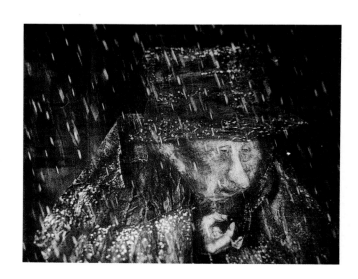

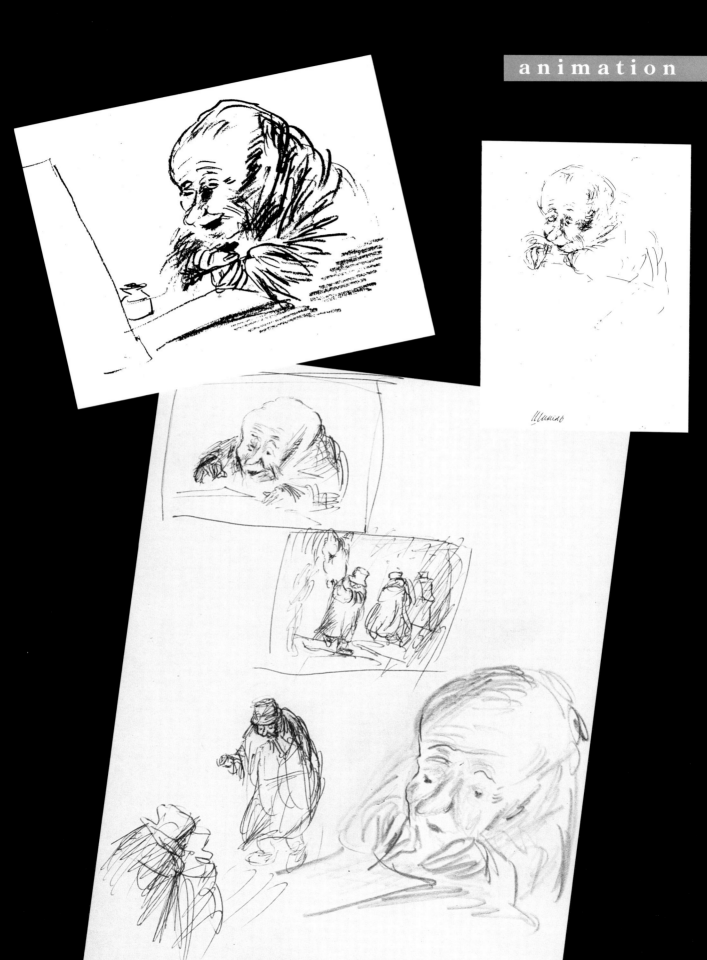

Шинель

"THE OVERCOAT"

# THE HISTORY OF ANIMATION

Over hundreds of years attempts were made to breathe life into drawings or silhouettes, with the Chinese shadow theatre, flip books and magic lanterns. In the 1830s, with a better scientific understanding of the phenomenon of "persistence of vision", inventors came close to prefiguring animation as such.

The Belgian, Joseph Plateau, produced his *phenakistiscope* in 1832, a mirror-lined viewer through which drawings on a cardboard disc were passed. In 1834 W.G. Horner in England invented the zoetrope, a revolving drum with slits through which you could see a moving image.

In France in the 1880s and 1890s, Emile Reynaud developed a praxinoscope, a sophisticated version of a peep show which used a complex mirror arrangement; by combining it with a projector, he was able to show strip cartoons in 1888. Reynaud is notable for his *Théatre Optique*, opened in 1892 specifically to

give shows of his little cartoon skits.

Meanwhile the ciné camera was developing fast, and mechanical methods such as Reynaud's were destined for obscurity. In Paris by the mid-1900s Georges Melies and Emile Cohl were

making trick films using the cinematic techniques of cutting and editing, and in 1908 Cohl was to produce one of animation's first characters, *le fantche* (the puppet).

The title "father of modern animation"

▶ MARC DAVIS
*Chanticler*
In the early 1960s, when the studio was moving towards the decision to withdraw from animated features, Davis and several colleagues began to work on the idea of doing Rostand's *Chanticler*. They made a presentation of their work, but had no success in changing the studio's policy and the 50 or 60 drawings, of which "Reynard's wife and kids" is one, were stolen.

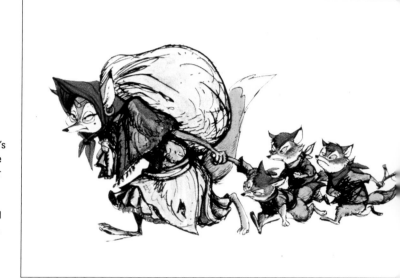

▶ MARC DAVIS
*Bambi*
Davis is one of the "nine old men" who, along with Disney, created the body of animated classics synonymous with the Disney name. This was his second feature (as animator), his first being *Snow White and the Seven Dwarfs* (as assistant animator).

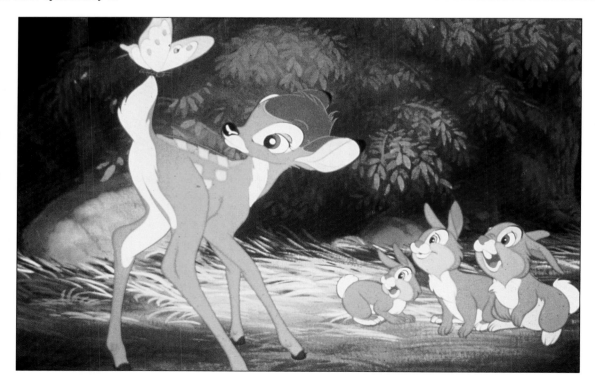

probably goes to J.S.Blackton, an American newspaper strip cartoonist, who successfully combined his art with cinema to make the first animated cartoon – *Humorous Phases of Funny Faces* – in 1906. Equally outstanding technically and perhaps more so artistically is Winsor McCay, originator of the newspaper strip, *Little Nemo*. He produced an animated version in 1911, and took the cartooning world by storm in New York in 1914 with the public release of *Gertie the Trained Dinosaur*. It was Gertie who showed the world just what animation could do, artistically and (much to McCay's disgust) commercially. The following years, during which World War I made big demands on the acknowledged propaganda and instructional capabilities of animated film, saw the adoption by American animation (Bray, Barre, Pat Sullivan, the Fleischers, W. A. Carlson) of the cinema studio system as technical innovations improved the

economic viability of the form. Entertainment animation, like cinema, was generating its own stars, many of them crossovers from newspaper cartoons. The undisputed doyen was Otto Messmer's *Felix the Cat* from the Pat Sullivan studios in 1920. Felix was a seminal influence because he was the first believable animated cartoon character who moved with an "interior will".

In the 1920s animation output in Europe and Russia began to move apace. Rabier and O'Galop in France, G.E.Studdy in England with *Bonzo*, and the first Russian cartoon, *Buskin's Soviet Toys* (1924), are notable. Fernand Leger's *Ballet Mecanique* (1924) is held to be an outstanding example of European experimental animation. Competition between the American studios was fierce; attempts had been made to put sound on to cartoons, but the first with a synchronized soundtrack – *Steamboat Willie* (1928), with Mickey Mouse – was by Walt Disney.

### The golden age of animation

Disney's output dominated the 1930s and early 1940s; he won every Academy Award for animation between 1932 (when the category was initiated) and 1940. His other breakthroughs included the first cartoon shot on colour stock – *Flowers and Trees* in 1932 - and the first successful animated feature – *Snow White* in 1937. *Pinocchio, Fantasia, Dumbo* and *Bambi* followed in the period 1940–42.

Disney's successes created a boom market for commercial American animation; many more studios set up in competition, the most notable being Leon Schlesinger's Pacific Title and Art, which produced films for Warner Brothers. Schlesinger's talented animator/directors included Bob Clampett, Tex Avery and Chuck Jones, all of whom had a hand in the appearance of Bugs Bunny in final recognizable form by 1939.

Meanwhile, independently of the studios and waving a flag for "art" or

◀ MARC DAVIS
*Chanticler*
These two drawings from Davis's never-made film show "the white pheasant and her manager" and "Reynard drinking absinthe in a bistro."

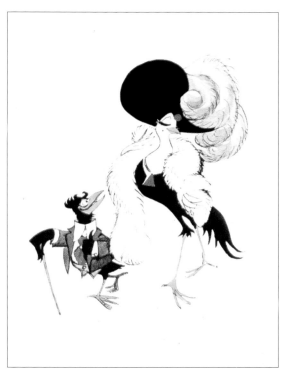

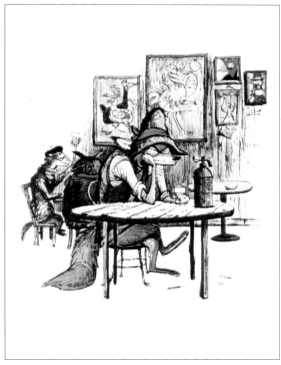

experimental animation, were: Len Lye and Norman McLaren in Britain, Alexeieff and Bartosch in France, Masaoka in Japan, and Fischinger in Germany.

Schlesinger sold out to Warner Brothers in 1944. The distinctive anarchic style of his cartoonists is characterized, in contrast to Disney's more comfortable work, by such characters as Bugs himself, Porky Pig, Daffy Duck, Tweety Pie and Sylvester, Road Runner and Wile E. Coyote, Bill Hanna and Joe Barbera's Tom and Jerry for MGM, Walter Lantz's Woody Woodpecker for Universal Studios, and a host of others.

In the late 1940s and early 1950s John Hubley (a former Disney artist) and Chuck Jones were among the leading creators of a new style of animation that came from the now renamed United Productions of America.

The UPA style starkly contrasted with that of Disney et al. Directors were encouraged to use a free approach and, influenced by contemporary fine art, these animators made the visuals, the pictures and strong flat colours the focus of the drama. Their soundtrack treatment was equally innovatory.

John Hubley's animation developed further towards the avant-garde and he left UPA in 1955 to form an independent production company, Storyboard, with his wife, Faith. They developed a high reputation, winning a prize at Venice in 1957 with *Adventures of an \**. The Hubleys were also improvisers, using their children's fantasies and voices in the Oscar-winning *Moonbird* (1959) and in *Windy Day* (1967). They produced some of the first animated television commercials.

**Avant-garde animation**

By the end of the 1950s, the cheaper

standards of TV were heralding the end of mainstream animation's golden age. But parallel to the work of the American studios, independents such as Norman McLaren had continued to work in an abstract, avant-garde aesthetic, and there was a great growth in serious work worldwide. In 1941 McLaren helped to found Canada's internationally

◀ JOHN HUBLEY
**Carousel**
Hubley was one of the first animators to make a real effort to design human characters. At this time most of the others were cats, dogs or ducks, although there had been occasional people, such as *Betty Boop* and *Popeye.*

▲ JOHN HUBLEY
**Adventures of an \***
The UPA style was very different to that of the Disney Studios, and Hubley is credited with simplifying both line work and colour. He abandoned the traditional palette consisting of some 20 colours, preferring to use a few basic ones.

► JOHN HUBLEY
***The Hole* (above) and *Moonbird* (below)**
By reducing the characters to a minimum of lines and angles, the Hubleys (John and his wife Faith) were able to "precis" their imagery to provide maximum impact. For both these films, they recorded the voices of children, creating powerful visualizations of the words.

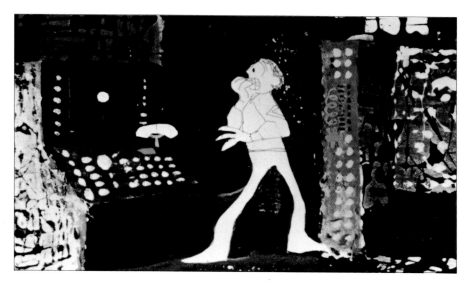

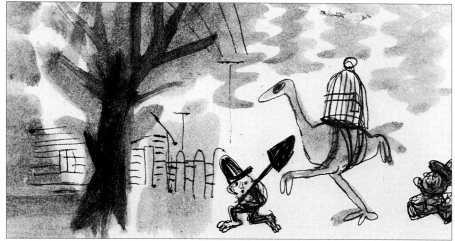

significant animation industry with the National Film Board of Canada. The English studios, Halas and Batchelor, made *Animal Farm* in 1954, Grimault and Image were dominating in France; in Poland, Czechoslovakia, Japan and China, there was much creativity; in Yugoslavia, Dusan Vokotic and others of the Zagreb school injected new life into the art of animation.

More recently there have been some outstanding tours de force of animation, such as Richard Williams' title credits for *The Charge of the Light Brigade* (1968), *Yellow Submarine* produced by George Dunning and designed by Heinz Edelmann (1968), and *Who Framed Roger Rabbit?* (Williams again, 1988). *The Charge of the Light Brigade* credit sequence was a key factor in the removal of animation from the doldrums it fell into in the 1960s. Williams gave the medium new dignity and seriousness.

Amongst the best of the true animation artists is Yuri Norstein, still working in Russia. His bewildering mix of techniques and his profound treatment of great themes are both outstandingly individual. Three-dimensional animation, by Norstein and other artists who combine personal and commercial work takes on yet another dimension with the recent computer breakthrough that allows a solid to be "bent" in form. Other previously difficult or time-consuming tasks, like colourization or putting live action and animation together, are open to new possibilities of interpretation with the computer. In both art and strictly commercial application for advertising, the speed of technological development means that effects undreamed of in animation last year will be old hat before this book is printed.

▲ ROBERT BREER
**Bang**
Modern industrial methods of animation avoid the necessity of redrawing more than a small proportion of the images for each frame. Breer, however, seldom uses such methods as the separation of background from foreground and movement from static areas, preferring to re-create the image afresh each time. His artwork thus provides an unusually full documentation of the genesis of a film.

◄ ROBERT BREER
**Trial Balloons**
Breer's method of working is unusual. In the 1960s he began to work on small white index cards rather than the conventional 8 x 10 inch animation paper. These allow him to draw each image more quickly, and also lend themselves better to the trick of riffling through to check the movement. He also likes the way the lines and brush-marks appear when magnified for projection; they would be less noticeable if drawn to the usual scale. This film, made in 1982, combines animation with re-photographed live-action footage, and gives an impression of both elegance and spontaneity.

his genius to entertain, like Disney; instead he tried to surprise to impress.

There are many more forms of animation "language" – as indeed there are animators – and animation is bad only when an animator doesn't do his or her own job well.

Animation has suffered at times from being condemned to minority entertainment and not taken seriously. But it is important to remember just how powerful a force entertainment can be. Animation's unique expressive quality, its broad gestures, allow it a place in serious, as well as commercial, art.

**The qualities of an animator**
An animator's motivation is to make moving pictures – to be free of the ordinary artists' or illustrators' limitations of a flat, static surface. However, you are still working on a canvas of certain proportions (the 35mm camera sees to that), and within cinematic, televisual or theatrical contexts, or a combination of these. You must have a more complicated set of instincts than a straightforward illustrator, although you still need the illustrator's ability to encapsulate an idea – tell a whole story – on a single piece of paper.

First and last, you must be a performer and manipulator – of your characters and your audiences; you must understand and love dramatic art. You must also know how to draw, be a writer, a director, a layout artist, an editor, an animator, a camera operator, a photographer, a set designer, a lighting designer, a special effects person and you must be an overall designer. To draw the "look" of the film is perhaps the most important element, alongside performance. In commercial work you will of course have an art director's input into the visual quality of the production, but it is held together by the animator's complete sense of the design.

It is impossible to be a good animator without learning how to watch. Disney artists would always talk not just about technicalities like how many drawings per action, but also about their observations: how a pregnant woman walks, where she holds her weight. Each of your drawings must have a sense of movement; you cannot rely on the fact that they will all be strung together. However outrageous or bizarre the character, it must move and breathe, and be believable. Marc Davis, the animator of Cinderella, was a master of expressive economy, able to make tiny details build to an epic quality. Chuck Jones would not take the animator's easy way out and let his characters rest for a frame or two; Bugs Bunny

would stand and think. To be a first-class animator you must develop a fine sensitivity to how movement is created.

Perhaps more subtly, your drawing must be cinematic as well as kinetic. Rembrandt, for instance, has the action, lighting, narration and directionality of cinema, while Bosch or Giotto do not. It is a matter of relationship with the camera; the basic language of film has to be understood from the classic point of view. You have to be aware of the classical tradition and to understand what film can do.

In many cases illustrators are successful because they purvey their own characteristic style. Unless you are in "art" animation, which is comparatively rare, you do not work with such individual distinction – you develop a style to suit. It must be in accord with the subject and its treatment – again, a matter for the art director and animator to chew over together.

As a commercial animator, although you must have a facility in any style the job demands, you still need to find your own language. The key to this lies somewhere between technical innovation and an original approach. Robert Breer's work, for example, shows all the freshness of someone who has just stumbled across animation itself.

Finally, it pays to be able to tell a good joke. If you can choose the right words and deliver them at the right pace and time, you can act; and if you're an actor who can draw, you can be an animator.

◀ NORMAN McLAREN
**Begone Dull Care**
McLaren himself gave a lucid description of what drawing for animation involves. "Animation is not the art of *drawings* that move, but the art of *movements* that are drawn. What happens between each frame is more important than what exists on each frame. Animation, therefore, is the art of manipulating the invisible interstices that lie between frames. These are the bones, flesh and blood of the movie."

### Animation today

Since Richard Williams' Light Brigade credit sequence, the craft of animation has developed apace in the UK and although there is a great deal of serious "art" animation being produced in North America and Eastern Europe and, of course, by Norstein (in the face of considerable difficulty) in the USSR, the commercial creative "buzz" focuses on London. It need not be automatically concluded that advertising art is inherently cheaper than "serious" art; there are those who argue strongly that film and TV commercials represent a contribution to folk culture, and once their immediate relevance is over they can settle into their longer-lived position in social history.

### Making an animated film

However it is that you decide to try to get your work in the public eye, you will never be taken on as an animator or "picked up" by the industry if you do not have work to show. There are animated "shorts" and features, the festival circuit, experimental animation, computer animation, selections and competitions for annuals and awards, and there is the college degree show.

Colleges by and large are technical resource centres where you can work out your own ideas; festivals and competitions are important for the fertilization of ideas as much as for the publicity. But if you want to "make it", particularly in advertising (which gives animation the

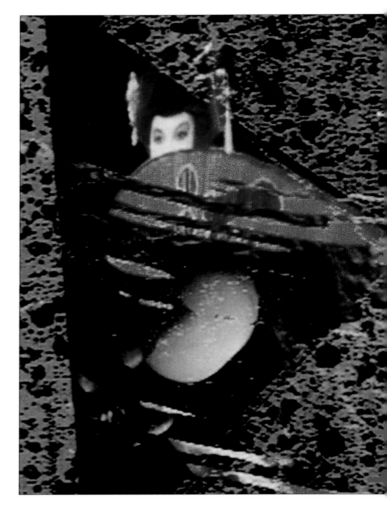

▶ MATT FORREST
The title sequence for the music programme *Wired* is a combination of computer graphics and live-action motion-controlled photography. The desert background was a built set, with the real footage for the clouds keyed into the picture.

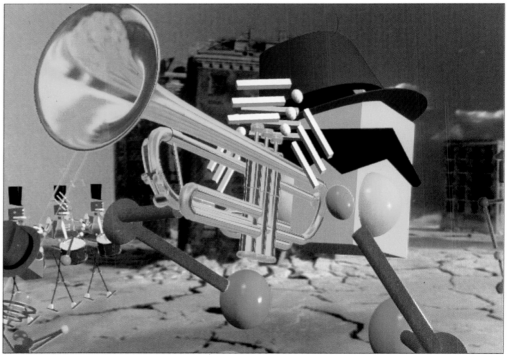

most opportunities and the highest profile) then you must be producing original work, and it is the idea of the work rather than success that must inspire you. If your desire to make a film is the paramount one and if your ideas are good enough, you will eventually find yourself in demand.

Part of the attraction of advertising work is the budgets; a 30-second film could quite easily cost £50,000 – plenty of cash to float your ideas. Commercial animation can also be as artistically sophisticated as anything more intellectually ambitious.

### Taking a brief

Whatever its pretensions, a TV commercial will always start with the brief, which can sometimes by very tight

◀ MATT FORREST
*Network 7* is a current affairs programme, whose title sequence is a visual montage of a journey through Britain, ending in London. Computer graphics were laid over assorted images achieved by models and motion-controlled shots.

◀ ▼ CAL GRAPHICS
Launched in 1989, Channel 4's early morning programme, *The Channel 4 Daily*, is built around six main elements: World News; Box Office (arts); Business Daily; Streetwise (consumer advice); Kick Back (sports) and Comic Book (children's cartoons). CAL was commissioned to design and produce a presentation package, involving over 20 sequences and a main identity, that would provide a framework for the whole series. It was an opportunity for recently qualified designers to work as part of CAL's design team.

and at others demand a high level of creative input from the animator. Agencies in the UK tend to have a better understanding of the medium and its potential, and are thus happier to give the animator imaginative freedom, but the sophistication and developmental speed of technology in the 1990s will demand that agency creative directors up-date their appreciation yet again.

It is many an illustrator's and animator's plight to be briefed by someone with very strong but misguided ideas. The only solution is to use diplomacy mixed with a willingness to take a risk and trust your own judgement against the client's. As in any form of illustration, taking the brief fully and accurately is crucial; you must keep asking questions until you have understood, or pinpointed any grey areas. You might be given the script at this point, or it might be developing at the same time – but you ought to expect some script input.

The film is then designed by way of visuals which are best drawn big. These are pictures that show your interpretation of the client's concept (the client can mean the agency, of course), in particular of the characters, who may be the crux of the whole thing. It is often sensible to put the visuals on video so your clients can get a "moving picture" idea of what the film will look like. At this stage you will find out whether you have read correctly what was in the minds of those who briefed you.

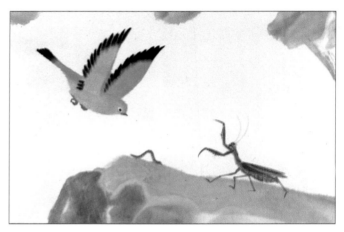

▶ SHANGHAI FILM STUDIOS
Chinese animators make imaginative use of traditional styles or techniques of art and popular theatre, such as line and wash painting, puppetry and paper cutouts derived from origami. The films illustrated here, Te Wei's *The Cowboy's Flute* (top and bottom) and Hu Jinguing's *Mantis Seeks Cicada* (centre), are characterized by fine use of ink and wash and dry-brush watercolour.

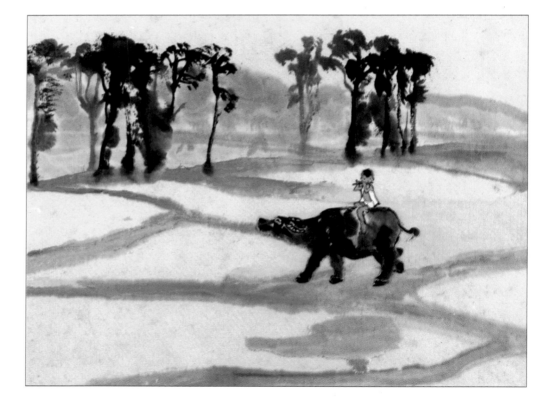

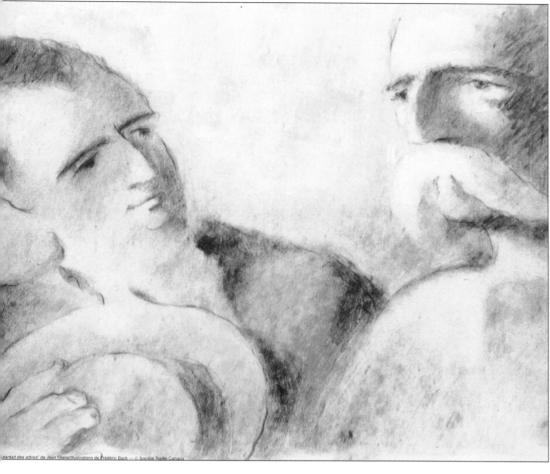

*plantait des arbres' de Jean Giono/illustrations de Frédéric Back — © Société Radio-Canada*

◀ FREDERIC BACK
## *The Man who Planted Trees*

This film, made for the Canadian Broadcasting Corporation, and with separate soundtracks in French and English, was winner of several awards. Back's powerful images, supplemented by a voice-over narration, tell the story of a determined but self-effacing shepherd living high in the French Alps. Single-handed, he plants and matures thousands of oak trees, transforming a barren, desolate region into prosperous farmland surrounded by his vast forest. Its message is simple – one man can make a difference.

Back studied in France, emigrated to Canada in 1948, and worked at various jobs including farmhand before becoming a full-time animator. His deep commitment to the natural world is evident in both his lifestyle and his work. Like the hero of the film, he has himself planted over 10,000 trees in his country retreat, and one of his earlier films, *Crac!*, deals with the effect of humans on the animal world.

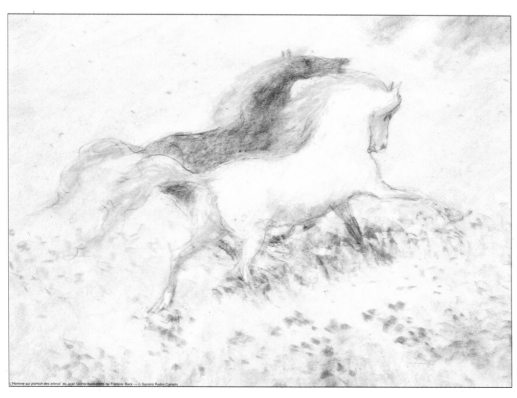

*L'Homme qui plantait des arbres' de Jean Giono/illustrations de Frédéric Back — © Société Radio-Canada*

▼ ► CAROLINE LEAF
*Interview*
American-born Caroline Leaf
joined the National Film Board of
Canada in 1972, where she was
able to develop her unique and
intensive method of working. In
this film made in 1979 and co-
directed with Veronika Soul, she
mixed live action film with
animated sequences using paint
on glass as in *The Street* (facing
page). Interviewed in 1985 she
said, "After Interview people said
it was good to see a woman with
independence, a woman working
and that's what they've gotten from
this film. . . Many more women are
now working in ways like I do,
under the camera, in a personal
style."

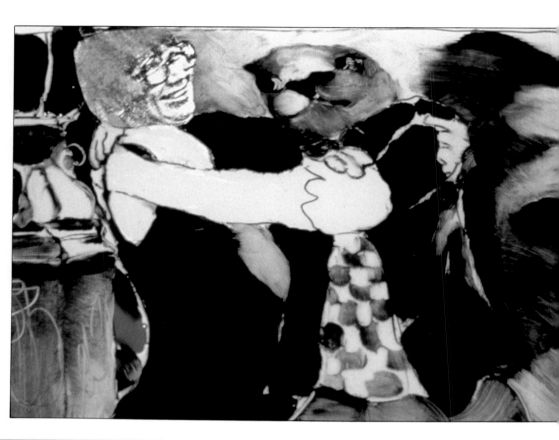

## The storyboard

Next comes the storyboard, the spine of the film, where
pictures and script first come together. Everything must
be resolved on the storyboard; it's no good expecting to
fill in the gaps later. It doesn't matter whether it is a piece
of highly finished artwork or a collection of roughs, it
must make film sense. The storyboard allows you to time
the plot and craft its structure towards a climax; it can
also be a guide to the sound, unless that already exists, in
which case it must be a guide for the storyboard. Though
it is quite common to decide on voices as early as the
original briefing, and a big help since that gives you a
style to work to, rarely if ever will you animate to existing
music.

## Layout

From the storyboard you go to layout, the process by
which the scenes are drawn and worked out technically.
Camera guides are worked out at this stage, which
implies that you have already thought about shots and
angles; layout also deals with the positioning of the main
characters against the backgrounds, the "match lines"
that give their relationship with static objects (if you walk
behind a chair, for instance, you must be sure to lose a
leg for a moment). Characters and backgrounds are on

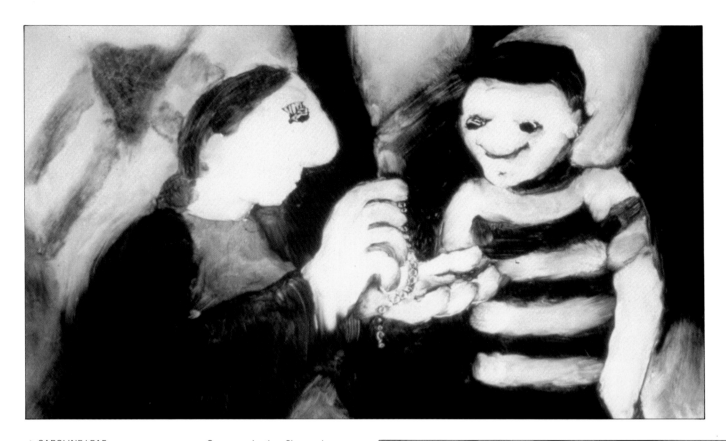

▲ CAROLINE LEAF
**The Street**
Based on a story by Mordecai Richler about a Jewish boy growing up in Montreal, this film made in 1976 brought Caroline Leaf international acclaim and an Oscar nomination. She used non-drying tempera colours painted under the camera on backlit glass, which was then moved about to produce the animation.

different sheets; the animators will be drawing "key" frames from this to show positions at the beginnings or ends of movements.

From the layouts come the animation drawings themselves. The "in between" drawings are normally the work of assistants. Again, video technology is enormously helpful and you can check the progress of your work daily.

## The line test

The "line test" is shooting and showing complete sections of built-up but as yet uncoloured film put together to see how the structure works, whether the characters and backgrounds interact correctly, and whether you have convincing action. It will give you – and the client – the most complete impression of what the final result will be. Confirmation that you are on the right track can come here as can the heartbreaking process of re-thinking and re-drawing.

▲ CAROLINE LEAF
**The Metamorphosis of Mr Samsa**
In this early film, the artist experimented with an unusual technique in which she worked directly under the camera with sand lit from beneath to produce dark, shadowy shapes. The sand was moved about slightly between frames to produce movement.

183

▶ BRAD CASLOR
*Get a Job*
The film, released by Canada's
National Film Board, began as a
government-sponsored project with
a semi-educational slant. The NFB
producer, however, liked it enough
to take it on as a studio film, and it
was developed more as a musical
drama.

Then comes colourization, usually painting on cel, which is done by illustrators more than animators. It can also be done now, of course, by computers, but not until the drawings have been photographed. Modern techniques of digital "frame storage" and computer colourization using such devices as "Harry" and Paintbox, have revolutionized this section of the process. Now you can turn a line drawing into a full-colour painting, marry pieces of film together, take a character or element from one film and put it in another, mix and match live action and animation, re-touch, re-colour, re-time, and re-direct; a certain number of frames can be made to last longer, or a sequence can be "squashed", all electronically. The boundaries topple.

**The final film**
After colourization the film is actually shot – the drawings put under the camera – and the sound and music are put on to it. Here, too, the capabilities of "Harry" and the newest generation of computerized image manipulators can be used, as they can during the transfer of the film to video. The pictures can be colour-balanced ("graded") and the image "cleaned" in this process. Titles will also be added here.

Despite the new technological wizardry it is the heart and soul of the animator, not the techniques he or she uses, that finally determine the quality of what he or she produces. Animation deserves the same respect as any art form. It is about people talking to each other, trying to express what otherwise wouldn't or couldn't be said; it should reflect the world we live in and help us to understand it and ourselves.

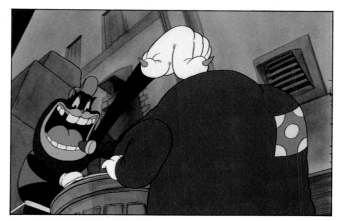

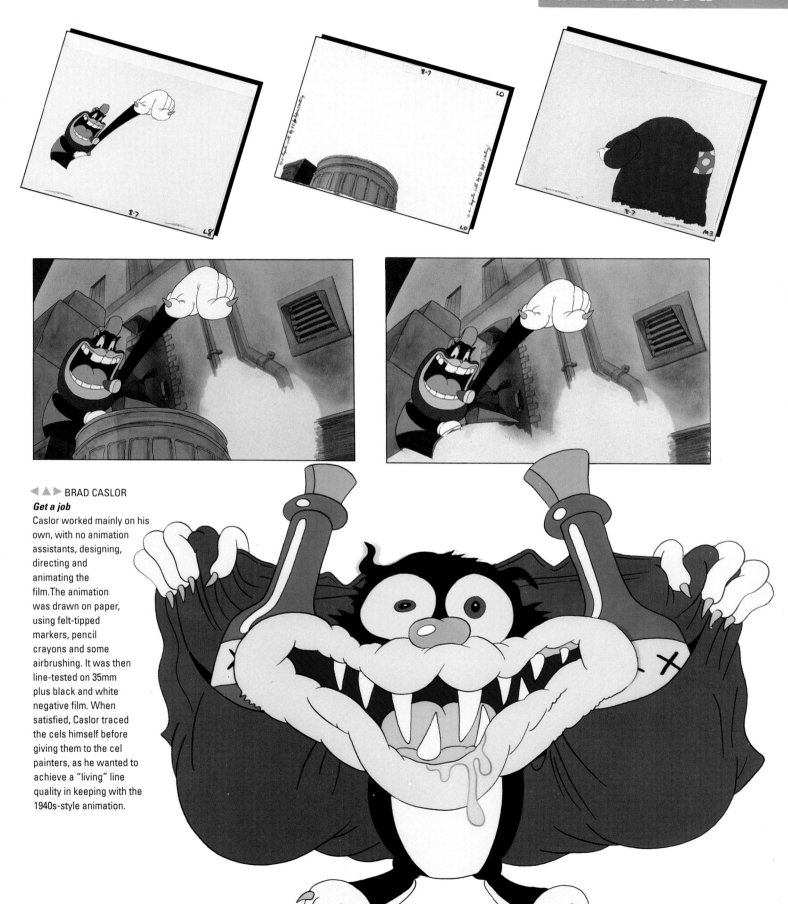

◀ ▲ ▶ BRAD CASLOR
**_Get a job_**
Caslor worked mainly on his own, with no animation assistants, designing, directing and animating the film. The animation was drawn on paper, using felt-tipped markers, pencil crayons and some airbrushing. It was then line-tested on 35mm plus black and white negative film. When satisfied, Caslor traced the cels himself before giving them to the cel painters, as he wanted to achieve a "living" line quality in keeping with the 1940s-style animation.

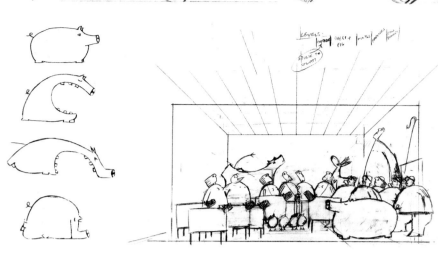

case study

## ANIMATED FILM
**CLIENT** *National Film Theatre*
**ILLUSTRATOR** *Mark Baker*
**BACKGROUND** *The Hill Farm (completed in 1988) was produced at the British National Film Theatre School. This 18-minute animated film won the British Academy Award for animation in 1988 and the Annecy Festival Grand Prix in 1989.*

Mark says that "the script developed slowly, starting with the idea that I wanted to make a film set in one location and involving several characters, each acting out their own stories. I developed each story separately, and gradually worked out ways of combining them, photocopying each new draft of the script and cutting and pasting chunks in different orders. Now I would use a word processor.

"As I was working on the script I was also tentatively designing the characters and locations, in the form of rough sketches on the page, so that there was constant interplay between words and drawings. I then made the story into a practical shooting script by breaking everything down into self-contained sequences. This has the advantage of allowing you to make the film in any order. In this case I began by animating all the 'animals eating' sequences first."

▲ **Model sheet of pig**
Model sheets are used to keep characters consistent. This one was made by photocopying key drawings of the pig from the first animations. When more were done, some months later, this sheet was used for reference.

▲ **Rough layout for a scene**
These are used to plan out shoots before any animation is done. They are often based very closely on early drawings

made at the scriptwriting stage. In the final version, all the characters were drawn on separate layers of clear acetate and the background was drawn on paper.

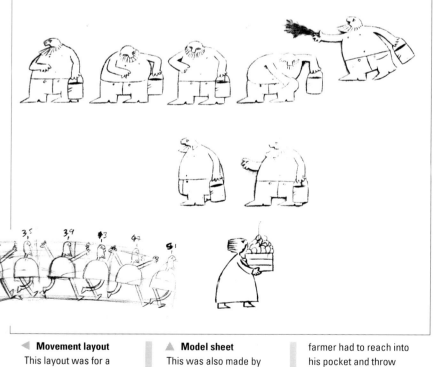

◀ **Movement layout**
This layout was for a character running up a hill and moving slightly away from us. The whole action was drawn on a single sheet of paper.

▲ **Model sheet**
This was also made by photocopying key drawings from early animation of the characters. At several points in the film the

farmer had to reach into his pocket and throw some grain on the ground for the chickens, so it was useful to have this for reference.

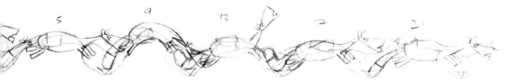
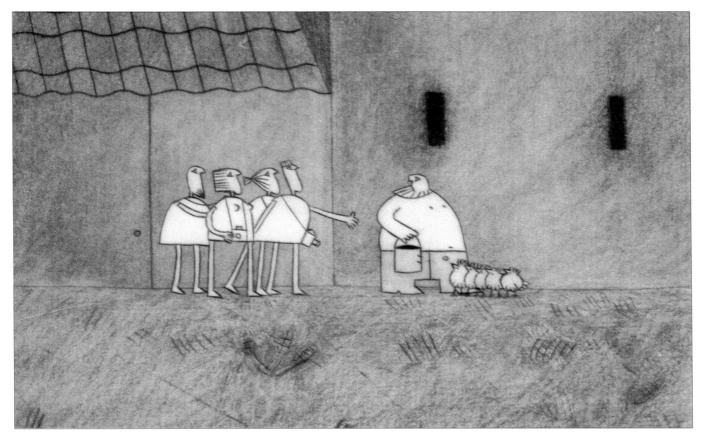

**▲ ▶ Final artwork**
The characters were
animated directly onto the
acetate, painted on the
reverse with white paint,
and on the front with
coloured pencils. The
backgrounds were drawn
with a combination of
pencil, crayon, emulsion
and watercolour. The
same background is used
throughout the shot, with
the characters animated
on successive sheets of
acetate.

**▼ Movement layout of
a car**
This was done to work out
the perspective of the car
and the characters.

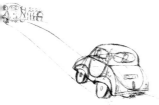

## ACKNOWLEDGEMENTS

Quarto would like to thank the following for their help with this publication and for permission to reproduce copyright material. Whilst every effort has been made to trace and acknowledge all copyright holders, Quarto would like to apologise if any omissions have been made.

Key: a = above b = below c = centre r = right l = left br = below right bl = below left

p10 Marshall Arisman
p12 James McMullan Inc.
p13 James McMullan Inc.
p14 Ralph Steadman
p15 Paul Davis
p16 Bush Hollyhead
pp16/17 David Boys
p17 Milton Glaser
p18 Chloë Cheese
p19 Tom Curry
p20 Lane Smith
p21 Lane Smith
p22 Brad Holland
p23 Marshall Arisman
p24 Cathy Felstead, Sharp Practice
pp26/27 Bill Vuksanovitch
p27 David Boys
p28 Mervyn Peake Estate
pp28/29 Mark Reddy
p29 Stephan Daigle
pp30/31 Jeanne Fisher, Sue Llewellyn (art director), Stereo Review Magazine
p31 Liz Pyle, Mary Lewis (art director) of Lewis Moberley Design for ASDA
p32 Lynn Gregory
p33 (a) Steven Guarnaccia; (b) James McMullan Inc.
p34 Barbara Nessim
p35 Brian Grimwood
p36 Mark Edwards
p37 Tom Curry
pp38/39 Marshall Arisman
p39 Lane Smith
pp40/41 Ashley Potter
p41 Bob Murdoch
p42 Julien Lightfoot © Bournemouth and Poole College of Art and Design
p43 Andrew Kulman
p44 Melissa Grimes
p45 (a) Andrew Ekins, Steve Devane (art director), Director Magazine (client); (b) Felicity Bowers
p46 (a) Jonathan Inglis; (b) Hazel Morgan © Bournemouth and Poole College of Art and Design
p47 (a) Jane Strother; (b) Paul Davis

p48 Robert Anderson
p48/49 Kinuko Craft, Wendell Harrington (art director), Esquire Magazine Dec 1987 (client)
p49 (bl) Mark Baker; (br) Bee Willey
p50 (b) Jon Blake
p52 (b) Graham Rosewarne
p53 (bl) Hannah Firmin, Sharp Practice
p54 (a) Antonia Enthoven
p56 Ian Murray, Sharp Practice
p59 Marshall Arisman
p60 (l) Milton Glaser (ar) Rhythm & Hues Inc (br) Jerry Cave © Bournemouth and Poole College of Art and Design
p61 (a) Brad Holland; (b) Thunder Jockeys
p65 (a) and (b) Stephan Daigle
p66 Elfande Art Publishing
p67 Artists Partners
pp68/69 Andrzej Dudzinski, Sharp Practice
p70 Mirko Ilic
p72 Peter Knock
p73 (a) Dolores Fairman; (b) Jane Strother
p74 Ross Thompson (Ross)
p75 David Suter
p76 Paul Cox, Acorn Studios
p77 (a) Bill Anderson; (ar) Mirko Ilic; (br) David Suter
p78 (a) David Suter, The Listener, (b) Mick Brownfield, The Listener
p79 (a) Richard Parent, Sharp Practice; (b) Matilda Harrison, The Observer
p80 Ashley Potter
p81 Cliff Harper
pp82/83 Brad Holland
pp84/85 Brad Holland
p86 Michael Frith
p87 (a) Hector Breeze; (b) Nicholas Garland
p88 Peter Sullivan
p89 John Grimwade
p90 Cel Gulapa
p91 Mirko Ilic
p92 Lynne Riding
p94 Christopher Corr
p95 Miles Aldridge
p96 Ken Cox from The Diary of a Nobody by George and Weedon Grossmith (Penguin Books, 1945). Reproduced by permission of Penguin Books Ltd.
p97 Paul Hogarth
p98 Weedon Grossmith from The Diary of a Nobody by George and Weedon Grossmith (Penguin Books, 1945). Reproduced by permission of Penguin Books Ltd.
p99 Alan Aldridge

p100 (a) Andrew Davidson; (b) Mervyn Peake Estate
p101 Maggie Silver, © Oxford University Press
p102 Glynn Boyd Harte
p103 (a) © Leslie Forbes, 1985
p104 Art Spiegelman
p105 'From Cartoon King Lear by Ian Pollock, published by Oval Projects/Sidgwick & Jackson'
p106 David Pelham and Harry Willock
p107 Jan Pienkowski
p109 (bl) Rob Stone
p110 Eric Tenny
p112 Ivan Bibilin
p113 (a) Mitsumasa Anno; (b) Ron Brooks, reproduced by permission of Penguin Books Ltd.
p114 Kevin Dean and John Norris Wood
p115 (a) Tony Ross; (b) Eric Carle, © 1967, 1983 by Holt, Rinehart and Winston, reprinted by permission of Henry Holt and Company Inc.
p116 Teresa Foster
p117 Robin Lawrie
pp118/119 Raymond Briggs
p120 Susanna Stuart-Smith © Royal Botanic Garden, Edinburgh
p122 Stephen Ortega © Bournemouth and Poole College of Art and Design
p123 Paul Shakespeare © Patrick Collection
p124 (a) 'Reproduced by permission of the National Maritime Museum'; (b) © Science Museum, London; (a) © Science Museum, London
p125 (c) Stephen Ortega © Bournemouth and Poole College of Art and Design; (b) Mogul Neilson © Science Museum, London
p126 Terry Collins, Ford Motor Company
p127 (a) Hide Nakajima; (b) Paul Selvey
p128 Keith Hulme © Bournemouth and Poole College of Art and Design
pp128/129 Eric Webb
p129 Peter Jarvis
p130 Drawings by Samuel F. Manning first published in Wooden Boat Magazine, September/October 1984
p131 Lynn Gregory
pp132/133 Sharon Beeden, Natural History Museum
p133 (a) Sydney Parkinson, Natural History Museum; (b)

Susanna Stuart-Smith, © Royal Botanic Garden, Edinburgh
p134 (l) Carol Roberts © Bournemouth and Poole College of Art and Design; (r) Margaret Mee © protected, Nonesuch Expeditions
p135 David Boys
p136 John Busby
p136/137 Laura Wade © Bournemouth and Poole College of Art and Design
p137 (a) Eric Ennion, The William Marler Gallery; (b) Clare Roberts, reproduced by permission
p138/139 Kevin Dean
p140 (l) Peter Cull; (r) Urban & Schwarzenberg Gmbh
p141 Peter Cull
p142 Claire Smalley
p143 Howard Tangye
p144 Caroline Gaudy and David Holmes
p146 Mark Reddy
p147 Richard Adams and Mark Reddy
p148 (l) Dan Fern, London Transport Museum; (r) Gerald Scarfe, English National Opera
p149 Simon Packard, Lynx
p150 (r) Mansfield Clothing Company
p151 (l) Mansfield Clothing Company; (r) Jane Strother
pp152/153 Andrew Mockett
p154 © 1989 Guy Billout
p155 (a) Brian Grimwood; (b) Paul Davis
pp156/157 Walter Van Lotringen
p158 Jeff Fisher
p159 Christopher Corr
p160 Andrew Kulman
p161 Kevin Dean
p162 (a) Jeff Fisher; (br) Andrew Davidson
p163 (a) Miles Aldridge; (b) Andrew Davidson
pp164/165 Graham Evernden
pp166/167 Graham Evernden
p168 © Bob Godfrey Films Ltd.
pp170/171 Yuri Norstein
pp172/173 Marc Davis
pp174/175 Hubley Studio Inc.
p176 Robert Breer
p177 Norman McLaren
p178 Matt Forrest, Snapper Films
p179 Cal Video Graphics Ltd
p180 Shanghai Animation Film Studios
p181 Frederic Back
pp182/183 Caroline Leaf
pp184/185 Brad Caslor
pp186/187 Mark Baker